How To Make Webcomics

Brad Guigar | Dave Kellett | Scott Kurtz | Kris Straub

HOW TO MAKE WEBCOMICS

ISBN-10: 1-58240-870-X
ISBN-13: 978-1-58240870-5

First Printing.

Published by Image Comics, Inc.
Office of publication: 1942 University Avenue, Suite 305, Berkeley, California 94704.

PRINTED IN CANADA.

Cover photograph by Erica Stephens (http://www.ericastephens.net).
© 2008 Erica Stephens.

For information, write to: ww@halfpixel.com.

HALFPIXEL.COM

Image Comics, Inc.

Erik Larsen - *Publisher*
Todd McFarlane - *President*
Marc Silvestri - *CEO*
Jim Valentino - *Vice-President*

Eric Stephenson - *Executive Director*
Joe Keatinge - *PR & Marketing Coordinator*
Branwyn Bigglestone - *Accounts Manager*
Paige Richardson - *Administrative Assistant*
Traci Hui - *Traffic Manager*
Allen Hui - *Production Manager*
Drew Gill - *Production Artist*
Jonathan Chan - *Production Artist*
Monica Garcia - *Production Artist*

www.imagecomics.com

Table of Contents

Introduction

Greetings, cartoonist!

If you're like us, you have an insatiable desire to create your own comics and books, get them out there for the world to see, and more importantly, make a living doing it. Years ago, the only way to get your work to the masses and earn a living from it was through a publisher or a syndicate. They held the keys to the mass market, and only they had the resources to brand and market your comic.

But all that has changed. The playing field has been leveled. The Internet broke the barrier and busted the bottleneck. The entire world is out there waiting to discover your work and they don't need a newspaper or a bookstore to do it. The Information Age is here. The barrier between you and success is yourself.

You Know What Assuming Does

So that nobody makes assumptions, let's set some expectations for this book. This is not a primer course on how to make cartoon characters or comic strips. We're assuming that you already have that down and have polished your work to a professional level. This book is about your next steps. We're not here to teach you how to make faces out of shapes — there are wonderful books that can help get you up to snuff on all that. Here are some we recommend:

- "Action Cartooning" by Ben Caldwell
- "Toons" by Randy Glasbergen
- "How to Draw Comics the Marvel Way" by Stan Lee and John Buscema
- "The Everything Cartooning Book" by Brad Guigar

This book is broken down into two major sections: Creative and Business. You're going to have to understand the advanced concepts of both if you want to make it as a professional. Now I understand that most of us creative types have a really difficult time thinking about business and numbers. It's not easy for us to switch gears. That's why most creative people hire professionals to handle that aspect of their business for them. But we're not there yet! For a while, you're going to have to get comfortable with the idea of wearing two hats. You're both the cartoonist and the agent. The talent and the representation. The art and the numbers. Luckily, to get by on the business side of cartooning, all you need is some common sense, and a little courage. None of us went to business school and we've managed to get by.

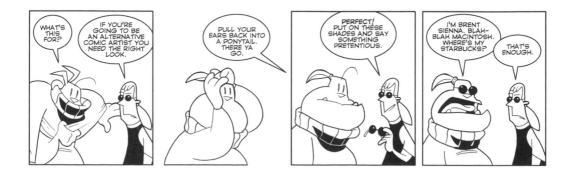

How To Read This Book

When it comes to passing along knowledge, we don't subscribe to the belief that too many cooks spoil the soup. The best thing you can do to further your career as a Webcartoonist is network. Meet as many people as you can in a position to help and make friends. You never know who can help you down the road with an opportunity or a piece of advice. We're going to start off your professional Rolodex with four names.

This book is written in four different voices. Dave, Brad, Kris and myself will each take turns offering our advice, giving our opinions and weighing in on the most important topics of making Webcomics. Each chapter is written by one of us — you'll know which by the illustration at the start of each chapter — but the others will be chiming in with their opinions or counter-points.

Like this!

Or like this!

Sometimes we'll be in agreement. Other times we'll vehemently oppose each other. This isn't meant to confuse you, but to illustrate that there is no single "right" way to do this, and that there are many paths to the same mountaintop (albeit, most of them challenging). We're also going to fill some sidebars with the many professional tips, inspirational quotes and links to resources that we've gathered over the years and which helped us along the way.

Sprinkled throughout the book, we'll also have "Hot Seat" spotlights, in which we'll turn our critiquing eyes on to our own specific cartoons to talk about technique, style, writing, layout and more. It's a conscious effort on our part to show that every cartoonist, at every level, can continue to learn and grow throughout their career.

In the end, remember as you read this book that you're in charge of your own path to success. We're happy and excited to pass along what we've learned, but not everything we say is going to or needs to apply to you. Read everything, run it through your mental filter and sift out the gems that will ultimately help you achieve your goals.

— Scott

On Starting...

Whether you think you can or think you can't, you're right.

— Henry Ford

Four-Word

A brief introduction to the four authors.

Brad Guigar

Brad started creating a six-day-a-week webcomic called "Greystone Inn" (www.greystoneinn.net) in February 2000. It was carried in a few newspapers — the largest of which was the Phialdelphia Daily News. After five years, he ended "Greystone," and spun-off "Evil Inc" — a comic about a corporation run by super-villains for super-villains, which is also carried by daily newspapers. In addition to "Evil," Guigar also create two weekly comics. "Courting Disaster" (www.courting-disaster.com) is a single-panel comic about love and relationships. "Phables" (www.phables.com), a longform comic about everyday life in Philadelphia, was nominated for an Eisner Award for Best Digital Comic in 2007.

Brad is the author of "The Everything Cartooning Book," and he lives in Philadelphia with his wife, Caroline, and their two sons, Alexander and Maxwell.

Kris Straub

Kris graduated from the University of California, Los Angeles, with a degree in Computer Science and Engineering, but his heart was firmly in comics. He first arrived on the Webcomics scene in 2000, with "Checkerboard Nightmare" (www.checkerboardnightmare.com), a thrice-weekly satire about Webcomics and the search for instant fame. Five years later, he launched "Starslip Crisis" (www.starslip.com), a six-day-a-week sci-fi comic strip about the crew of a decommissioned warship-turned-art-museum-turned-warship. The first two years of Starslip Crisis are collected in the book "Starslip Crisis: Volume 1."

In 2007, he began the studio site Halfpixel.com to hold his many smaller print, Web, animation and musical projects — a site that ultimately expanded to include Scott Kurtz, followed by Brad Guigar and Dave Kellett.

Kris relocated from Los Angeles to Dallas in 2007.

Scott Kurtz

Scott has wanted to make a living writing comic strips since his mother bought him the first "Garfield" book in 1980. His hobby turned into a full-time career in 2000 when Scott quit his job as a Web designer to go full time as a comic-strip artist. Scott's comic, "PvP," has been running since 1998 where it started with "Penny Arcade" at the now-defunct MPOG.COM. Over the last 10 years, Scott and his wife Angela have built PvP into a self-proprietorship with over 200,000 daily readers, a monthly comic book published by Image Comics, and a burgeoning online store for PvP merchandise.

Because of the neutrality of the net, and the support of thousands of PvP fans, Scott has been able to keep PvP a creator-owned property, side-stepping traditional avenues to a career in cartooning. PvP has been nominated for multiple Harvey Awards and won the Will Eisner Comic Industry Award for Best Digital Comic in 2006.

JAN. 18. 2005

Dave Kellett

Dave's been a lover of sequential art since those first crayoned comics in the first grade. After a professional start with cartoons in the *Los Angeles Times* and the *San Diego Union-Tribune*, in 1998 Dave began creating his Webcomic "Sheldon" (which can be read daily at sheldoncomics.com). Dave holds two Masters degrees in the art and history of the cartoon from the University of California, San Diego, and England's University of Kent. After working in the UK as a junior archivist at the British Cartoon Archive, Dave returned to the U.S. to begin an 8-year stint at Mattel Toys, becoming a senior creative and toy designer. In late 2006, the readership and income growth from "Sheldon" allowed Dave to step away from the corporate life and make the Webcomic his sole, full-time job.

Currently, there are four "Sheldon" book collections: "Pure Ducky Goodness," "The Good, The Bad & the Pugly," "62% More Awesome" and "A Blizzard of Lizards."

Dave lives in Los Angeles with his far-more-talented wife, Gloria, and can be reached via e-mail at: dave@davekellett.com.

Your Webcomic

As far back as you can remember, you've loved to draw cartoons.

You've loved sitting down and crafting those little worlds of text and images. With them, you can share a joke, tell a story, or transport people to a place that exists wholly in your mind. It's a pretty amazing artform, cartooning, and it's a passion you've never been able to shake. And now, you want to bring your art to the world via the Web.

You want to create Webcomics.

What's Old is New Again

Why Webcomics? Well, probably because you already read dozens of Webcomics daily – and you've watched in wonder as the artists behind "Penny Arcade" or "Achewood" or "PvP" turned their online outlet into a career. And you can't imagine a life better than that. And you probably have guessed – all too correctly – that the income streams in traditional print are drying up for all but a few new cartoonists a year. More and more of the cartoonists you love are creating exclusively for, or moving to, the web — and the money seems to be following them there.

But you've also surmised that something is different about the way Webcomics work. For one thing, there's no corporate kingmakers in Webcomics. No editor or publisher who will pluck you out of obscurity and create your career for you. Nope, all your favorite Webcomics grew by the strength of their creator's sole efforts, and by the quality of their own work. They made their own magic, building their audience and their income slowly, over years, until they could eventually run their comics as a full-time job. And now, these Webcartoonists are steering their own show, and doing as they see fit. In a whole host of ways, these cartoonists operate their Webcomic very differently from print comics.

- They don't rely on a publisher, a syndicate, or a distributor – they deal directly with their audience.

- They don't conform to size or style or color limitations – they can change their format to fit the mood and method of that day's comic.

- They're not limited by content or word choice or editorial filtering – they can write exactly what they want, for an audience as broad or as niche as they want.

- They're not an anonymous personality. You often hear as much from them via blogs and forums and e-mails as you do from their comic.

In some ways, Webcomics are a step back to the days before mass media. We've become so used to the idea of an artist being co-opted by a corporation (newspaper, TV, film, etc.) that we've almost forgotten what it's like when an artist deals directly with their audience.

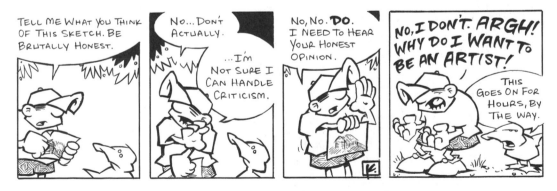

Just Do It

Whatever you do, or dream you can, begin it. Boldness has genius, power, and magic in it.

— *Goethe*

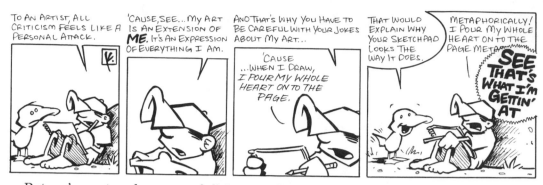

But we've entered an age of disintermediation, where the middle man can be cut out of the equation in distributing art. For better or for worse, a band can now release an album directly to their fans, an author can sell e-books directly to their readers, and a cartoonist can build up a cottage industry around their online work. This is, of course, both wonderful and terrifying. It's wonderful, because it unshackles cartoonists from earlier restrictions. It's terrifying, because it also unshackles the artist from the resources the corporation could provide: the accounting, legal, editorial, marketing and sales services. Now, the artist has to wear many hats, and learn entirely new sets of skills.

What does this mean for you, as a Webcartoonist? It means it's no longer just you sitting at your drawing desk. At times, you'll be taking on marketing, P.R., publishing, sales, and a thousand other worrying and wonderful tasks. And with all these job titles added to the equation, some artists will sink and some will swim — and a precious few will grow to super-stardom.

But the Web allows for all levels of success. Not every Webcartoonist has to be the ultimate jack-of-all-trades. You may just want this as a hobby, or a supplemental income. You may want this to be a purely artistic outlet, a way to work out your creative impulses in a manner your day job might not permit. Then again, you may want to make this your life's work, with the hope of being self-employed (or a multi-employee operation) in 5-15 years. Your path and destination are entirely up to you.

Sometimes the first reaction to the magnitude of handling all of these divergent tasks will be to say, "But I'm just an artist."

Over and over, the "just an artist" argument gets used as an excuse for not having an aptitude for business. You might even find it in this book once or twice!

But I would say to you that you are not an artist. Unless you are in a collaboration with a writer, you are a cartoonist. A cartoonist has mastered art and writing — two very different talents.

And if you can do that, you can balance a checkbook.

The blessing and the curse of Webcomics is the low-entry point. Compared to any traditional print model, it's ridiculously easy to start a Webcomic: You could be up and running by the end of today. There won't be insurmountable obstacles toward

Breaking from the Pack

We must overcome the notion that we must be regular... it robs you of the chance to be extraordinary and leads you to the mediocre.

— *Uta Hagen*

getting your first comics up on the Web. There is no editor to run the comics through, nor syndicate nor publisher's submission process. But this is also the curse of Webcomics: It's easy for 10,000 terrible new Webcomics to start up right next to the 1 or 2 sparkling gems. There is no filter for quality. So the trick is not in starting a Webcomic...the trick is starting a good Webcomic.

Or, to put it another way: It can take you a day to start in Webcomics, but can take you years to master.

What Is A Webcomic?

Before we go too far into this discussion, let's clear something up: Webcomics are not a genre. They are a medium. To put it in the simplest equation, Webcomics are comics + Web. They're everything you loved about long-form comics, short-form comics, sequential strips and single panels — transposed to a new means of distribution. They can be goth, or superhero, or family-friendly comics about puppies, and all still be "Webcomics." Webcomics aren't separate from or distinct to other forms of comics — they're just transmitted differently. So for our purposes here, we'll use the term as shorthand for a cartoonist who puts their work on the Web.

There are 10,000 permutations of form and function and content and craft within Webcomics. But I'm not here — "we're" not here — to give you a strict, biblical definition of the look and feel and style of a Webcomic. There isn't one. And even if there was, why focus on the limitations that might keep you from creating the next great format — the one no one has thought of before? The four of us are artists. We'll leave the boxed-in definitions to the theorists who don't create. It's enough to say that Webcomics are comics on the Web, and leave it up to your artistic side to decide what that means.

Before We Start...

In later chapters, we'll be getting to all the juicy bits of creating a Webomic: How to write, create, display, and promote your work. But in this chapter I want to touch on a few short-but-important thoughts to prime your thinking. These will be preparatory ideas, really, to get your mind in the right space. Think of it as a pep talk, before the big game, or a short, introductory speech before an afternoon of in-depth presentations. Let's talk about motivation, finding your voice, and getting your priorities straight.

The Artist

It takes a lot of courage to show your dreams to someone else.

— *Erma Bombeck*

Fear of Starting

Like every artist who has ever lived, you want your creations to be great, right out of the gate. It's understandable: You want to start on the best foot possible. But no amount of rewrites or re-illustrations will get your first comic perfect — or even close to perfect. So here is what I propose you do: Post it anyway.

It may not meet your hopes — in fact, I guarantee it won't meet your hopes — but post it anyway. Then move on to the second comic. And the third. They will all, incrementally, improve.

You have to find the courage within you to make that first post, and to never look back. Don't let fear of starting keep you from getting where you want to go.

— Dave

Motivation

First, we need to consider your motivation for starting a Webcomic because — as it is in all forms of art — your motivation is everything here. If you're doing it for the wrong reason, or with the wrong mindset, it's a death knell for your creativity. Your heart has to be in it, and your mind has to be prepared for the hurdles it might face.

Simply put, you can't make Webcomics for the money or the fame. Because, statistically speaking, that won't happen. There is no grand life with swan-filled pools waiting for you; only hard but fulfilling work. You must create because the act itself brings you joy. Because you want to craft and populate your own worlds. Because you have a unique story or sense of humor that only you can convey. Because there is a comic inside you burning to get out.

The truth is that you could invest years into a comic before it returns any significant amount of notoriety or financial reward. Sadder even, you may *never* see any return despite your best efforts. And if these are your sole reasons for starting a webcomic, you could be setting yourself up for a great amount of dissapointment and resentment.

I guess what I'm saying is, this has to be a work of love, first. It has to be that the cartooning itself brings you joy. In your early years, you'll be doing this for little to no financial return, so the payoff has to be in the process itself. If there's no innate pleasure in drawing up a few panels and sharing them with the world, then you'll lose heart. And if you plan on doing it for years to come, it won't be enough to make up for the sacrifices you'll be making to your free time, your late nights, your relationships and your other hobbies.

Still interested? Good, you should be! Because, all warnings aside, this is a fantastic artform to work in, and a great medium to use. Comics are a powerful, personal way to tell stories, and the Web is an amazing way to distribute those stories to the world. And despite all the work, Webcomics are immensely, immensely fun to create.

I just wanted to make sure you had your head on straight.

Finding Your Voice

The premise of your Webcomic has to be natural to you. It has to be a theme that speaks from your experience, and that grows out of your natural voice. If you don't do that — if you try to write a video game Webcomic when you're not even a big gamer — then you'll produce 10 comics and suddenly run out of ideas. Or, more likely, you'll write 10 bad comics about video games.

A lot of cartoonists go about it the wrong way, by mimicking whatever successful comics are working at the moment. Or, if they're slightly more cunning, they try to start from a broader marketing angle, and try to plan out the class of "consumer" they could sell to. "Health clubs are a billion-dollar industry," they say, "I'll do a Webcomic about gyms!" Well, no, that's backwards. First comes art, then comes commerce. The marketing angles and business considerations are important, but they have to come later. If Webcomics were an oil painting, the business considerations are the frame, placed on after the art itself is finished. But the art has to come first.

In fact, the marketing and business angles are far less important to the success of a comic than you would think. Look at "Bloom County!" You try and tell me what marketing team would cobble together that cast of characters? Half the time, that strip made no sense, from a structural standpoint. And what marketing segment did it "appeal" to? Penguin owners? Cat abusers? Closet users? The marketing and sale of that strip were an afterthought. It was the singular artist's voice that truly sold it and made it work. When you're first looking for your Webcomic's voice, follow your heart, not your head.

> That kind of "fill-a-niche" approach to comic-strip conceptualization is exactly why syndicated comics are dying a slow death in American newspapers. If that kind of thinking were effective, this book would be called "How to Make Syndicated Comics."

On the flip side, do you have a brilliant idea that springs right from your heart — but feels like it's following too closely in the path of something that came before you? It's definitely a problem, but don't panic. Keep in mind that there is nothing truly new under the sun, and refine your concept until the premise is uniquely your own. Look at the comic strip "Get Fuzzy," for example. It involves a dopey guy, his mean cat, and his half-witted dog. That, my friends, is the elevator-pitch for "Garfield." Yet the two

Success

I have always found that my view of success has been iconoclastic: success to me is not about money or status or fame, its about finding a livelihood that brings me joy and self-sufficiency and a sense of contributing to the world.

— Anita Roddick

strips look and feel and sound completely different. They're worlds apart, when you read them. So don't walk away from that superhero idea you have, just because every superhero idea has been "done." Find your creative angle, find your voice, and make it your own.

Getting Your Priorities Straight

Once you get your Webcomic up on its feet, make sure you keep your focus on the right things. Do you have an ultra-polished Web site, for example, but the Webcomic itself stinks? Maybe your true passion lies in Website or graphic design. Do you have 10 comics up in your archives, and you're already worried about trying to sell T-shirts? Better to put up 100 comics, and then maybe start worrying. Your first and only priority, during your initial year or two, is your Webcomic. Don't worry about some fancy Flash interface, or creating a store, or installing some ultra-slick Web 3.0 interactivity. Focus on your characters, and your craft. Focus on getting better with every update. Focus on your Webcomic first.

 I would take that advice a step further and suggest that many of those fancy Web add-ons should be introduced slowly after the site is up and running. For the first several months, your site should be slavishly devoted to the comic and little else. Bring in the Flash-animated cast page a little later.

During that first year, you will have a tendency to look outward at the world with frustration. "Why isn't the audience coming, yet? Why isn't the readership growing?" The simple truth is, the world doesn't owe you an audience. You owe the world a quality Webcomic, and in return it may — *may* — grant you an audience. Before your Webcomic can grow, you have to prove that you're professional, talented, entertaining, and reliable in your updates. That takes time, a year or more, and a lot of consistent, on-time work on your part.

You have to create an implied (or explicit!) contract with your readers: "I will make an update schedule and I will stick to it." And being on time is not the only requirement. You have to maintain or improve your level of artistry. You have to give readers a reason to want to come back, and to tell their friends to do the same. During your first year or so, you'll want to look outward and ask what's going wrong. That's incorrect: The focus should be inward, and on doing everything you can to *earn* your audience.

Be the One that Didn't Give Up
Many of life's failures are [people] who did not realize how close they were to success when they gave up.

— *Thomas Edison*

 HOW TO MAKE WEBCOMICS

In fact, you may want to see it as a blessing that you don't have a huge audience during your early days. It gives you the chance to try, and fail, and try again...in relative obscurity! Do you know what a luxury that is? There's a reason famous authors sometimes take a pen name. It's so that they can recapture the early days when true experimentation, and anonymous failure, were still possible! You have that anonymity — use it. Because here's the uncomfortable truth: your first 100 comics will probably stink. Be glad that you *don't* have 100,000 people telling you they stink! Use your small audience as a opportunity to learn, to grow, to get feedback, and to get better...and be thankful you don't have the whole world reading you (yet)!

One Last Bit Of Advice

Before you jump into the following chapters, let me give you one final pep talk, sprinkled with a little tough love.

First, this stuff is fun. Never forget that. You're not working in a Siberian salt mine, or building a highway overpass in a hot Arizona summer. You're creating Webcomics. You're trying to create a body of art and build an audience around it. In the pages ahead, don't let the process stress you out. The two core steps here are to draw a comic, and then share it with the world. If it ever gets too overwhelming for you, just dial it back to that. If you start to lose the joy, then you start to lose the comic.

Second — and this is the tough-love part — there is genuine work to be done if you want to make this your livelihood. If you do not have a strong desire to work and improve, you'll need to cultivate one. Develop an inquisitive, omnivorous habit of reading everything you can that'd help you improve your Webcomic, your site and your salesmanship. Develop a constantly tracking eye that's on the lookout for what's working, who's succeeding, and how they're doing it. This book is a jumping-off point. It's our attempt to give you a big headstart using our years of research and experimentation and failures. But it's only that: a headstart.

So, if you're in this for the long haul, prepare your heart and mind for years of work. Like all great things that are worth achieving, your Webcomic will require lots of it — and not just on the artistic end. Your knowledge of the Web, of marketing, of audience interaction, and of sales — all those skills will grow and improve, with time and effort. And though we've tried to give you a leg up with this book, there are precious few shortcuts to making a creative life suddenly click, and suddenly provide you with an income. As Thomas Edison famously said, success is 10% inspiration and 90% perspiration. This will be a slow, growing process involving 10,000 tiny steps — each building on the last. But take heart in this: There are few things in life with greater rewards than finding a voice, and an audience, in comics.

Characters

Your characters are arguably the most important element of your comic strip. Your characters will be telling your stories, delivering your punchlines and drawing your readers in. They are your liaisons and your ambassadors to your audience.

As we stated back in the Introduction, we've made some assumptions in writing this book. One of those assumptions is that you are already past the beginner's stage of cartooning ability. We're not here to teach you HOW to create comic-book characters out of circles and squares: we're already assuming you know the basics.

You know how to draw a cartoon character, but do you know how to make an iconic character? Do you know how to simplify your art style to say more with less? Do the members of your cast artistically complement each other, or do they all look the same? It's important to create a balanced cast of characters — each with their own strengths and weaknesses — who can interact and play off each other well. They all need to fit together cohesively and each one of them needs to be unique — both in how they speak and how they look.

Designing Your Characters

You're going to find that the art style in which you design your characters is integral in setting the mood of the strip. Many textbooks instruct you to remember that a wacky comedy strip would do better to have very cartoony and fun styles, where a dramatic strip would do better with a very detailed and 3D-constructed style. But I'm not sure how true that is.

I mean, think about how exciting it would be to design against type. Imagine if Scott Adams drew Dilbert with characters that had the same anatomical construction and detail as you might find in an adventure strip like Prince Valiant. It totally changes the mood and expression of the strip. Now imagine a very dramatic and dark strip drawn in a Dilbert style. The cartoony art immediately gives off a new context in which you're mocking the drama — maybe even satirizing its perceived importance.

I think it's valuable to experiment with that — especially considering that you're going to be trying to make your Webcomic stand out and get noticed against a backdrop of thousands of other Webcomics.

The only caveat I'll add to that suggestion is this: Remember that the art of a strip is usually the first impression your comic makes. If you have a very cartoony style, people are going to assume it's a cartoony strip and may not realize it's really quite dark and cutting-edge. That's something you might consider when you choose your working style. Doing something against the grain means extra work down the road when you're thinking about marketing and branding.

This is why a lot of alternative comic creators get down about mainstream work. It's easier to market broadly-appealing mainstream concepts and executions, and it's harder to get people to invest in something against the grain. It's a challenging balancing act.

But you're up for the task, right? So don't back away from it.

In designing iconic characters, I'd like to share a neat trick I learned a while back that's always served me well. Can you identify your characters from their silhouettes? Take a drawing of your cast of characters and black them out into silhouette. Are your

Line Up Your Usual Suspects

Remember all those movies in which the cops bring in the usual suspects for a police line-up? They all stand in front of the wall with lines denoting height in feet so the suspects' heights can be compared. Do this with your cast, and post it above your computer or drawing board.

Use it as a reference as you're drawing. Does Bill's nose line up with Carrie's shoulder? Use that to get your characters' heights correct in every panel.

— Brad

characters instantly identifiable from a first glance? Is there any confusion between them? If so, you might want to tweak your designs a bit. Play with the heights of each character and their body shapes. Your readers will be looking at these same characters day after day, so make them unique.

Overweight or rail-thin, tall or short, long hair or bald, glasses or not. There are plenty of ways to distinguish one character from another.

Body Issues

The size and shape of your character speaks volumes to your readers. Before they read Word Balloon One, they think they know about your character based on his or her body. Of course, as Scott says, playing against type is great fun, but let's take some time to discuss types.

Weight. American pop culture has a complex relationship with the issue of weight. In general, a heavier character is a happier character. We assume "fat" and "jolly" go together hand in hand — and not only around December. Adding a few pounds to a character's midsection makes them more friendly and less intimidating. Don't make the mistake of thinking that fat characters are automatically stupid. In comedy, all characters are dumb — they're just stupid in unique ways. Ralph Kramden wasn't any smarter than Ed Norton. Conversely, a thin character is often assumed to be sly, sarcastic and conniving. Slim is often aristocratic and refined. Slender bodies lend themselves to more physical humor and wonderfully goofy gestures.

Height. Taller characters are more imposing than shorter ones. Almost inevitably, the villains are a little taller than the heroes. Shorter characters take on a more approachable demeanor. Taller characters are more sophisticated (how else can they "look down on" others?).

Age. Offended yet? Stay 'tooned. Young characters are seen as more attractive — physically and socially — than older ones. And this is especially true for women. In fact, many of the features we associate with an attractive female face — the upturned nose, the thick lips and the dominant eyes — are parallel to those of an infant! Since cartoon illustration is visual shorthand, be very careful when depicting age. Every line on a character's face adds several years. Don't overdo it.

Eyes. There are as many eyes in comics as there are characters. From big, round, "Garfield" globes to the tiny dots over Skull's nose, the eyes have it. When you're designing eyes, put your character through a barrage of emotions. Those eyes are going to convey the majority of your character's feelings. If they're not up to the task, go back to the drawing board.

Clothes. We take an awful lot of personality cues from the clothes a character wears. A necktie gives a character an air of authority — and you could write a book on headwear. Baseball caps give a character a sense of youth and activity. A fedora connotes a different identity, indeed — most often that of a detective or private eye. A uniform can be especially potent because they carry the personality traits of an entire group of people. For example, put a lab coat on a character and you have a brainy, analytical science geek.

Glasses. Glasses add I.Q. points, plain and simple. However, be careful in designing a character with glasses. Big, circular glasses give your character a look of perpetual astonishment. Drawing opaque glasses that don't show a character's real eyes tend to give that character a soullessness, and will throw up roadblocks towards conveying emotion in those important reaction shots. The exception to that rule is sunglasses. They, always, are cool. If you're going to draw a character with glasses, take some time to plan out how the character's head will look at different tilts and angles. Fine tune the glasses to look good from all sides.

Props. Don't hesitate to give your character a signature prop. This could be a pipe or a cane or anything else inanimate that the character carries around. This can be a useful tool in telling your readers about the character, and it may become a useful part of the storytelling itself — becoming part of the overall storyline or the subject of occasional gags.

— Brad

Or, try a different experiment. Imagine it's Halloween, and in your comic the characters will be in costume. Are your characters' features unique enough such that, when they put on a vampire outfit, or a Frankenstein disguise, you could still tell them apart?

Consider gesture, too. Have you ever stood up in your studio and acted out a comic you wrote before you sat down to draw it. It's profound. You'll find that each of your characters gesture somewhat differently, and you, yourself didn't realize it until you shifted the mode used to describe these characters from illustration to acting. Your gestures speak volumes about your characters.

Right. You may be comfortable drawing a certain posture, perhaps, but if you've got a lovable loser and a football hero, chances are they're not going to both have their shoulders slumped, or their chests puffed out.

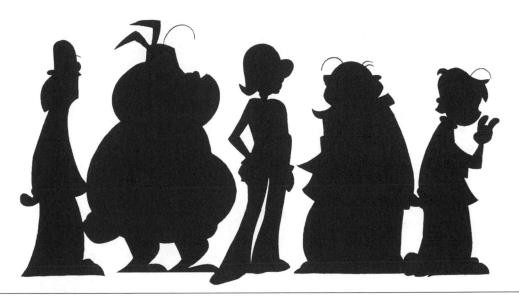

Sprites and Sprite Comics

"Sprites" refer to reused or recycled art in Webcomics, especially drawings of characters – for instance, a strip in which the same character images are copied and pasted among the panels to avoid drawing the same pose four times.

Thanks to the digital nature of Webcomics, we tend to be a lot more lenient about reusing our own art. "Starslip Crisis" uses sprites that I drew, and if the scene calls for a position change or new art, I draw it. Some Webcomics draw everything fresh for each strip, while others use the exact same images day after day (like Ryan North's "Dinosaur Comics" at www. qwantz.com)! Whether or not you decide to use your own sprites — or the extent to which you use them — is up to you.

"Sprite Comics," on the other hand, make use of pre-existing clip art or images that the author

did not draw themselves. There are many, many comics that use characters from the Mega Man and Final Fantasy video games, for example. Going this route severely limits your ability to market your Webcomic and create books and merchandise, since technically you don't own the images you're using, and therefore cannot legally reproduce them for profit — if at all! Video game sprites and other clip art usually aren't in the public domain, and aren't yours to use or profit from freely.

Don't approach your Webcomic as if it's just a hobby that doesn't need any original art because it won't go anywhere. What's a hobby today could grow into a popular Webcomic tomorrow, and if you're using someone else's images, you're out of luck when it comes time to start making money.

— *Kris*

The best part about paying attention to gestures is that it's an instant introduction to what kind of characters you have. If a new reader spots the guy wringing his hands and looking around uncertainly, they'll sense he's an anxious type. That makes your writing job a little easier when you're reinforcing personality with character design.

You should also consider how your characters look standing next to each other, especially characters that frequently find themselves in each other's company. For me, it's Cole Richards and Brent Sienna. They're best buds and spend a lot of panel time together. Cole is shorter and wider with rounded features. Brent is taller and slender with very angular features.

On the other hand, my character, Francis, has similar, rounded features to Cole. He's also around the same height. Francis plays well against other characters in the cast, but he's very similar to Cole. Because of this, I need to find another way to differentiate him from other cast members (like Cole) who might be constructed similarly.

A good way to do this is with color. For those of you who color your strip, you have an *invaluable* way of differentiating your characters from one another. The color palette you choose for your cast should be as deliberate as their other design elements. Borrowing our experiment with the silhouette before, let's do the same thing with basic color palettes.

All of my characters are instantly identifiable from their color palette. What if you're not working with color? What if you're only planning a black-and-white strip? That's not a problem at all. I work primarily in black and white myself. What I do is break my

Naming Your Characters

Comics are written with a sparse, almost haiku-like amount of text. You say a lot with very few words.

And because space is so limited, keep one thing in mind when naming your characters: every letter takes up valuable real estate, so keep names short. Trust me, you will come to despise your decision if your main character's name is "Montescue Worthington Pennyweather", and you have to write that out in every strip. "Opus," "Snoopy" and "Calvin" are all just as memorable, and cut out all the fat. Keep them short, and keep them memorable.

— *Dave*

characters up into "spot blacks." Spot blacks are areas that are entirely shaded in solid black. I am conscious about which areas of my characters have heavy black spots, and make sure they complement the other characters.

Let's take a look. Cole has heavy spot blacks down low. His pants are solid black, leaving his top half spot-free, except for his tie. Brent, on the other hand, is heavy in spot blacks up top. He has his trademark shades and his black shirt. Putting Cole and Brent next to each other, you see that their black areas compliment each other. The same concept is applied to Cole and Francis. (Here the black spots help separate Cole and Francis despite their similar builds). Of course, now Brent and Jade clash because they are both heavy in black in the upper half of their bodies. So we have to find something else to differentiate their designs.

> In "Starslip Crisis," which is black-and-white, I follow the same spot blacks technique, but not as strongly. Vanderbeam's suit is mostly solid black with a thin white tie. Cutter's wearing a black vest over a white shirt.
>
> These fills are actually kind of similar if you think about it. So what I do to further differentiate my characters is give them instantly recognizable hairstyles. Vanderbeam's black hair looks like the tail fin of a Cadillac, and Cutter's white hair is much flatter.

It's not a perfect science. Certainly, the more characters you add, the more difficult the challenge becomes. But if you remain aware of the design challenge, you'll keep your cast looking unique and iconic, even against their equally iconic counterparts.

Archetypes

My wife and I were watching the television show "Monk" and discussing how much we enjoyed it. Being a writer, I, of course, started dissecting the show, trying to figure out what made it work so well. In the end, I came to the conclusion that "Monk" isn't good because it's a detective show or because the mysteries are exciting to try to figure out. "Monk" works because the main character has personality traits that work against him being a detective and solving mysteries. *That's* why we watch. We watch because of Monk's personality and quirks.

We're all well-versed in the familiar comic-strip archetypes and genres: Family strips, college buddies, gaming nerds, etc. And within those genres, we have familiar personalities: clueless boss, annoyed girlfriend, single-minded nerd, and so on.

When Style and Design Collide

As a cartoonist, one of your big tasks is to develop a "style" — or a look — that's distinctly your own. Your line quality, line stiffness and/or flow, chiaroscuro and color use...it all adds up to a style. For your audience, that style is a framework for how to "read" the world you're creating. It helps set and reinforce your themes, moods, and worldview. But when it comes to creating distinctive characters, your style can sometimes be *too* set in its ways, resulting in characters that all look the same.

We've all seen the comic where every character shares the same nose, eyes, height and posture, because that's the gimmicky "style" the cartoonist draws in. Sure, it's a great style, but how does it distinguish separate characters? How does it serve as shorthand for their personalities?

Make sure your cast benefits from unique design. Force your character design out of its fixed patterns, and experiment with face structures, body types, and postures.

— Dave

Dave is clearly referring to my character design. You didn't have to stage an intervention in this book! A phone call would have sufficed!

— Kris

And here we are trying to create the next big comic strip that's going to set the world on fire. So the best thing to do is avoid all those familiar trappings and come up with something **completely** original, right?

I'm not sure the answer to that question is yes. I think we might want to reconsider those archetypes and examine why they work so well and how we can use them to make our strips more appealing to a mass audience. We can't stop there, because if we do, our characters will end up being one-dimensional and our audience will get bored with them and move on. But let's not discount archetypes as a starting point.

The truth of the matter is that clichés are clichés because usually they're true. It's also true that your audience will have an easier time identifying with your characters if you paint in broad strokes. It's going to be harder to identify with a protagonist who never leaves the house, is passionate about ichthyology and only speaks in rhyme. That's sounds like a wonderfully complex character and wholly original but it has quite an investment overhead for new readers. We might end up turning people off to our character before we ever get them interested in the first place.

And remember, we're fleshing out these characters in four-to-five panels every 24 hours, so space and time is limited. Your mileage may vary if you draw more than a strip-a-day comic (See Chapter 3 on this).

Monk has OCD; he's germophobic; he's tragically lost his wife; and he has a photographic memory. He's weird and he's nervous and he's off-putting. He is very hard to identify with. But once we make him a detective and place him in an hour-long mystery show, suddenly his character has a familiar context and the audience is provided a safe road to discover his complexities.

Use familiar genres and archetypes as starting points for new readers to discover the hidden layers you've built around your characters. Give them an easy path to invest.

Writing Compelling Characters

They say that everybody loves a winner. But do people **identify** with winners? Successful strips have characters that readers can relate to and identify with. Even the most bombastic characters and the most vile villains have some sympathetic characteristic that make them just like you and me.

I write flawed characters. I want my cast to have problems and foibles. They don't always win and they don't always do the right thing. They're sarcastic to each other. They lash out and hurt. They goof off when they should be working, and they work when they should be taking a break and enjoying life. I do this because I write what I know: My own life and the people I know. And we're — all of us — flawed individuals.

Your Characters Are You

Whenever I'm meeting readers or giving a talk at a comics convention, people invariably ask me which of my characters is most like me. It's a perfectly fair question, but I think my answer surprises some people. Because I tell them they're all like me. The jerk characters, the sweet ones, the idiots, and the geniuses. They're all me. And if you're doing your job right when you're designing new characters, the same will be true for you. Your characters are all the different parts of your personality made flesh. The rowdy side of you who does immensely stupid things? Give him form and draw him up. The sweet, bookish side of you who gets too shy to talk to people at parties? Figure out what she looks like, and give her life. You'll have an endless supply of material to draw on, because your characters will all be little versions of you.

— *Dave*

Giving your characters backstories helps you know what drives them, and keeps them consistent.

The more completely you envision your characters, the more your readers will respond to them. It really doesn't help you to simply classify one as the smart one and another as the sarcastic one. One approach is to write a "bible" of your universe. It describes their backgrounds — where they came from and how they got here — and the dominant factors that play in their reaction to any issue.

Comic bibles also help when you get stuck in a writing slump and need to reach back for some of the basic elements that comprise your universe. When in doubt, as they say, take things back to the basics.

The beautiful thing about character bibles is that they're for your eyes only. The tragedy in one character's past? The secret they'll carry to their grave? It never needs to be revealed in your comic, but fleshing it out in your own mind gives greater potency and depth to your writing.

And once you flesh out your characters, something wonderful happens: they end up writing your material for you. When you know how a character will react to a certain situation, you don't have to write their dialogue so much as let them speak in your head.

Have you ever heard of "The Mary Sue character?" It was a term recently explained to me. "Mary Sue" is a term that originated in fan-fiction used to describe a character in the story that is clearly a representation of the author. As a result, the character is shown to always be better, well-loved, successful and flawless. This Mary Sue character certainly serves to make the author feel great about himself, but it doesn't give the reader anything to love.

Nobody wins all the time — or always has the perfect response to any situation. And therefore, nobody can identify with a Mary Sue character (and they're pretty easy to pick out).

Flawed characters are compelling characters. Remember that. I have a couple characters in my strip that are purposely perfect. They seemingly have no flaws and always come out on top. Because of this, they are **hated** and resented by all the other characters in my strip. Thus, even my perfect characters have one fatal flaw: They can never be a part of the group.

Know your characters. Give them life. Learn how they would react to certain situations. Learn to think as them. If you can get into this mindset, you can come up with an idea or situation and the characters will start writing their own dialogue for you

in your head. It will become second nature to you and to your readers as well. Start with broad strokes to draw in new readers but round out your archetypes by adding layers of complexity. Have them play against their type or struggle with it.

Your readers will thank you for it.

Write Who You Know?

A lot of cartoonists base their characters off the people they know in their real life. It's a natural practice. The first rule of writing is to write what you know, it's only a natural extension to write who you know too.

Just a word of advice: be careful not to base your character too closely off real people. I have learned from experience that such practices bring with them a whole host of problems and once you open Pandora's box...

It might seem cool to template your lead character on your best friend. He may even like the idea. Basing your characters on your buddies will provide a convenient crutch at first. It's easier to tell familiar stories about real people than create them from whole cloth.

However, you're creating a work of fiction, and attaching that fictional character to a real person is going to limit what you can do with them. Eventually you're going to get the hang of things, and your mind is going to wander from your stable of college stories to new stories you want to tell. And what if these new ideas don't conform to how your character real-life counterparts would behave? How will your friend appreciate "his" character suddenly doing something very out of character?

I'll spare you some of the horror stories I have about people in the real world, not being too happy with the way things turned out for the characters they inspired. It ranges from upset phone calls to threats of legal action (which ultimately and fortunately went nowhere).

There's a reason that fiction is *based* on true stories. Real life should inspire your work, not write it for you.

Write what you know... just don't write it verbatim.

I always called this kind of Webcomic "the vanity strip." The characters are all taken directly from the cartoonist's life, and their conversations tend to be transcripts of actual conversations they've had with their friends, co-workers and so forth.

I made this observation a long while back: **The more inside a joke, the funnier it will be, but to fewer people.** You may have a gag that cracks three of your friends up, but that same joke is probably too inside for the rest of us to get. We just weren't there. And although had you rolling for an hour, it might not be a joke you can use with an audience.

This can lead to the cartoonist putting an explanatory note in their blog that day — sometimes a really long and rambling one. But if you need to explain it, it's probably not a very good joke in the first place.

There are always more ideas for strips, so don't be afraid to let go of an idea if there's no way to make it work as a strip!

Characterless Strips

Some of you out there might not want to create strips with a recognizable set of characters. Not all comic strips are character driven. Take a look at "Bizarro" by Dan Piraro, or Gary Larson's "The Far Side" in the newspaper, or Randall Munroe's "xkcd" and Nick Gurewitch's "Perry Bible Fellowship" online. These strips are wildly popular and have no specific characters that drive the feature.

In these cases I'm of the opinion that the main character of your strip is you: The author or narrator. The character that you're developing is your own. If you take a look at any of these non-character driven strips there are reoccurring themes, people and items that show up over and over again. "The Far Side" became famous for their cows and women with behive hairdoos. Dan Piraro always hides sticks of dynamite into the drawings of "Bizarro."

People frequent comic strips on a daily basis to see what the characters are up to today. People frequent gag-driven strips to see what the **author** is up to today. Populate your strip with unconventional characters that your readers can learn to identify with your feature. Your strip may not have characters, but it should certainly have **character.**

I've been a fan of *Star Trek* since my father introduced me to the original series. Trek certainly has no shortage of well developed and colorful characters, but for a moment forget that. Close your eyes and remove all the characters from the halls of the Starship Enterprise. All that's left is the ship and it's cacophony of beeps and clicks and whooshing doors. It still feels like *Trek* and is undeniably identifiable from all other sci-fi series. That's because the ship and settings itself have their own characteristics unique to the show.

Even if you want to create a strip without an ensemble cast, remember you're not off the hook. It's still imperative that you fill your strip with identifiable and unique characteristics that will stick in your readers mind and stand out amid the thousands of online comic strips competing for your reader's attention.

Formatting

You may ask why formatting is important on a playing field like the Internet, where you're not limited by the constraints of paper. You could have a Webcomic that's a single panel one day, and a hundred panels stretching a couple yards on-screen the next. That's the great power of the Web.

But I shouldn't have to tell you what great power comes with... especially as relates to webs. (Get it?!)

You could play the look and feel of your Webcomic by ear week to week, but maybe it's the mind-boggling freedom of the Internet that makes a solid format necessary for success.

Good formatting will help your Webcomic in all areas — audience retention, book production, even down to the style you'll be drawing and writing in.

Formatting provides everyone — both you and your readers — with a set of clear expectations. Living up to those expectations will keep readers coming around, and it'll take a lot of pressure off when it comes time to set up and nail a gag, if you don't have to reinvent the wheel each time. Maybe most important of all from a merchandise standpoint, book production is much, much easier when you don't have to rework your strips to fit on identical-size sheets of paper.

> Believe it or not, there's something artistically freeing about working with set formatting. Here's why: A clear format lets you focus on your character poses, your backgrounds, your storyline advances, and your dialogue. Removing the need for a constantly changing, constantly "inventive" format means the other elements have more of a chance to flourish.

Size Ratios

The first thing you'll want to consider is your Webcomic's dimensions, and the number of panels you'll be working in. A lot of these decisions are dependent on the kind of strip you're doing — and if you've done a couple character mockups and played with sample dialogue, you probably have an idea of the kind of Webcomic you want to do, and what dimensions you'll need.

Let's take a look at common sizes, and what they're best suited for.

• **Single-panel comics (also called "gag" comics).** One lone panel doesn't give you any room for character development, but it's perfect for simple sight gags or a little wordplay. These kinds of strips fit well within a square.

• **Multiple-panel horizontal strip.** This is the most common format you'll find, and the most flexible. You've got room to tell stories that can continue from day to day, and more importantly, you have room to set up a punchline in the last panel. Three- and four-panels are my favorite size — they strike a good balance between storytelling, joke setup, character development and economy of space.

A lot of Webcomics orient their multiple panels differently. For example, PvP was always four panels, but the strip used to be two panels by two panels. A straight-across 4-by-1 layout will give you more versatility if you decide, occasionally, to break down your panel borders and do a scenic one-panel strip for the sake of a joke. It's up to you what you feel visually comfortable with.

• **Full-page comic.** A strip with more than, say, six panels — especially if it's sized like a comic book page rather than horizontally — opens up many more options for the mood of a strip. If you've got only one joke to tell at a time, using eight panels to do it in is probably overkill. This format is great for a more epic, or "longform" story, with lots of potential for character development. Comic books featuring caped heroes use this form for this reason.

There are always exceptions to the rule, though. For example, "Copper" by Kazu Kibuishi (www.boltcity.com) would be considered a full-page comic, but each page is a self-contained little story. Longform comics have a sprawling story that may take upwards of fifty strips to tell (your mileage will of course vary!).

I'm not ashamed that when I settled on dimensions for "Starslip Crisis," I just tweaked the dimensions on newspaper-style strips that I liked.

As did I, and there's nothing wrong with that. Take the 3-5 comics that appeal to you most online or in papers, and Xerox or Photoshop them up to size you'd be comfortable drawing. This will give you a great idea of the border thickness, font sizes, and character line-qualities that you should experiment with. You'll be surprised at how big (or small) some text is written, and how thick (or thin) some lines are drawn in your favorite comics.

For a newspaper-style comic strip, I try to size my work to an aspect ratio of 6 x 1.84". In other words, I expect my final work to be printed at the size, so I create my original at a proportional measurement.

I work at an original size of 13 x 4". Dividing the area evenly into four panels will result in four 3 x 4" panels with a 0.25" gutter between each. A three-panel strip has panels of about 4 x 4" with 0.25" gutters.

I strongly suggest designing single-panel comics to fit in a square (even if the panel itself is circular). This is especially true if you have aspirations in print. A square shape makes your work incredibly easy for a magazine or newspaper editor to slide into a preformatted page design. It's also unobtrusive — which is to your advantage if your work is not expected to be the dominant art on the page.

Gutters

My mom will relate to you this story if you ask her — when I was a boy of eight or nine years, I would spend an inordinate amount of time taking blank sheets of paper and drawing a single line down the center lengthwise, and another line across the middle widthwise. All I knew was that I needed to divide my paper into four places for the comics to go. I didn't know it at the time, but I was making strip templates. Even back then I had my mind in the gutters.

A strip's "gutters" refer to the white space between the panels, and most cartoonists will tell you that three vertical dividing lines for four panels doesn't really cut it. Gutter width visually distinguishes one panel from the next, and it helps the reader make better sense of what they're looking at.

Because drawings are made up of lines themselves, panel borders have to stand outside of that and look different, to keep the reader from thinking they're just more lines in the same panel. The common way to do this is to maintain a little white space between one panel and the next, while bordering each panel with a black line at least as thick as your thickest stroke inside the panel, if not thicker.

Gutters can also be solid black — but only if there is a solid, black border of equal width all around the comic.

But boy, I rarely see this applied well. To me, all-black gutters carry an implication of heaviness, of a world weary with toil, or of the macabre. Which is great, if you're writing "Maus" or a Charles Addams cartoon. As a cartoonist, you can't escape the fact that black has an emotional weight, and too much of it changes the mood of your comic. In contrast, white gutters carry far less emotional baggage. They're a neutral statement that lets your comic do the heavy lifting.

Once you have a striking, easily identified gutter, you can do more with your panels besides the usual four-boxes-of-equal-size-and-spacing.

Brad lays out his panels to great effect in "Evil Inc," adding space to panels that need more detail or more background to explain the scene, and tightening up panels on important details or dialogue. He even eschews the traditional "move right, move right, move right" path the reader's eye takes when reading most other horizontal strips — depending on the layout, you may read "Evil Inc." a little up and down too. Brad keeps it from getting confusing with great gutter technique.

Part of that credit belongs to gutter width. While I keep mine narrower than Brad's, there's no question that the white space between panels doesn't belong with the insides of a panel.

How Many Panels?

You always have the option of deciding how many panels you want to use for a given joke. Sure, you'll probably stick with your chosen four or three, but don't forget that you can knock down all the frame borders for a big scene or single gag, or, if you're working in a horizontal format, you can slice up that space anyway you want to.

If your joke for the day is going to go beat-beat-punchline, but you've got four panels instead of three, trying knocking one panel out instead of drawing everyone standing around in panel three waiting for panel four. It works for me, and it'll work for you.

— *Kris*

For "Starslip Crisis," I also wanted to evoke a hand-drawn line even though all my work is digital. One of the minor touches I employed was a slightly scratchy line for the outside of my panel borders. That line quality doesn't show up in the strip itself anywhere, further differentiating my panel borders and gutters from the actual content.

 Gutters are also helpful places to put some of the errata that goes along with the comic strip: Copyright notices, e-mail addresses and Web site, for example. Just remember to keep anything you place in a gutter small so they don't interfere with the gutter's main job — which is to keep the panels separate.

Lettering

Lettering is what appears in your Webcomic in word balloons and narration. You can hand-letter or use a pre-made font for your strip — it's up to you.

The style of lettering greatly affects the look and feel of a Webcomic, especially for character dialogue in word balloons. I'm of the school of thought that your lettering should fit the art and the tone of your strip. If you're drawing a hard-boiled detective story, chances are you don't want him speaking in a cursive font where all the i's are dotted with hearts. (Actually, that sounds pretty funny.)

Whatever style of lettering you decide to go with, legibility is more important than character. Stay away from "title" or "sound effects" fonts; those are intended to be used sparingly, like in logo design. Reading a complex title or overly-blocky sound effect font in full sentences strains the eyes. Also be cautious of fonts that have uppercase letters for both upper- and lowercase keys — especially if the uppercase font is a bolded or italicized version of the lowercase! There you'd only want to shift up to capitals for emphasis on whole words, not for proper capitalization of names and places.

Another great reason to letter using upper-case letters: It gives you a greater degree of latitude in writing gags. For example, you can disguise a proper noun as a regular noun since there's no capitalization to identify the proper noun by.

MAN: I COULDN'T HELP NOTICE YOU CALL YOUR FIRST MATE "HAWKEYE" — EVEN THOUGH HE'S BLIND.

PIRATE: THAT'S IRONY.

MAN: OH. I THOUGHT HIS NAME WAS HAWKEYE."

 If "irony" had been spelled in lowercase letters, it would have drained the surprise out of the joke, ruining the humor. (What there was of it.)

Ha! I had to read that three times before I got it! Dave Kellett: Master of Comedy.

Once was enough for me. On all fronts!

Upper and lowercase use can even affect the way the way your audience reads dialogue in your Webcomic. You might use lowercase letters to suggest whispered speech, or a child's voice. Uppercase letters in comics don't usually imply shouting, but they can if the letters are bold and perhaps sized bigger for that particular piece of dialogue. But if you're using upper and lowercase for your standard dialogue, then all capitals is definitely yelling.

That said, I think cartoonists do well to stick to the same font for dialogue throughout a strip — writing one character's speech in Helvetica, one in Times Roman, one in Impact and another in BrushScript can make things really busy and hard to read. This kind of topic makes for some serious typography discussion.

There are sans serif fonts specifically made to be legible even at smaller sizes on the Web — DigitalStrip from Blambot.com is a good example. There are literally hundreds of good dialogue fonts to download on the Web for free, and they're all a Google search away. Compare and contrast, and try your Webcomic out with various fonts until you find a favorite.

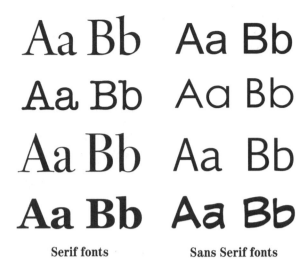

Serif fonts **Sans Serif fonts**

Comic Craft (www.comiccraft.com) also does some truly beautiful hand-lettering fonts.

There are even sites on the Web — like Fontifier (www.fontifier.com) — at which you can upload your own hand lettering to be transformed into a digital font. I haven't experimented with this, though, so don't take this as an endorsement. I have no idea if these fonts work well in a hi-res setting. They get scanned in at 72-100 DPI, so I have my doubts. (We'll be talking more about hi-res and lo-res in Chapter 4.)

I've tried Fontifier, but it's no substitute for creating your own font from scratch.

If you don't want to hand-letter, but don't want someone else's lettering style in your strip, you can make your own handwriting font using font-creation software. I did my fonts, Straubetica and StraubeticaBold, for "Checkerboard Nightmare" using High-Logic's Font Creator Program. It's a very full-featured program for Windows at a good price.

Typography

Take a little time to study typography before you make any serious decisions about your comic's lettering. Typography is the art of forming words with letters.

So much of it has to do with the shapes of the letters and the spacing between those differently shaped letters. It's truly an art form worth familiarizing yourself with.

Typography separates fonts into two families: Serif and Sans serif. Serifs are the little strokes at the tops and bottoms of letters that make them easy to read — especially when they are printed small. Newspapers, magazines and textbooks often choose serif fonts for their body text. Times is a popular serif font.

"Sans" is French for "without." Sans Serif fonts, therefore, are those without serifs. Those same newspapers and magazines often choose Sans Serif fonts for headlines because they are bold and informal. Helvetica and Arial are both Sans Serif fonts.

You might think Serif lettering would be well suited for comic work because it's meant to be read at smaller sizes. But Serif lettering also carries with it an air of seriousness and formality. That's not exactly great for comics.

For comics, the nearly unanimous choice for lettering is Sans Serif.

— Brad

I'll be honest — it wasn't very easy. There's lots to learn about font naming conventions, kerning, letting, and a lot of other font stuff, but to me it was worth it. Fontifier.com offers a much simpler process, and for $9, the results are pretty decent. Just write letters in your hand onto their template, scan, upload and get your font right away.

Now for the more hardcore lettering solution: Hand-lettering requires dedication, focus, and nerves of steel, which is why I'm ill-equipped to talk about it. Dave letters "Sheldon" by hand, and even has a couple different lettering styles he bounces between. Check out the sidebar below for Dave's take on hand-lettering.

Word Balloons

Word balloons (also called voice bubbles) have three parts, and without them you wouldn't be able to hear anybody. Thought bubbles, your characters' private internal monologue equivalents, follow similar rules, but chances are you'll be using them a lot less.

Unless you're drawing *Garfield*.

Hand-Lettering

Lettering by hand is a distinct artform, separate from your cartooning skills. (And if you don't believe me when I say "artform", wait 'til you see how much your calligrapher charges you to apply their "artform" to your wedding announcements!) All the rules of fonts and layout that Kris and Brad have mentioned apply to your hand-lettering, but a whole new level of planning is involved. As with anything done by hand, you'll need to think ahead to avoid unrecoverable mistakes.

First, let's go over the steps you'll need to hand letter:

1.) **Dialogue:** Before you begin any work on the strip itself, finalize the dialogue you'll be using. Unlike digital lettering, it's much, much harder to change your mind when lettering by hand. So on a separate piece of paper, edit and re-edit until you've got it just how you want it.

2.) **Text Layout:** Begin working on the strip itself by laying out your dialogue first. Using a pencil or non-repro blue pencil, plan out the length and space your text will need, and create

an easy flow for your reader's eyes to follow.

3.) **Word Balloons:** Using pencil or non-repro blue again, sketch out the word balloons that will encompass your text. A great way to do this is with those thin, plastic, circular and elliptical templates sold in art stores (common brands include C-Thru, Alvin, Pickett, and Berol). Your blocks of text and your word balloons may fight one another at first, but with practice, your chunks of text will start to anticipate the circular shape you'll draw around it. By that I mean, your mind will start to "see" the circle you'll eventually draw around the text, and will lay out words to match.

4.) **Sketch:** Once you've approximated the space you'll need for text and word balloons, you're left with a large gap of negative space in which to draw the actual comic. This negative space should be two-thirds of your strips' height. Within that space, sketch out or thumbnail your characters, backgrounds, props and more, using pencil or non-repro blue pencil.

5.) **Inking:** Now, at long last, you can begin to ink out your text, your word balloons, your characters, and your borders.

6.) **Erasing:** If desired, you can now erase your pencil markings. Non-repro blue, obviously, won't require that you do.

You've no doubt been writing on lined paper for most of your life, so hand-lettering onto the blank canvas of your comic can be unnerving. It can also produce unexpected results, as your handwriting begins to drift down or up as you write out a sentence. To counter-act that natural drift, most hand-letterers create an artificial line system that they can follow. There are two ways to do this. The first is to lightly pencil in guidelines for your text to follow, which you can erase later if needed. The second is to create a text-line template, which you can then use underneath the comic along with a lightbox. I prefer the second method, as you never have to draw those dang pencil lines again, once you've made your template.

The bubble. The bubble is the actual space that contains the words a character is saying. They can be any shape, depending on the artist's style, but they're usually elliptical, and almost always closed.

Text. When it's inside the bubble, text is traditionally centered, and the word flow matches the shape of the bubble as closely as possible. If you're lettering by hand, it'll help if you map out the words in pencil first. Then you can see if it's necessary to bump a long word to another line, or even add a bit of extending punctuation or bolding to change up your word layout.

The tail. The tail is attached to the bubble, and it points at the character who is speaking the words. Exactly where the tail should point is another matter of taste — I like to have it point in the general direction of the character's mouth on close-up shots. Otherwise I point it at the character's head.

WELL, YOU'RE A LITTLE LATE TO THE PARTY! THE *KIERKEGAARD* JUST KNOCKED A HOLE IN THE WORLD-SHIP'S FLAK COVER!

(And here's an added tip: get your template laminated at Kinkos. It'll last for years!)

The pens you use to hand-letter will very often differ from your drawing pen or brush. In general, you'll want tighter control with your lettering pen, to produce clearer, easier-to-read text. I'd recommend the beautiful lines of a Micron Pigma 05 or 08, the Staedtler Pigment Liner 05 or 07, or the Copic Multiliner SP 0.7. All are smear-resistant, produce a strong, clear line, and scan well. But the Micron pen also features the best archival and lightfast qualities — which is something you'll want to keep in mind if you're selling your original art. (You don't want someone coming back to you in ten years saying the text in their original art has faded, and they want you to re-do it!)

Even more so than with digital fonts, it's critically important that your lettering be as easy-to-read as possible. Pacing, joke timing, and the sheer joy-of-reading can all be ruined if your text looks like a doctor's handwriting. A good pen helps, but how you use it is more important.

First, you'll definitely want to go with upper-case letters. Upper case letters allow your letterer's eye to better gauge how much space you'll need in a given sentence. If you imagine a letter as sitting in an invisible, square box, then upper case letters do a much better job of "filling out" those boxes -- giving you a fixed width and height to gauge how many boxes can fit on a line.

And, most importantly of all, upper-case letters avoid many of the trickier curves, negative spaces, and serifs that will confuse your reader's eye. They just read cleaner.

Since legibility is so important, give yourself an extra five minutes to carefully ink your text. Don't rush. Slow down, and write with clear, confident strokes, taking (infinitesimally small) pauses between letters. That slower pace will ensure that your letters don't start mashing together, and will give you the cleanest read possible.

As your hand-lettering starts to develop a stye (and it will!), you'll want to experiment with different hand-written fonts and looks. Lettering is a tool you can use to reinforce the mood of the comic, so use it!

If someone is weepingly sad, can you make their dialogue look that way? If someone is screaming at the top of their lungs, how will you change up your lettering to match?

I've developed five different "hand fonts" that I can use when needed. But just as Kris said before: use them sparingly. They're meant to be task-specific, and used only for emphasis.

Good grief, you're saying, why would I ever want to use hand-lettering? Well, there's no argument that it's trickier to master, but the result is a unique look and feel that only you can create. Digital fonts, in my opinion, have a certain coldness to them, a machine quality. Hand fonts spring with personal style in a way that mirrors your art. Additionally, hand-lettered text within a hand-drawn comic makes for a wonderful, all-inclusive piece of art. They sell well at conventions, and in your online store. For me, that's translated into a third of my business. No small consideration, when making a living from your Webcomic!

— Dave

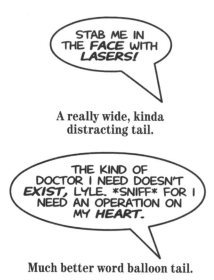

A really wide, kinda distracting tail.

Much better word balloon tail.

I've evolved my tail size quite a bit in the last decade. For some reason, when I was drawing "Checkerboard Nightmare," I felt like the tails needed to be as fat and thick as possible. I'm not sure what the logic was, there — maybe since the tails took up so much space, it got me out of drawing more background.

This is actually the only thing I remember about my first time meeting Robert Kirkman. He took one look at "Checkerboard Nightmare" and said, "What's going on with those word balloon tails? Work on that." I looked at the tails with new eyes for the first time, and shuddered. They were all too fat!

At any rate, you'll get the best results if you keep your tails on the narrow side, and straightforward — either straight at the speaking character, or arcing around other characters or props in the scene. Making your formatting "polite," in general, is a good policy. Format is there to guide the reader, not provide another layer to confuse them with.

Figuring Out Tail Placement

Tail placement is sometimes a tricky issue. In "Starslip Crisis," I'm not afraid to have the tail actually cross in front of the edges of a character's more frivolous anatomy, like the top of their hair, or in front of an antenna, but a lot of cartoonists consider even that a no-no. Having the tail bisect a character's face or body is bad form, and definitely to be avoided at all costs. (We'll come back to balloon placement in just a sec.)

Think of every balloon as a component of speech, like a sentence or paragraph. If your character has a lot to say, don't just fill one giant round word balloon — split it up into two or three smaller word balloons, and give the reader a flow to follow using "connectors." Connectors are modified tails that tie one balloon to another, letting your separate and compartmentalize what might otherwise be a long monologue.

You've seen connectors used in comics to guide the reader's eye through a rapid-fire exchange between more than one character. If you've got dialogue that's becoming unwieldy in a single balloon, break it up!

Putting a single line of dialogue in its own bubble can give it more importance, too. Check out the third panel in the "Starslip Crisis" strip below. Both statements were important to the strip (and the storyline), so putting them in their own bubbles let them carry a little more presence.

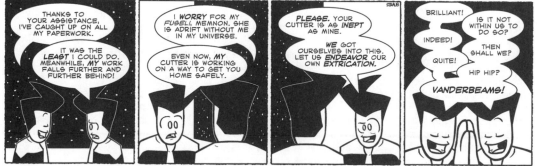

Connectors and good balloon placement make it clear which Vanderbeam is talking at all times.

In much of Kris' discussion, he's talking about what I call a "closed word balloon." Of course, there's also an "open word balloon." Usually, as in the case of "Bloom County," this is simply a line from the text to the speaker.

Open word balloons are very graceful, but they're also tricky to design — since one character's text might run into another's words in a two-speaker panel. Two avoid this, I like to avoid a panel with two open balloons. In a two-speaker situation, I recommend using one open and one closed — or two closed.

Great point! And in general, I'd place the closed balloon first, as it seems to carry an odd, unbalanced weight when placed second. Your eye, anticipating the second voice bubble in your peripheral vision, wants to drift over and tackle that chunk of text first.

Now that we've been introduced to all the major elements of a comic strip, it's time to put them all together in frame. You have your character designs, your dialogue, and your format. In laying out your strip, you'll need to find a balance among the space you devote to showing characters, showing backgrounds, and showing dialogue.

Character Placement

Let's tackle characters first. The most important part of your character to show in any given panel is their head. Maybe it goes without saying, but it's the component that'll most quickly convey which character is relevant to the scene! Unless the strip you're setting up is dependent on an area of interest elsewhere (for example, a close-up in one panel of a prop a character is holding and talking about), you'll want their head in frame.

Traditionally, comic strips show characters from the waist up, but that again hangs from your character designs. Charles Schulz's "Peanuts" and Steve Troop's "Melonpool," to name two, have stubby characters that easily fit fully into a panel, from head to toe. Don't be afraid, however, to pan out and show characters' full bodies standing there, walking side by side, pouring a cup of coffee, etc. Sprinkling in shots like this give your strip a little variety.

Occasionally you don't even need to draw your characters in frame — just their silhouettes. Putting your characters in either silhouette or reverse silhouette (where the character's shape is filled white and the background is black) can add visual interest to your panels, as well as imply a dramatic or important moment.

Changing your "camera angle" can also be a great way to make a point or emphasize a mood. If your character is feeling like the world is against him, and there's nothing he can do to fight it, draw your camera angle looking down on him from twenty feet up.

Ellipses and Em-Dashes

An ellipsis is three periods, and I'm using it in this...sentence to indicate a pause or a hesitation.

An em-dash is a long dash — like this — that works a little like a more conversational parenthesis. Use them in pairs to show an aside, or highlight an important idea — BAM.

When writing out your comic's dialogue, note that some types of punctuation don't really work, even though the "speech" is written down. For example, semicolons and parentheses look out of place when used in character speech. How do you pronounce ";" out loud, anyway?

— *Kris*

Well, heck, Dave, while they're at it, why don't you really show off and tell them about Socialist art?

DAVE Conversely, Socialist Realist artists showed long ago that painting or filming a character from ground or waist level gives them an omnipotent, god-like feel. Take a page from superhero comics: Experiment with your comic's camera angles to see what moods you can imply!

Backgrounds

In this day and age, backgrounds are a lost art for many comics. It's something Bill Watterson of Calvin and Hobbes lamented: Take away different camera angles, varying panel sizes and layouts, and backgrounds, and all you're left with is talking heads in a featureless white void.

But whether or not you decide to include backgrounds, you have a choice as far as the level of detail you include. For "Starslip Crisis," I don't draw too many background objects, but I have created sort of a background symbology to let readers know what part of the starship *Fuseli* we're in. Corridors have a simple scalloped ceiling. Crowd scenes have a simplified representation of cross-hatched people. Engineering features a dark fill above the characters' heads to make things look a little cramped. Even Watterson would use a single scratchy tree, or a lone nightstand and chair to help set the scene.

SCOTT For the longest time, "PvP" had absolutely no backgrounds in them. I admired the background work of my contemporaries and would sometimes experiment with no success. For some reason, I couldn't come up with a style of backgrounds that felt right behind my characters, so I just omitted them.

I went for years this way. The only elements I used to construct a scene were characters and the props they were holding or interacting with. When one day I just started inserting backgrounds, my readership revolted. They hated the backgrounds. For years they had mentally inserted backgrounds into the scene and what I was drawing wasn't matching what they had in their head.

Scott McCloud told me that "PvP" was Shakespearean in this way. My panels were the theater arch and my characters were the actors with their props (there were no background scenery in those days).

The background can be as complex or as simple as it needs to be for the scene.

Much like theater performers, my flat, 2D character design meant my characters were always face front to the readers, theater style. I had accidentally stumbled upon a successful and familiar way of constructing a scene.

Since then, I've expanded my style to incorporate a more 3-D style and occasional background elements. I found a balance. But I still enjoy taking false credit for applying Shakespearean standards to Webcomics.

Balloon Placement

It takes time to train yourself to set up a panel that best fits the flow of character dialogue. Bad word-balloon placement makes dialogue confusing and hard to follow: if readers can't tell which character is speaking first, you've got placement problems in your panel. Let's solve them with these simple rules.

Left to right, top to bottom: English reads left to right, so English speakers instinctively think of the leftmost side of your strip as "first," and the rightmost side as "last." It's the same on the inside of an individual panel, too.

Typically you'll have two characters in a panel for a dialogue exchange. The character on the left is the one that speaks first in the panel, followed by the character on the right. This is pretty much iron-clad, and in light of this, you may have to work out ahead of time who should be standing on which side of the panel.

Let's suppose, in your strip, in panel one you've got Alice on the left and Zach on the right. Alice speaks first, so her word balloon is floating at the top, and maybe a little to the left. Zach responds, with his balloon a little below and to the right of Alice's.

But what if, in Panel Two, Zach needs to speak first? If you just swap Alice and Zach's places, you'll confuse the reader! There are two solutions. Solution one is to try an angle change, to let the reader know the viewpoint has changed. If the two characters were both in three-quarters perspective in panel one, try putting Zach on the left in three-quarters, and Alice's back to us on the right, in shadow. This dramatic change lets the reader see, peripherally, that there's been a change-up and that they should pay attention to who's saying what.

The eye follows these arrows when reading word balloons.

The second solution is to bite the bullet, and just cheat out your word balloon placement by putting Zach's balloon above Alice's — as close to the top-left corner as possible. Then you can put Alice's balloon beneath his. Follow the rule of "Left to right, top to bottom" if you're attempting this — it can get tricky, because you don't want to cross their balloon tails.

Balloon tails are like the energy streams in "Ghostbusters." If you cross them, all life as you know it stops instantaneously and every molecule in your body explodes at the speed of light: Total protonic reversal.

OK, maybe not that bad. But it's sure hard to read.

Exactly. It's too confusing for the reader to have your left-side balloon directed to the right-side character, and vice versa.

Kris' solution for bubble placement is a great one, but let me chime in with a few more. If you've had Alice speaking on the left-hand side for the first three panels, and need her speaking on the right-hand side in the fourth, sometimes the only solution is to physically move her.

Of course, suddenly having her on the right side doesn't work, as it looks like she jumped five feet over without reason! So what can you do? I'd suggest either a closeup character shot or exterior-building shot in panel three -- which allows you to less-conspicuously "switch" sides in panel four -- or using forced-perspective in panels three or four to bring one character heavily to the foreground and moving them to the other side.

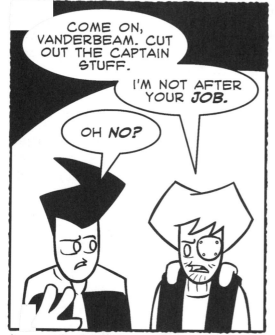

An example of cheating out that works. Cutter, on the right, is clearly speaking first.

Look for examples in your favorite comics, and when in doubt, remember: Left-right is visually more important than top-bottom. In other words, if you have a balloon in the top-right, and another one on the bottom-left, the reader will interpret the bottom-left balloon as being spoken first, even if that wasn't your intent. There isn't a situation like this, though, that a change in camera angle won't fix.

If for some reason you need to have your characters be speaking about something with them out of the panel entirely, follow the first-second rules of word balloon placement to let your audience know which character is saying what.

Here's an example: Alice is on the left and Zach is on the right in the first panel. Alice speaks first, Zach speaks second. Zach says, "Look at that sunset!" Panel two is just a shot of the sunset, but you want Alice and Zach to continue talking. If there's a word balloon on the left in panel two, it had better belong to Alice, because that's how your readers will interpret it.

It's up to you whether to have the voice bubbles floating above the panel borders, to have them meld into each other (like Dave does with "Sheldon"), or keep them beneath. My philosophy is, even though representing speech in word balloons is a symbolic act — in the same way looking at panels in a row is supposed to represent

the flow of time -- I put the word balloons firmly behind the panel frames to show that they happened within that time frame.

> That's strong logic. I've taken a more liberal approach with voice bubbles, though, so I should touch on my technique.
>
> In my strip, whenever two voice bubbles "meet" (i.e., come into contact), the bubbles merge, the lines between them disappear, and we're left with white negative space. Rather than having a complete voice bubble sitting behind another complete voice bubble, mine become like two distinct water droplets that have merged together on a flat surface.
>
> I go to great pains to make sure both bubbles are still distinct, though: it's important that readers still be able to distinguish who says what. But I do it for two reasons. First, conjoined voice bubbles use ever-so-slightly less space, and in the constrained real estate of comics, that can make a vital difference. And secondly, I've found it to be a unique way to show the liquid back-and-forth between two characters, where ideas and personalities mix and flow.

Schedule

There's only one thing more important than choosing an update schedule for your Webcomic, and that's keeping an update schedule.

One of your goals as a Webcartoonist is to attract an audience, and keep them coming back for more. It may not seem like a big deal to post a strip late a couple days out of the month, but remember: You want to make visiting your Webcomic a ritual for your readers — whether it updates once a week or once a day. If you break that ritual, you'll lose readers.

This is a broad concept that deserves exploring. Ideally, your readers should think of reading your Webcomic as the first thing they do over their morning coffee, at their desk at work, or in their dorm room at college when they return from classes at night. Having them think of your Webcomic as a part of their day is crucial to your success! And the simplest way to enable that is to have your strip updated — and on time — when it's promised.

How often you update is another critical question. When I was planning to do "Checkerboard Nightmare," I wrote a few Webcartoonists for advice. They all said pretty much the same thing: Don't overpromise. Having a strip five days a week seems like a good place to start, but if you've got work and school to worry about, you might find yourself slipping.

Font Size and Joke Size

Paul Southworth of "Ugly Hill" gave me something to think about when choosing a font for "Starslip Crisis." There is a desire to give yourself as much room and freedom as possible when choosing what font to use and how big to size it. A compact font used at a small size means more room for dialogue, and that's good, right?

Well, generally, no! Paul uses a relatively wide font — and used it large. It doesn't leave him a lot of wiggle room — it forces him to write dialogue as concisely and directly as possible, and that can give his dialogue a much better impact. It hones his writing and makes the whole strip tighter. It's a great approach!

Of course, I **would** have to create a character that spouts long-winded critical theory most of the time...

— *Kris*

Tangent Lines

The term "tangent lines" refers to any two or more lines in a panel — whether they belong to part of a character, the background, or word balloon — that just barely touch each other. Tangent lines should be avoided, as they add a vague sense of sloppiness to your art.

For example, when pointing a word balloon tail at a character's head, the point of the tail should either float some distance apart from the nearest line of the character's head, or actually cross over that line fully. It should not meet or sit on that line, because the reader's eye doesn't interpret it as a separate element — now it looks like it could be part of your character's hair.

The same goes for character and prop placement. If you've got two milk cartons sitting on a table, either keep them spaced a little, or have one overlap the other. If they share one line on a side, that line ends up looking forced and ambiguous.

- Kris

It's better to launch with an update schedule you know you can handle. If the strip takes off, you can always decide to allocate more time to it and update more often.

That being said, will a Webcomic that updates more often do better than one that doesn't? Not necessarily. It's really dependent on the nature of the strip. You'll want your schedule to match your strip's content, though. For example, a four-panel humor strip probably wouldn't draw much of a readership if it updated every other week. But a full-color, action-packed, full-page comic might.

Whether or not your schedule is a good one depends on what you reward the reader with in every strip. Having a plot development, or a sight gag, or good dialogue, or a strong punchline can help retain readers if your Webcomic doesn't update every day.

Think about the dramatic comic strips in the newspaper. Not much develops from day to day - but at least it's a daily strip. If those strips only ran once a week, they'd hold your interest even less than they do now. Finding that balance of story development or joke writing in your update schedule is part of your journey as a Webcartoonist.

Just remember to pace yourself and make a schedule that works for you and keeps you excited to draw the next installment. Your Webcomic should feel like a fun challenge — not a burden.

Your Buffer

For the longest time, I did my Webcomics the night before they updated. I drew "Starslip Crisis" Sunday night through Thursday night, and "Checkerboard Nightmare" Sunday, Tuesday and Thursday nights. I had a day job at the time, and there was about a half-year stretch where I got six hours of sleep most nights.

Balancing all those jobs was tough, and I did it the hard way until recently, when I starting keeping a buffer. Building a buffer of strips ahead of time can make a big difference in your workload. Rather than rushing a strip and doing it all over again the next night, take a few hours on a weekend to get into Webcomics mode and crank through three or four strips.

It takes time to "spin up" to Webcomicking, and I didn't used to take advantage of it to the fullest when I was in that Webcomics frame of mind. Once you're in a writing and drawing mood, why stop at tomorrow's comic? Do one for the next day, and the day after that.

Having extra strips will also give you a chance to better react to other events in your life. On the nights that I couldn't update due to other obligations or unexpected goings-on, I just had to stay up even later to get it finished — or worse — I did that day's strip in the middle of that day, a practice which simultaneously

looks lazy to your audience, and actually requires more work!

In the U.S. and Canada, many newspaper readers have gotten used to the idea of a larger, color-filled "Sunday" comic format. Originally, it was a promotional tactic by newspapers to sell more weekend editions, and it worked. It gave cartoonists and readers a chance to really stretch out and have fun in a format that allowed for more play.

And even though the rules and traditions of newspapers need not apply to the Web, I'd strongly suggest doing something similar in your comic. Pick one day a week or a special time every year to change up your format and have some fun.

Vary the length and size of your comic, try a different color scheme, change the timing and pacing of your writing, and go for some character development that you normally can't do.

And here's an extra tip: Your readership will "dip" every weekend as folks step away from their work and school computers. Take a lesson from 1920s newspaper editors: Entice them back with something special on weekends!

Dave makes a good point. Once your schedule is established and you've got a buffer built up, you'll have more time for everything — including doing strips for weekends or special features. Even if it's not for a weekend strip, you can use the extra time to create desktop wallpapers or other downloadables, or spend more time on your blog.

Time management is key for a Webcartoonist, and this formatting stage is when you need to make sure you've got things under control!

Image Preparation

You've ironed out your character designs, decided on some basic formatting, and you've created a few strips for your Web site. So, just "GIF" those puppies and upload already, right?

Well...

First take a little time to pay attention to image preparation. In other words, there are a few crucial aspects to cartooning that take place just after your comic is created and just before it's ready to be enjoyed by your readers.

If you've created your comic using paper and ink, you'll need to scan it and prepare the digital file. If you've created it digitally, you're a little further ahead, but you'll still have pitfalls to avoid. In either case, there are issues of digital image preparation, file format, and basic file management that you'll want to keep in mind.

One note before we get into this. All of the instructions I'm going to give you will be fine-tuned for Adobe Photoshop. I couldn't repeat every step-by-step guide for the other image-editing software packages in use, and to be honest, I really can't endorse any software but Photoshop. If you've decided to use another software package, you'll hopefully find that everything I'm describing here has a parallel in your application.

Additionally, we should explain a few basics of image files before we proceed. An image file can be described by its mode, resolution and format. Knowing how to apply and control each will enable you to best present your work on the Web and in print.

Mode

The mode of an image describes how the image's color is handled. There are four basic image modes: CMYK, RGB, Grayscale and Lineart.

CMYK: This mode is used for an image that will be printed at some point. It gets its name from the four inks used in process printing: Cyan, Magenta, Yellow, and Black (which is designated "K" to avoid confusion with cyan, which is sometimes called "Blue" by some old-timers). Using these four inks, printers can create a spectrum of five or six thousand colors on paper.

RGB: This mode is used for images that are intended to be seen on TV or computer monitors. It's named for the three colors of light that monitors use to create images: Red, Green, and Blue. A spectrum of 16.8 million colors is possible using RGB mode — far more than CMYK mode.

Grayscale: A grayscale image is made up of black, white, and shades of gray.

Lineart / Bitmap: Lineart images are comprised entirely of black

CMYK vs RGB

When you're preparing to add color to an image, you'll have to decide: RGB or CMYK. Unfortunately, it's not as easy as switching between the two. RGB is capable of conveying millions of colors — CMYK only manages a few thousand.

That means that some colors you'll achieve in RGB mode are impossible to duplicate in CMYK.

So, if you're planning on reproducing your color comics in print someday — and you should be planning for this — you'll want to create your original image in CMYK mode.

The version that gets posted on the Web can be translated easily into RGB from that original CMYK mode.

— Brad

and white shapes — no colors and no grays. Of course, it is possible to create a "gray" effect through techniques such as cross-hatching and pointillism, but these are actually small, solid, black lines or dots — not continuous gray tones. Photoshop calls this mode "bitmap," which causes some confusion, since the word has another definition in digital images. When we're talking about printing, though, bitmap has a very simple definition: all of the pixels are either black or white. As a result, a 900 DPI bitmap TIFF has a suprisingly small file size — because there are only two types of pixel for the file to code.

Resolution

Resolution is described by two measurements: Dots per inch and Lines per inch. The higher the resolution, the more detail the image will have. Lines will be sharper and gradients will be smoother.

Dots per inch: In a traditional offset printing process, images are broken down into dots to make it easier to spread ink across a page. Dots per inch (DPI) describes the number of dots-per-square-inch found in the image. In general, DPI describes the sharpness of the image: The higher the number, the sharper the image. This measurement can also be called "pixels per inch" (PPI) in a digital images. The two measurements correlate exactly.

Line per inch: In a printed image, the dots used to create the image are distributed in lines of dots. This allows dots from the four inks used in process printing (CMYK) to be distributed in different angles. If all of the dots lined up in the same angle, a distracting pattern (called a moiré pattern — pronounced more-AY) would form. LPI also controls how closely packed (or sparsely spaced) the lines of dots are. In general, think of LPI as the coarseness of an image.

DPI

To help explain how dpi effects an image, here are five squares — each of which is 50% black. The LPI is unchanged at 150.

600 dpi (150 lip) **300 dpi (150 lip)** **200 dpi (150 lip)** **72 dpi (150 lip)** **53 dpi (150 lip)**

LPI

Below are four boxes. Each is 50% black and each is 300 DPI. The only change is in the LPI.

 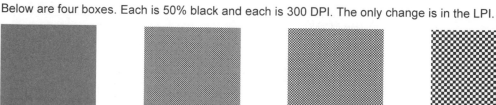 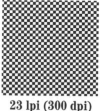

150 lpi (300 dpi) **83 lpi (300 dpi)** **53 lpi (300 dpi)** **23 lpi (300 dpi)**

The term "hi-res" stands for "high resolution." For printed grayscale or color images, hi-res is usually 300 DPI and higher. Printed lineart is also "hi-res," but it's 600 DPI and up. Low-resolution (or "lo-res") images are not printed; they're best suited for your computer monitor. For the comics you'll be displaying on the Web, lo-res means 72 DPI.

The general rule of thumb is that DPI is double the LPI — or LPI is half the DPI. This results in a nicely balance image.

To get a general idea of resolution in print, keep these general settings in mind. Most newspapers print images at 200 DPI, many magazines print at 300 DPI. Black-and-white lineart is typically created at 600 DPI. If you can get your hands on older newspapers (1960-1980) you can see the differences in linescreen (LPI). In the past, newspapers printed at a much lower LPI — which resulted in a coarser image. (It also decreased the chances of a moiré pattern in color images if one of the four inks didn't line up exactly with the others — which is exactly why they did it.)

Some artists — particularly manga artists — lower the LPI to allow the dots to be noticeable in the gray areas. As long as the DPI remains high, the image will remain sharp.

However, although the artist can easily control DPI, LPI is generally set by the printer — and usually at the rule-of-thumb described above. If you want to game the LPI, you're going to have to override the printer's settings. And that means creating a half-

Which Resolution?

At which resolution should you create your original image? If you're creating a vector image, this doesn't apply to you, of course, but for pixel-based images, I advise creating your image at the highest-possible resolution you can safely store on your computer's hard drive over time.

All of my original scans are at 600 DPI, but 900 DPI really isn't out-of-the-question for newer computers.

You can increase resolution without losing image quality, but you will sacrifice image size.

To do this in Photoshop, select Image Size from the Image menu. "Constrain Proportions" should be slected with an "X." "Resample image" should not be selected. Now you can change the resolution (in the "Print size" area) without sacrificing image quality. You'll notice that as you change the resolution, the image size

above decreases.
A 2x3 inch image at 300 DPI can be safely increased to 600 DPI. But it will shrink physically to 1x1.5 inches.

In short, you can always bring resolution safely down, but you can't increase it without penalty. So save your images at the highest resolution you can, and you'll be prepared for whatever comes your way in the years to come.

— *Brad*

tone bitmap, which I'll be talking about later in this chapter.

File Formats

Once you've determined the mode and the resolution, you still have to decide on the file format for your digital image. For the Web, you'll probably be saving your work as a GIF, a JPEG, or a PNG file. For print, most likely it will be EPS or TIFF. Let's take 'em one at a time.

GIF: Graphics Interchange Format (GIF) files are very popular because they're versatile enough to handle both color and black-and-white images while maintaining a very small file size. They can also be used to create simple animations. But they don't handle color gradations or subtle shifts in tone. BEST USE: Black-and-white images or images with flat, non-gradated color published on the Web.

JPEG: Since the Joint Photographic Experts Group (JPEG) can convey 16.7-million colors, it's a natural for images with gradient color or subtle tone shifts. It also produces a slightly larger file size, making it a poor choice for a black-and-white comic with no shades of gray. BEST USE: Images with gradient color tones published on the Web.

PNG: The Portable Network Graphic (PNG) file came to popularity only a few years ago. It handles both gradient color and black-and-white images at a very low file size. BEST USE: Either type of image published on the Web.

TIFF: The Tag Image File Format (TIFF) is the file format of choice for pixel-based images. If you created your image in Photoshop or if you drew it and scanned it, you're working with a pixel-based image and TIFF is the file format you'll choose when saving a file for print. TIFFs offer compression choices such as LZW or ZIP, but I advise against using them. I have seen problems with usability and image degradation occur as a result of these options. BEST USE: Printing pixel-based images.

EPS: The Encapsulated PostScript (EPS) file is very useful for vector graphics — images in which the lines and fills are described by math instead of pixels. If you created your image in Adobe Illustrator, Macromedia FreeHand, Adobe Flash, or CorelDraw, you're working with a vector file, and EPS is the file format for you. Vector files have a tremendous advantage in publishing because they are infinitely scalable — meaning you can enlarge them indefinitely without degrading the image quality. BEST USE: Printing vector graphics.

Back up Your Files

I can't stress enough how important it is to make multiple back-up copies of all your digital files. Don't just leave one copy of your new book on your hard drive. Make frequent backups to extra or external hard drives and make monthly hard copies to portable media like CD-ROMs or DVD-R disks.

Made two copies. Keep one copy of your archived media with you at home, and take one at an offsite location (at work, safe deposit box or with a friend or family member).

You can't have too many backup copies of your work, so make backups frequently and regularly. The next time you have a hard drive failure or lost disc, you'll thank me for it. Give a hoot, back up your media.

— Scott

You should be saving every comic you create in three file formats. I suggest saving a master file of the original hi-resolution image in the original Photoshop file format (.psd). Save a second file for print — even if you don't think you're ever going to print a book — as a high-resolution EPS or TIFF. And save a low-resolution file (GIF, JPEG or PNG) for use on your Web site.

A great time-saving trick when saving one image in different formats is to use "Actions" in Photoshop. Actions are a series of commands that you've asked Photoshop to record and remember. Hit one button, and Photoshop will perform all the steps you've recorded. Even better, an Action can be used with a single file or on a whole batch of files that need to be reformatted. Actions come in very handy throughout your file preparation, but really save you time when saving your comic in multiple formats.

How do you choose among GIF, JPEG and PNG for your Web image? Experiment with each and see which gives you the greatest image quality at the lowest file size. But remember, these three formats are for the Web only. They should never be used for printing projects. Yes, I know, some printers accept JPEGs — even ask for them by name — but I'm just not comfortable with their print quality.

Scanning

Your initial scan is crucial to the image quality of your work. A flaw introduced here is only going to become worse as you continue to process the image for its different uses. Harry Stone, a pre-press engineer with impressive credits like National Geographic magazine, helped develop the procedure I recommend for doing the initial scan. It works well on a wide variety of scanners and scanner drivers. Please join me up here on his shoulders.

Please note: This process assumes you're scanning a piece of lineart (with the intention of adding color or shading later in an application such as Photoshop).

(1.) Set your scanner setting to "Grayscale" or "Black-and-White Photo." Ignore the "Lineart" setting.

(2.) Set the resolution at 600 DPI (or higher).

(3.) Scan the image using your scanner's recommended procedure.

(4.) Open the resulting file in Photoshop.

Photoshop Elements

Adobe Photoshop is the industry-standard software for the print-publishing world. Simply put, I've yet to see software that can touch its quality and versatility.

Of course, world-class software comes with a world-class price tag. Adobe prices Photoshop way out of reach for the beginning cartoonist.

Or does it?
If you're a student, you may have access to student discounts for software. It's worth taking the time to look into.

Discounts aside, Adobe still offers a stripped-down version of Photoshop called Photoshop Elements. It has all of the major components of Photoshop, but doesn't have many of the bells-and-whistles.

Its handling of lettering is somewhat limited, and the Crop tool is a little stunted, but in terms of image preparation, it has everything you'll need. And at around $100, it's very affordable software.

— *Brad*

(5.) Go to the Image menu, and select Threshold from the Adjust option.

(6.) A dialogue box appears with an arrow under a range of values which charts the values of the pixels on your image from white (far left) to black (far right).

The Threshold dialogue shows the range of gray tone from white (on the left) to solid black (on the right).

This arrow determines the breaking point of your bitmap lineart. Everything on the left of the arrow will become pure white and everything on the right becomes solid black. You can experiment here (I usually keep my setting at between 120 and 130). Pulling the arrow more to the left will result in thinner lines and lost detail. Pulling the arrow to the right will "fatten" the lines and pick up specks of dust from your paper and other imperfections. The key here is to find a happy medium. (P.S.: Don't get freaked out by what's happening on your screen right now. Just trust me.)

The Unshark Mask filter tightens up your image.

(7.) Once you've OK'd that dialogue box, all of the pixels in your image are either black or white.

(8.) Under the Filter menu, select Unsharp mask. Set the amount at the highest number possible (between 400 and 500). Choose a radius between 1 and 3, and between 10 and 30 in the levels setting.

Bitmap Jaggies

Many people panic when they convert their hi-res grayscale image into bitmap mode. After all, when you see it on your screen, magnified a couple hundred times, it looks awfully jaggy. But fear not: As long as your resolution is suitably high (600-900 DPI), your image will look crisp and sharp. Need proof? Print it on a laserprinter and see for yourself.

MR. INVINCIBLE! WHAT GIVES?!

SORRY 'BOUT THAT, CAP...

(9.) OK the Filter dialogue box and repeat step 8.

(10.) Look over your illustration. Erase any imperfections and add any necessary lines with the appropriate tool.

The Bitmap Mode dialogue.

(11.) Go to Mode and pull down to Bitmap. In the resulting dialogue box, choose "50% Theshold" as your Method. OK the dialogue box. Remember what I said in Step 7? All of those pixels are either black or white. There's no need to save this file in Grayscale mode. Converting it to Bitmap is going to decrease the file size considerably.

(12.) Save your master scan as a TIFF (Remember: No compression, no LZW, no ZIP).

Most people panic at this point. They see those stair-steps in their line and they're convinced that their image is going to appear jagged. But please remember, you scanned that image at a significantly high resolution (600 DPI or higher). Those stair-steps will not be visible to the naked eye. Your lines will print sharply. If you need reassurance, print a copy out (on a laserprinter, preferably) and see for yourself. Remember: Never judge print quality on your computer's monitor.

If you find a mistake, open the file, convert it back to Grayscale mode, make the fix, and convert back to Bitmap. You won't hurt that image a bit.

Digital Art / WACOM Tablets

If you don't want to work with pencil, ink and paper, you can try your hand at drawing digitally with a tablet and stylus. I've used a WACOM Intuos for years, and it took me a little while to get used to the feeling of drawing where your eyes aren't looking. But now I save the step of inking and scanning my art, and to me that was well worth the time and the minor investment.

You can go one further (as I have done) and draw your strip using a vector art program like Adobe Flash or Illustrator. I like Flash's brush tool because it's pressure-sensitive and there's a little jitter correction. With it I've managed to give a lot of my work a hand-drawn, "inked" look without the ink.

The greatest benefit to vector art is that you can export it to any size or resolution. Unlike a scan of a drawing that is composed of millions of pixels (also called raster art), vector art is defined by mathematical curves and lines. Those lines get redrawn mathematically to the same proportions no matter what size they're scaled to, so I could export one of my strips at a resolution to fill a football field.

The downside? Since it's digital, you don't have original art to sell! Which can be a significant decision: For myself, original art sales make up a third of my income.

Coloring and Shading Lineart

Whether you've drawn the image on paper and scanned it or created it in a pixel-based application like Photoshop, once the linework is done, you're ready to start adding colors (even if those "colors" are gray). I have a process for coloring Lineart that I prefer. Dave has another that he's going to share. Both work well, but since this is my chapter, I'm going to go first.

(1.) Convert your Lineart/Bitmap image to Grayscale.

(2.) Choose "Save As" from the File menu and save this as a second file. Do not overwrite your master. You might need it later!

(3.) (Optional step) Reduce the resolution to 300 DPI in the Image Size dialogue box (under the Image menu). In this case, you *will* want to be sure to select "Resample Image" in the commands below. This simply decreases your file size, which will balloon considerably once you leave Bitmap mode. 300 DPI color/grayscale images print very well. You can go higher, too, but that file size is going to climb exponentially.

(4.) Convert to CMYK mode. (If you're preparing a Grayscale image, you can skip skip this step.)

The Image Size dialogue: Remember to select "Resample Image" for this process.

The Layers palette should look like this: Lineart on top (in Darken mode) and Colot on the bottom (in Normal mode).

(5.) Open the Layers palette. You'll see one layer, named "Background." Double-click this layer and rename it "Color."

(6.) Select All (Command-A) in the image area.

(7.) Open the Channels palette. You'll see five channels; CMYK, Cyan, Magenta, Yellow and Black. Select the Cyan channel only and hit your delete key.

(8.) Repeat this step for Magenta and Yellow. Leave the Black Channel alone.

(9.) Click on the Black Channel. From the Image menu, pull down to Adjust and then over the Theshold. Choose the same threshold

you chose in your initial scan procedure.

(10.) Important: Now click on the CMYK channel.

(11.) Go back to the Layers palette. With the Color layer selected in the Layers palette, click on the arrow at the upper, right-hand corner of the Layers palette. Select Duplicate Layer and call this new layer Lineart.

Channels palette: Before

(12.) With the Lineart layer selected in the Layers palette, select "Darken" from the menubar directly above. It was probably set to "Normal" as a default setting.

(13.) Lock the Lineart layer.

(14.) Select the Color layer.

(15.) Color the image using whatever technique you prefer.

Channels palette: After

I like to use the paintbucket tool to fill areas that are bounded by lines. If an area is not completely bounded by a line, I use a brush (set to the same color I'm using as a fill) to complete the area before filling it with the paintbucket.

I find it helpful to turn off the Lineart layer while I'm coloring the image. This is done by clicking on the eye to the left of the layer name in the Layers palette. This way, I can see the changes I'm making to the color layer without having my view blocked by the

Non-Photo Blue Pencils

A great trick for streamlining your drawing process is to sketch your cartoon in non-photo blue pencil and then ink directly over it. Non-photo blue, as the name suggests, doesn't photocopy — and it doesn't get picked up by a scanner — so you don't have to erase your starting sketch.

And if you've ever ripped a piece of finished art in the erasing process, you'll understand how important that is!

You can find standard non-photo blue pencils in any art-supply or office-supply store. You can also buy blue leads for mechanical pencils.

— *Brad*

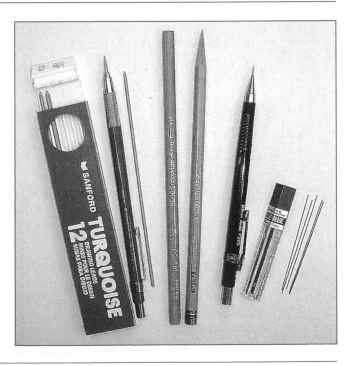

Here's another method of coloring strips that uses the Channels palette to achieve a printable color image.

(1.) Repeat Brad's steps 1-4 in the preceeding pages.

(2.) Open the Channels palette.

(3.) Duplicate the "Black" channel by right-clicking (PC) or CTRL-clicking (Mac) on that single channel and selecting "Duplicate Channel" — or by pulling the "Black" channel down to the new-channel icon at the bottom of the dialogue box. This will create a new channel called "Black Copy".

(4.) You will now have six channel-selections in your Channel palette: CYMK, Cyan, Magenta, Yellow, Black, and your new Black Copy.

(5.) Select the CYMK channel, and it will apply all of your colors to the C, Y, M and K channels, leaving your Black Copy channel untouched.

(6.) Color your comic using whatever technique you prefer. The paint-bucket tool will fill areas that are bounded by lines. But here's the big advantage to coloring with channels: You can also use your Lasso Tool or your Polygonal Lasso Tool to quickly and easily color un-bounded areas like a character's hair, or a pile of hay, or a cross-hatched patch of earth. Did you color over some black lines using the lasso tool? Don't worry about it! You'll be applying your du-plicate "Black Copy" channel later. So go ahead and work fast!

(7.) When you're done coloring, return to your Channels palette and select the eye icon next to the "Black Copy" channel.

Turn off the eye for all other channels, and you'll see your origi-nal, black-and-white image.

(8.) Using the Magic Wand Tool (Important: make sure the "Con-tiguous" check-box is clicked "Off"), click on a section of your black linework.

This will select only the original drawn illustration, producing the "marching ants" look around all of the black.

(9.) With those ants still marching, return to your Channels palette and turn the eye "on" next to CYMK, and "off" next to "Black Copy".

(10.) Select the CYMK channel.

(11.) Use the Fill command to fill the marching ants with 100% black.

(Note: Step 11 is a chance to experiment with coloring-by-Chan-nels. Try filling with a dark, dark brown as your Fill color in-stead of black, and see how nicely it softens your colored image! Experiment further with different Fill colors.)

(12.) And voilà! You now have a colored image, perfectly overlaid with your original linework!

(13.) Delete the "Black Copy" channel, and save this image as your print-ready file.

(14.) Then, to create a Web-ready version of the file, just follow Brad's JPEG-, GIF- and PNG-preparation instructions found at the end of this chapter.

lineart layer. This is very important because I might slip with the paintbucket and turn all of the lines into a color. If that happens, I choose Undo.

You can add shading and highlights to the image in any number of ways. The quickest and easiest is to select a colored area with the Magic wand tool and use the Burn (highlights) and Dodge (shading) tools in the toolbox.

Just remember to re-activate the Lineart layer before saving the file and exiting. Save this as a CMYK TIFF.

Why go through all of this? Photoshop breaks the color black down so it's distributed across all four inks in the CMYK printing process. This produces a richer, darker black. It also causes a fuzzy image if all four inks aren't lined up exactly when the image is printed.

My process eliminates the other inks (in Steps 5-7) and brings the black ink back to full strength (Step 8). Since it's on a higher layer, it will print over the color layer as a solid, single-ink color.

Halftone Bitmaps

As I said earlier, you can override your printer's LPI setting to game the coarsenes of your image and get some visual effects that many manga artists find very popular. But this procedure requires a fair amount of planning and experience (as I'll explain in a moment) so by all means, do not do this effect to your master file! This is another "Save As" procedure!

(1) Open completed art, with all coloring and shading complete, in Photoshop.

(2) Choose "Save As" from the File menu and save this document as a new file.

(3) Under the Image menu pull down to Mode and then select Bitmap. If you get a warning that asks if you want to flatten the document, choose OK.

(4) A dialogue box will appear. In the Methods area, choose halftone screen.

(5) This brings up another dialogue, and here's where you can game the LPI. For example, if you choose a lower number for the LPI, the gray areas will be comprised of dots that are spread out instead of

This dialogue box appears after you select "Halftone Screen" from the Bitmap Mode dialogue.

packed together (your lines will remain sharp). You can alter the angle of the rows of dots. Finally, you can control the shape of the dots themselves, choosing among Round, Diamond, Ellipse, Square and Cross (the later of which results in a kind of crosshatching).

(6) OK the dialogue box.

(7) Save the document as a TIFF.

Here are a couple benefits. First, you can get many cool manga shading effects. Secondly, you can convert a grayscale image to bitmap, which reduces the file size considerably. This is very important if your work ends up being printed on a regular basis by a newspaper or magazine. You can send small files that print sharply.

And here are a couple of dangers — and they're biggies. First, if the printer tries to enlarge or reduce the file you've provided, you run the risk of getting a distracting moiré pattern across your image. For the best possible results, a halftone bitmap should be

Moiré Patterns

A looser LPI will make it harder for a moiré to form — and you won't lose image quality. The images on the bottoms on this page and the next started from the same master file — a 600 DPI grayscale TIFF.

600 DPI / 150 LPI: 100%

www.evil-comic.com

600 DPI / 150 LPI: 62%

BGUIGAR@yahoo.com

www.evil-comic.com

run at 100% when its printed.

Mind you, setting the LPI low enough — I use 53 LPI for halftone bitmaps I send to newspapers — reduces the risk of moirés (and makes them harder to notice), but the risk is still there. See the sidebar at the bottom of the preceeding two pages for a deeper discussion.

Secondly, once you've converted to halftone bitmap, you have, in effect, changed all of those continuous gray tones into solid, black dots. You can not convert back to grayscale mode from here. You absolutely, positively have to keep that original file safe, or you can really wind up in a bind.

So my recommendation is to only convert to halftone bitmap format after you have sized the image to the exact dimensions at which it will be printed. And always perform a "Save As" before working the file.

The strip on the preceeding page is a halftone bitmap TIFF at 600 DPI / 150 LPI. The strip below is the same thing — except with an LPI of 53. Notice both look perfectly fine at 100%, but the tighter LPI yields a moiré pattern in the gray areas.

600 DPI / 53 LPI: 100%

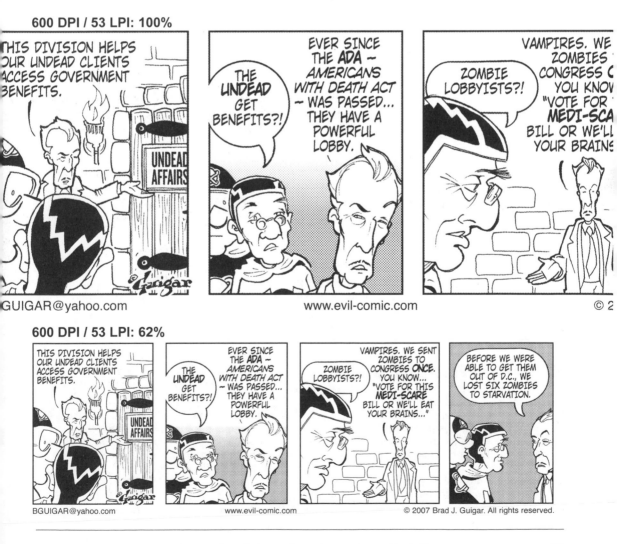

600 DPI / 53 LPI: 62%

Photoshop's "Save for Web" dialogue box (shown here and on the next page), has a number of useful options — along with two views to show you the original (on the left) and the version with the selected options applied (on the right).

Preparing GIFs

(1) Open the image file.

(2) If necessary, convert to Grayscale from Bitmap mode.

(3) Select Image Size from the Image menu, and change the resolution to 72 DPI. Be sure the box for Resample Image has an "X" in it.

(4) Under the File menu, select "Save For Web".

(5) To the right of the ensuing screen, you'll see an area marked Settings. Select GIF from the top toggle box.

(6) In the next two toggle boxes under that, I recommend choosing "Selective" and "No Dither," respectively.

(7) In the controls on the right-hand side, I generally choose eight colors for a lineart comic. I'll nudge the number higher if I have continuous tones of gradient shading. The image preview shows me the effects of my selections.

(8) Click OK.

Choosing the Interlaced options in the Settings field allows your readers' browsers to import the image in repeated passes — going from fuzzy to sharp before their eyes. This is useful if you have a somewhat large file that you don't want readers to miss. This way, they see something materialize and don't scroll past it.

File Size and Physical Size

Don't confuse file size for physical size. The physical size of your art is the actual size it would measure if it was printed out without enlargement or reduction. It would be measured in inches, centimeters, picas, etc.

File size is the amount of space, measured in bytes, that the image takes up on your computer's hard drive.

Webcartoonists want a physical size that will appear on most reader's browsers without horizontal scrolling (that still seems to be 800 pixels wide), and the smallest file size possible (for quick, easy loading on your readers' browsers).

— *Brad*

Preparing JPEGs

(1) Open image file.

(2) Select "Image Size" from the Image menu, and change the resolution to 72 DPI. Be sure the box for Resample Image has an "X" in it.

(3) Choose "Save For Web" under File.

(4) Choose JPEG from the upper-left toggle bar under Settings.

(5) Select "Progressive" if you'd like the same loading effect as an Interlaced GIF.

(6) Under Quality, you have to make a judgement call. A higher number results in a cleaner image but a larger file. A lower number has a less sharp image but a smaller file size. You can see the results of your choices on the screen.

(7) Click OK.

Preparing PNGs

(1) Open image file.

(2) Select "Image Size" from the Image menu, and change the resolution to 72 DPI. Be sure the box for Resample Image has an "X" in it.

(3) Choose "Save For Web" under File.

(4) Choose PNG from the upper-left toggle bar under Settings.

(5) As with GIFs, I recommend Selective in the next toggle bar down.

(6) Select the number of colors. If you have a very simple image with flat color or no continuous tones at all, you can safely use a low number. If you have gradient shading, choose the highest (256).

(7) Click OK.

Experiment with all of the file formats to see which one works the best for the type of work you're presenting on your site. And listen to your readers. They'll tell you if you're having legibility issues.

Perhaps the most common mistake you could make would be to assume that you're never going to want any of your early work in hi-res. This comes down to either false modesty or an overall lack of confidence. Trust me. You want to preserve *all* of your work in hi-res. Even if you don't collect it into a book right away, you will — someday — be working on a project that demands hi-res images of your very first strips. Whether it's a complete collection of your work or a presentation of your "early years," you'll want them — if only to say, "look how far I've come!"

Do it now. Don't get stuck having to re-scan this stuff later. You'll thank yourself for doing it when it comes time to collect that huge retrospective volume of work. Your work is good. It has value. Treat it as such.

In the Hot Seat...

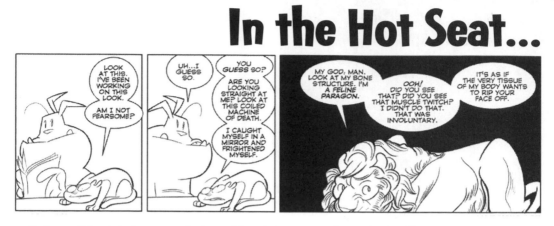

I chose this strip because I play with mixing art styles in it. And because the gag itself is based heavily on the art as opposed to the text. I've always been worried that this strip wouldn't deliver the punch to others that it did to me personally.

— Scott

You'd imagine the first comment for this strip would most likely be about the beautifully contrasted artwork in the third panel. But I think it's more interesting to see how Scott's written Scratch, here. When you're writing, look at what you can say without actually saying it. And what comes through so clearly here, in and among the witty diction and wish fulfillment... is that Scratch has the same insecurities we all have: To be more than he is. In addition to being a great gag with great artwork, this also becomes a strip that adds to the character. You get a sense for what goes on in that little skull.

I really like the dialogue too, and it's something you really nailed in another strip — the one where Scratch is watching a fat cat at a cat show stuff his face and just talking to no one in particular about how ridiculous and shocking it is. It's that kind of almost incidental dialogue that makes a character for me. The sudden shift to the classical-looking lion is also great, but I wish you had reoriented the word balloons so that the lion was more fully in frame. We don't even see his mouth and I feel like he's a little crammed in there. Still, there's a lot of text there. It's tricky to pull off.

I had the same reaction as Kris when I got to the last panel. I also wonder whether trimming some of the text would make it stronger.

I'm sure there was another reworking of the dialogue that would be as good and free up some space. With all my strip's dialogue, I don't have a lot of room to talk. My characters don't have a lot of room to talk either. Ba-dum-kssh!

The reason for the clipping was to use the panel border itself as a metaphorical "veldt" for this Scratch-lion to be hiding in before pouncing. I was actually really proud of myself for the clipping. Now I see it for the failure in vision that it truly is. Whose idea was it to do these critiques again?

I don't know, but I don't think Dave's feelings have been hurt enough yet.

... Scott Kurtz

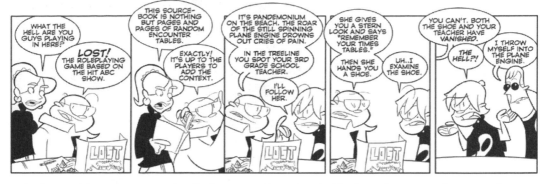

I chose this strips specifically because I'm afraid that "PvP" is not a "timeless" strip. It's hopelessly trapped in the time of the pop culture that it references. What's truly funny about this strip? The characters? The truth behind the message? Or is it just a rattling-off of popular culture references that, at the time, strike a chord with those currently obsessed with the topic?

How funny will this joke be if someone is reading this book in 10 years? Will anyone even **remember** the TV Show *Lost?* And as an extension of that, will people even remember "PvP?" But I keep doing these jokes because it's what my readers want in the here and now.

— Scott

There is a danger, admittedly, that a too-specific reference will get lost in the sands of time. But for every "Bloom County" strip that makes a Gary Hart reference that I can barely remember, there are ten talking about Opus' desire to meet his mother — a timeless, heart-tugging theme. "PvP" does a nice job of that as well. Balances the both.

You might be able to circumvent the timeliness issue in the second panel by replacing Cole's text with "Exactly! Just like the show!" Then, even if you've never seen an episode, you'd have all the background you need to appreciate the punchline.

My favorite part of this strip? Francis' eyes in the third panel. He's got that perfect, "lemme-think-about-this" stare. And those are the touches that get me, in a comic strip. While it's true that good writing matters far more than good art — if you look at those eyes in panel three, it really sells the mood.

I love Scott's technique of "rising" the voice bubbles out of the panels. That, combined with the lack of framing in panel two, adds a lot of visual interest to what could've been a straight-lace, boring, five-panel strip.

For me it's all about the dialogue again. The best part is "Then she hands you a shoe." Before that we weren't sure if it was truly going to be random, although I was secretly hoping it would be. So the fact that it's a shoe delivers the goods. Then they both vanish? Awesome.

Writing

How do I even begin a book chapter instructing you to write your comic strip? Half the time, I don't even know where *my* ideas come from and now I'm going to instruct you on how to spin gold from straw? That seems like hubris to me.

What I can do is walk you through some of the tools I use to push myself to be a better writer. And

when I say "push myself," know that I'm choosing my words very carefully here, because that is what it feels like. You need to push yourself through writer's block; push yourself to come up with an even funnier way of saying something; push yourself to not give in to self-doubt; push yourself to find a new way of doing things.

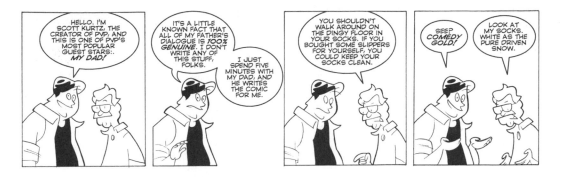

Writer's Philosophy

For me, writing is about connecting with an audience. How I write — and which parts of myself I put into my comic strip — will determine how my readers come to know me through my work. Personally, I'm a guy who wears my heart on his sleeve (and in his work). I'm all there on the page. When Skull has a vulnerable moment, it's because I've had a moment like that. When Brent pushes Jade away with a sarcastic quip, and then immediately regrets it, that's because I've experienced something similar with my wife. I write from personal experience. That's my style. It helps me understand my world and my life better by examining it through my work; and it gives me an opportunity to laugh at my problems and better cope with them. Because I'm able to do that publicly, my readers can connect with me through my work and see themselves in it.

I dunno, I've always felt that comic strips are a very personal medium — maybe more so than writing novels or screenplays. Comic strips are about a creator's uniquely singular voice and vision. When you look at someone's comic strip, you look at him. You know that old cliché about a dog owner looking just like her dog? I think the same thing applies here.

> That's what makes comics such a great art. It's one of the few truly solo artforms that's able to update regularly and still reach huge audiences. A regularly updating comic book usually requires 2-4 folks, while TV shows, film and animation can require hundreds of people. A webcomic? One person. What a great venue to speak directly to the world, unfiltered by editorial direction or other artists' input.

The important thing to realize here is that we're all trapped within ourselves and our own sensibilities. We can't **help** but write from our own personal experiences. One way or another our work is going to say something about **us**. It's not going to live separate from us. You're putting yourself on the page whether you know it or not.

Capturing Ideas

Once you start training your mind to spot the storyline and humor ideas all around you, you'll find that the real trouble lies not in generating ideas, but in finding little pieces of paper to write those ideas down. To avoid that, I recommend you carry a tiny pocket notebook. Cheap, spiral versions cost as little as $.60; while a beautiful, leather-bound Moleskine notebook with strap costs $10-20. Another great alternative is the idea-capturing device we all carry in our pockets: Our phone. Text yourself, leave yourself a voicemail, do whatever it takes. But don't trust your brain to remember the idea, it will turn on you like a Cold War spy. There is nothing worse than getting home four hours later, sitting down to begin your comic and finding that you haven't the foggiest what the idea was. Or, even worse, you only remember it involved a watermelon and a zombie Genghis Khan...and...aw dang it, what was the punchline?!?

Do yourself a favor: Always carry a way for you to capture ideas.

Dave

It's important that I tell you one more thing before I move on: Please don't try to manufacture this. If you're not a hip, indie-rock guy and you try to pass yourself off as one through your work, it's going to come off as forced and fake and you'll alienate readers. I think you're better off writing honestly about a character who *wishes* he was the hip, indie-rock guy. Or better yet, take out your anger that you'll never be that hip by pointing a satirical finger at the hip crowd. But if you try to manufacture that, and pass yourself off as something you're not, especially to fill a niche, you'll be doing yourself a great disservice.

Let me throw in here another good reason not to manufacture a premise: if the topic doesn't come naturally to you, not only will your readers be able to tell and get turned off, but you'll get bored too. Writing like that is a chore, and if you're bored and frustrated, it'll show instantly in your work, and that's no fun to read.

You'll end up feeling like Kris does, anytime I ask him to come over and hang out: Bored, tired, uninspired and restless to move on to something else.

Humor

So, let me go right ahead and burst your bubble right now before anyone gets their hopes up. I'm not going to be able to tell you how to be funny. I don't know how to be funny. If you find me funny, that's a blessing and I want to cultivate that. But I don't know how to manufacture funny.

And you need to know something about me and probably every other cartoonist out there: We're all terrified that we're not funny. We're all scared to death that nobody is going to laugh at our strips. We're all horribly insecure. So you're in good company.

Here's the only real rule I'm going to give you about writing humor: Write for yourself. You are your audience. You have to write

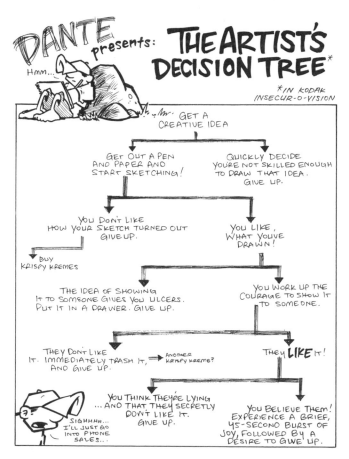

what makes **you** laugh. Don't worry so much about making other people laugh. You're going to hit some days and miss other days. The trick is to hit more than you miss. The easiest way to do that is to write the strip that you would want to read. Write to make yourself laugh and make yourself happy. Trust me, there will be other people out there who share your sense of humor. We call them your future readership, and they're waiting for you.

And if you're worried that your interests are too niche — too small for an audience to gravitate toward -- you may be surprised. Once upon a time, cartoonists all had to write golf jokes, or guy-on-the-deserted-island jokes, or angry-spouse jokes, just to appeal to the diaspora of a mass-market audience. Now you can write about the subjects and ideas that really touch your heart -- **especially because** they're niche topics. And in return, a niche audience will discover your work, and find you've perfectly captured their mindset.

What About Drama Strips?

I know, we're focusing a lot of this book on humor writing. Well, we're funny guys and that's our thing. But listen, in all honesty, writing for drama is not that much different from writing for humor. It's all about building tension and releasing the tension. With humor you're building to a laugh. With drama you're building to a dramatic reveal. What's important is that you learn the basics: pacing, delivery, and streamlining dialogue.

Pacing

Timing is everything when it comes to comic strips. Despite the fact that we have the infinite canvas of the Net before us, we are still limited in space and the amount of time we have per day to dedicate to our comics. Because of this, cartoonists are still making daily comic strips of around 3-5 panels in length. That's not a lot of time to tell a joke.

I work really hard to get down a good pacing to the jokes I tell in my comic strip. There is a cadence you'll develop that's unique to yourself. Everyone has her own

Pressure - Release

Ask any good stand-up comic and he'll tell you that one of the keys to humor is "pressure – release." You build up pressure steadily and then release it with the punchline.

This is why editing is so important to the success of a gag. Any sentence — any word — that doesn't help to build the pressure is a detriment to the set-up of your joke.

If you find yourself cramming multiple punchlines into a single comic, you may want to consider breaking that comic up into several comics and spending more effort on building the

pressure for each individual punchline.

You're going to be doing a webcomic for a long time. There's no need to go through a week's worth of material in one day.

Of course, the exception to this rule is adding a "button" or a "stinger" after a punchline. This is a very short word or phrase presented after the punchline that has adequate humorous charge to stand on its own without additional build-up.

— *Brad*

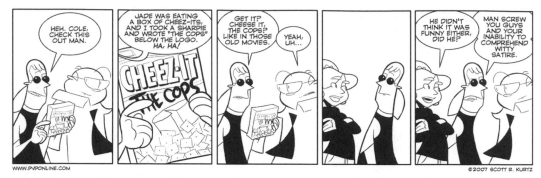

The "silent penultimate panel," as it is sometimes called, helps to build the tension.

unique voice and way of talking. That can come through in the written word too, if you know a couple tricks. Here are some I like to use.

The interruption bubble. One way I like to pick up the pacing of my dialog is to have one character interrupt another before they can finish what they're saying. I achieve this visually by having the word bubble of one character overlap the word bubble of the other. I just line it up so that Character A's first word starts right where Character B's last word gets cut off. It's very effective.

The pause. Okay, I'll admit, sometimes I use this a little too much. It's easy to do. But sometimes, if you want a little time to pass, you just put in a silent panel showing both characters pausing for a moment. It ads a beat to the timing of your strip that can really help deliver a joke. But like I said, it can be overused easily, so be careful (and forgiving when I use it too much).

Play with font size and cases. I think it's pretty obvious that when a person is yelling, we make their text bolder and bigger. But I think a lot of people overlook how effective making text smaller or changing the case of the text to lower case can make a characters words come across in a softer or meeker tone. Another great trick to softening the tone of the written word is to make the word bubble much bigger than the text it contains. It really gives off the impression that the mouth is open but not much is coming out.

Writing Broadly

Kris and I spend a lot of time joking around at the office and we come up with "bits" and act out "sketches" all the time. A lot of what we joke about in real life makes it into our strips. More times than not, however, the jokes make it into my strip. That's because Kris feels that his comic strip has too narrow of a niche. He's crafted his writing into a tighter niche and can't always fit in references to modern popular culture.

"PvP" is written in a very broad humor style. Because of this, it's pretty easy for me to fit any type of joke or humor into the strip and have it work. I never have to worry about coming up with a joke and not being able to use it. My characters are pretty versatile and I can bend them into pretty much any wacky situation.

My characters are versatile too — within their universe. Since my cast is on a starship in the far future, they can't exactly make jokes about current events, unless I couch it in "Remember, back in the 21st Century, when Halo 3 came out?" I tend to stay away from that device, so I don't really get to make those jokes.

So who's better off here? I think it's a balancing act. Certainly, I have the easier go of

it. But my father always taught me that easier isn't always better. And it's not. Because I write so broadly, I also fall into the danger of my work being considered too mainstream and not very challenging or edgy. I've beholden myself to a more mainstream audience and so when I want to experiment in the niche genres, I might get backlash from readers who I've just alienated.

Also, a broader audience will have broader tastes — and broader buying habits. A strip with a tighter niche of writing might be able to more easily cultivate a very dedicated readership that's hungry for merchandise. I might get more eyeballs more easily, but 90% of my audience may never feel compelled to buy anything.

Just like everything else, deciding how broadly to write is a balancing act. If you get too niche, you might limit your potential audience. If you get too broad, your audience may be larger but less dedicated and focused.

Writer's Block

Look, it's going to happen. You're going to have a strip that's due and you have no ideas. Or it certainly feels like you have no good ideas at least. Don't panic. We all go through this. You just got to push through it.

There are all kinds of ways to combat writer's block. The first thing I will suggest is to get away from the paper or the computer. Don't just stare at that blank page. A change of venue always helps. For me, the best thing is to take a small drive in the car with music playing. Don't ask me why it works, but it just works. Do some chores. Take a walk. Change your venue.

> For me, getting out and among people is the best cure. I love to go to a coffeeshop, sit down, and play an improv game I call "Voice Planting." Pick a pair of people sitting across from you, and generate in your mind the funniest possible conversation they could be having. The two cops drinking their straight-black coffee? Why not have them talking about the Lithuanian ballet classes they loved as a youth. You get the idea. Getting out among people steps you out of your closed-loop of self-reflection (i.e. "writer's block), and getting into their imaginary lives does it doubly so!

> The more I write, the more I've come to see writer's block in a different perspective. Writer's block is not the lack of ideas. Rather, it's an overabundance of ideas — and a lack of confidence.

> When I look back in my sketchbook to the times I felt blocked, I see dozens of good ideas laid out in the pages. It's not that I couldn't think of an idea — I couldn't commit.

> In Art class, you're taught: "There are no bad colors, just bad color combinations."

> For a writer, I would say: "There are no bad ideas, just ideas that get executed poorly."

> The next time you experience writer's block, choose an idea and commit to it, determined to make it work somehow. You'll find that once you mentally commit, the writing will flow.

Over the years, I've developed a couple different subcategories of strip ideas for PvP — little themed folders that you could fit all my strips into neatly. That's probably not something I want to be bragging about. Maybe that means my writing is pedestrian and predictable (there goes that insecurity again). Oh well. Regardless, this has helped me

The "Killer Panda" running gag has become a mainstay of the PvP universe.

out of some sticky situations when deciding where to go next and also helps me keep my humor over the course of the year seem balanced. It helps me make sure none of my characters are getting neglected too.

My subcategories of strip ideas are: Character arcs, one-shot gags (or filler gags), storylines, and running gags. Of course, sometimes these overlap. I try to always get a little character development into every strip. But these categories more-or-less help me keep track of what needs to happen next.

Character arcs are any strips or storylines in which the main purpose is to add another layer of complexity onto one of my characters or move them forward in their lives. We spend a lot of time setting up iconic archetypes for our characters to make them identifiable and unique amongst our cast. But for veteran readers (and for ourselves) we need to flesh out our characters over time and add layers of complexity to them as well.

One-shot gags or filler gags are any random idea you've been saving up. These are jokes, pure and simple. One-time gags are great opportunities to comment on the news, an event like a new movie or TV show, or get something off your chest.

Storylines are simply dedicating more than a day of strips to any one topic. Think of them as multiple-shot gags. The sole purpose of the storyline isn't character development, and we can't say it all in one strip. Storylines are there when an idea just is too big for one strip.

Using Your Subconscious

I'm a firm believer in using my subconscious mind to help me write.

The night before I'm going to write, I chant to myself before I fall asleep in bed: "I will write 'Evil Inc'... I will write 'Evil Inc'... I will write 'Evil Inc'... " I try to do this right up until the point that I actually fall asleep.

When I awake the next morning, it's not as if I have a group of fully formed gags in my head waiting to be transcribed on a bedside notebook. But when I do sit down to write, I honestly find that the "lightning" strikes with more regularity and more force than when I miss my pre-writing routine.

In case you're wondering, I'm also a firm believer in that bedside notebook I just mentioned. Dreams are an excellent source of writing material. Have a notebook handy so you can capture them before you drift back off to slumber. In the moment, you always think, "Oh, I'll have no problem remembering a dream about Kris Straub doing a hula dance in a yellow hat singing 'Papa's Got a Brand New Bag.'"

And then you wake up and wonder what was so funny about James Brown and yellow hats.

— *Brad*

This one-shot gag turned out to be so popular, it was made into a desktop wallpaper.

Running gags are one-shot gags that are unique to your strip, and they ususally involve an inside joke that only you and your regular readers are familiar with. I also call this "fan service." A good example of a running gag would be how Garfield always hates trips to the vets or kicks Odie off the edge of the table (maybe those are actually **horrible** examples, but they're examples nonetheless). It's a familiar call-back for regular readers.

Certainly, I'm not suggesting that you set up some formula to writing your comic strip. But hey, it never hurts to have a couple tools in your back pocket to help you through writer's block.

Finding Your Voice

Sit down with any book on writing and you'll see chapters dedicated to finding and developing your own voice in your writing. The idea is to write in a way that is instantly identifiable as YOU. As I said earlier, comic strips seem to be more of a personal medium than others, and because of this, comic-strip readers are looking to find unique voices in the strips they frequent. They're looking for honest voices and unique outlooks.

When I started PvP in 1998, there were only a handful of Webcomics on the Internet, so it was much easier to get noticed. Now, there are thousands of people publishing their comic strips online. People from all walks of life are making public their own personal takes on the world. It's getting harder and harder to stand out from the crowd.

Sounds daunting doesn't it? Don't worry, it's really not.

The bottom line is that we're all human, and because of that we're trapped inside very ego-centric worlds. Everything we experience in life, we experience from our own point of view first. Most of us have to work hard to overcome our personal biases and see the world from a different point of view (why do you think so many people have therapists?).

The secret to developing your own unique voice is to be fearless in your writing. By that I mean that you can't be afraid to be **you**.

I'm going to be honest here: There's a reason that cartoonists

On Writing...

"In Act I, get your characters up a tree; in Act 2, throw stones at them; in Act 3, get them down."

— George M. Cohan

are all so insecure. We're putting our hearts out for the entire world to accept or reject. We're offering our hopes and dreams to the public and risk having them torn to shreds. We're all looking for validation in one way or another. To create something, and offer it to the general public, takes courage. It takes guts. And it's easy to hold back or pull a punch, especially if your view on the world might skew different from the norm.

To be truly fearless in your writing is to risk rejection from an audience. It means putting your heart visibly on your sleeve and leaving it there with confidence. Finding your voice is more about overcoming your insecurities and allowing your true views and passions to shine through.

Some Tips:

- **Don't overanalyze your work.**

You're going to be writing strips for years. Your first strip isn't going to be perfect. Give yourself a time limit to work on one strip. Once your time is up, post that strip (as imperfect as it is) and move on. You'll grow more from the experience of working on several strips than from hanging on to one idea too long.

- **Go with your gut.**

That brilliant joke you came up with on the way home from work is going to seem less and less brilliant as time goes on. By the time you've finished penciling, inking, lettering and scanning in your work, you've read this stupid joke 12 times. Now you can't

Misdirection

"Misdirection" is a term used by magicians to describe the practice of distracting their audience. If a magician misdirects the audience's attention to his left hand, for example, he can secretly prepare the trick with his right hand.

Cartoonists use the same concept. Most commonly, the trick is to write a sentence that can be understood in two ways. Your reader is going to assume the logical meaning. You, on the other hand, are going to present the illogical one. For example, take the cartoon to the right. A mother is surrounded by three, screaming children. With exasperation, she yells at her husband, "I can't just drop everything and go out to dinner with you! Why don't you call the babysitter?" Her intention is very clear, but **his** response shows an unpredictable interpretation of her sentence. This kind of joke relies on an ambiguous sentence and a response that answers the unintentional meaning.

Or how about this old gag: A man says to his friend, "All night long I had hallucinations that there were little aliens in my closet." His friend says, "Have you seen a doctor?" The man responds, "Nope. Just aliens."

Another way to approach this is understand that

© 2007 Brad Guigar

every sentence has a perceived operative word or phrase. the sentence revolves around this word or phrase. Switching the operative word(s) is excellent misdirection. For example, a woman may enter a store and ask the salesperson, "Do you have a large baby department?" Then he leads her to a portion of the store dedicated to gigantic babies (as opposed to a large department of baby clothing). The operative word was switched from "department" to "baby."

— *Brad*

tell if it's even funny enough to post. Go with your first instinct and post the strip.

- **"You can please some of the people some of the time..."**

Instant feedback and interaction with your audience is a wonderful benefit to having a Webcomic over a traditional print comic. But that feedback can also be a detriment. Eventually, somebody's going to have a vehement negative opinion about your work and it's **very** easy to get swept up in the idea of changing the way you write to please the vocal minority. **Don't do it!**

Remember: This is your work. It's a singular voice. The minute you start to alter your writing in an attempt to please your audience, you're going to do a great disservice to the silent majority of your readers who already have fallen in love with what **you** have to say about the world.

Puns can be verbal (top) or visual (bottom), but they should always elicit a groan.

Framework: Puns

At the risk of coming off in favor of joke "formulas," I feel it's important to add a discussion of humor frameworks to the discussion. Sometimes, learning some of these basic comedy building-blocks can be a good jumping-off point for a beginning humorist. So, at the risk of revealing myself as a total hack, I'll share with you, on the bottoms on the next several pages, some tried-and-ture approaches to writing gags.

Puns: Take a familiar phrase, idiom or cliché, substitute a word with another word that sounds almost the same — and end with a sentence that reads equally well with both the original word and the substitute — and you have the perfect pun. Example: A buzzard tries to bring two dead squirrels onto an airplane. The flight attendant says, "Sorry, sir. We have a rule: One carrion allowed per passenger." "Carrion" substitutes for "carry-on." The joke comes from the switched word *and* from the fact that the sentence reads understandably using either word.

— Brad

- **Refine your language.**

Can you say it in fewer words? Then do it. Sometimes less is better and the art of writing sharp dialogue is key to developing your own unique voice. Trim down the fluff and get to the heart of the matter.

I often think of the "punchword" inside the punchline. The punchword is the word in the punchline that carries the greatest charge — the biggest surprise. I think the punchline should be the very last sentence in a comic — and the punchword should be the last word in that sentence.

Anything that happens after the punchline is a distraction — unless it carries a charge as well. When you lead up to a nice punchline and then follow with an extraneous comment — like "Oh, man!" — it draws energy away from the punchline.

I always tell people this about editing for a comic strip: If a word or sentence doesn't lead TO the punchline, it leads AWAY from the punchline. I wouldn't impose a word count or other limits, but I would encourage you to be honest with yourself. Find excess verbiage and prune it.

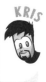

Brad and I displayed a difference of punchline philosophy on one edition of the Webcomics Weekly podcast. I feel that, if dialogue is tight and lively enough, it can almost supplant a whiz-bang punchline in the last panel. But I do agree that every strip (especially ones with only three and four panels) should stay on topic and on target, gearing up for a twist in the final frame.

BGUIGAR@yahoo.com

www.evil-comic.com

Framework: Wordplay

This is similar to a pun. In this case, often the order of the words in a familiar phrase, idiom or cliché is switched around. For example, in "Evil Inc," there's a charitable organization run by villains called the "Divided Way." They have a motto, "Hurt 'til it gives," which is a play on the familiar cliché used by charities, "Give 'til it hurts." Worldplay sometimes gets based on rhymes or establishing a rhythm. "You can do more evil if you do it legal" gets much of its humorous charge from its rhyme and rhythm.

— *Brad*

- **Write like you talk.**

Making your writing sound natural and conversational is as simple as writing the way that you speak to your friends and family on a daily basis. Incorporate your own cadence, slang and mannerisms into your writing. Pretend you're saying it aloud to your best friend.

Here's a great trick I've been able to use again and again to make my conversational writing stronger: Start your comic's dialogue "in medias res" (Latin for "in the middle of things"). Pretend that you've just walked in on your characters' conversation which is already in progress, and start writing panel one right there. Not only does it reduce your amount of exposition, it immediately piques the interest of the reader. Right off the bat, your reader is curious to know what's going on!

Right. Rather than writing in panel one, "So I got a phone call. The doctor says I need to come back in for testing," have the reacting character start with "What do you mean the doctor wants you back for more testing?!" See how much more energy that has?

Writing is like any other activity — the more you do, the better you get. You need to exercise your brain — train it to find the drama or the humor in your daily life. Make it a habit. With each joke you write — hilarious or lame — you'll learn more about how

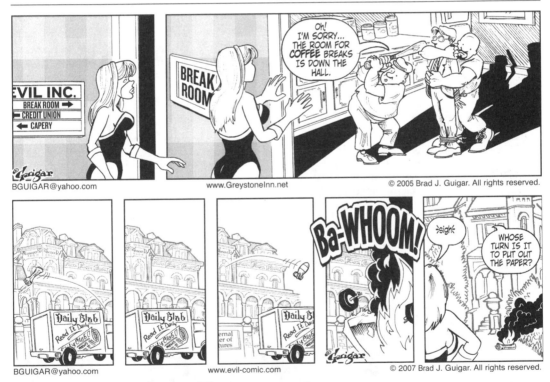

Framework: Something Odd Done Normal

Google Charles Addams. This cartoonist made an entire career out of this technique. His characters, a ghoulish collection of creatures, went about their bizarre behavior in complete deadpan routine. A familiar Christmas card features a group of Christmas carolers joyfully singing at the front door of a mournful mansion. At the top, the haunting homeowners calmly prepare to dump boiling oil on the group.

— *Brad*

humor is constructed. And, yes, you'll learn more from your mistakes than from your successes, so don't sweat the lame ones too much. You'll become a master of nuance — fully appreciating how words have lives of their own. You'll find yourself trying to find the punchlines to routine sentences that float your way. And you'll catch yourself gathering gags like a squirrel collecting nuts for the winter. Some you'll find a use for, and others will be hidden and forgotten — only to take root in your brain and sprout something completely new.

You'll write and write and write some more. And then, after a year or two, you'll look back at your first strips and make a startling discovery: You've become a darned good writer. Heck, you might even think about writing your OWN tutorial about how to write. Yeah! You'll sit down and prepare to pour out everything you've assimilated over your years as a daily webcartoonist.

...And the abyss stares back.

Framework: Fill in the Blank

The charge for the humor comes from the reader filling in a missing part of the story. This can happen two ways. The missing part comes in the middle of the strip and the payoff is the result of that action (as shown above). Or you can set up impending conflict for a character and then present the scene seconds before the action starts. The reader can easily put all of the pieces together and make the action happen in his mind.

Framework: Something Normal Done Odd

This the polar opposite to the framework on the preceeding page. You can mine for humor by presenting a twist on a familiar scene. A superhero, during a visit to an optometrist, might use his X-ray vision to read the eye chart two rooms away.

— *Brad*

Framework: Hyperbole

Exaggeration makes almost any situation funnier. Hyperbole makes for a perfectly adequate gag alone, but I prefer to use it like salt. I think it adds to the flavor of most jokes. "He has a face that could stop a clock" is a funny line. "Not only could his face stop a clock; it could send people five minutes back in time" is even better.

Framework: Understatement

Understatement is the exact opposite of hyperbole. Usually, an extreme situation is summed up in the most pedestrian manner possible. A mad scientist surveys the scene: The lab is in disastrous disarray, and through a jagged hole in the wall, the mad scientist watches as his huge, berserk monster lumbers towards the city leaving ruin in its wake. His assistant looks up and says, "Well, back to the drawing board."

Framework: Easter Eggs

Easter eggs can be a great way to give your readers a little something extra in a strip. They can't really take the place of a good punchline, but they can add a dimension to your work that your steady readers will truly appreciate. An Easter Egg is a small, hidden gag (like the flyers on the bulletin board above) that adds an additional source of humor.

— *Brad*

Web Site Design

So you're getting your Webcomic squared away in these early stages. You've finished about thirty or forty strips, and you have a handle on your characters and your production time. You're feeling pretty confident about the whole thing.

If you were a newspaper cartoonist, all you'd have to do is submit what you had to your editor, wait for your work to appear in the newspaper, and watch the fat syndicate checks roll in!

But you're not a newspaper cartoonist. And you're not under the heel of some cold, indifferent syndicate. You're a Webcartoonist, and your job is only half done. It's part of your job to harness the raw, people-connecting power of the Internet to bring it all home. There's a lot to learn about Website design, but you know what? There's nothing better than making something for yourself — by yourself — then standing back and watching it run like clockwork.

A Few Rules

Web design, like print design, follows a number of straightforward rules. These are things you can count on no matter what the content of the site is, and they're rules you'll find applied again and again. I'm going to assume you know a little HTML, and your way around an editing program like Microsoft FrontPage or Adobe Dreamweaver. Let's go!

- **There are two top attention-getters on a Web page.** The first is the top left-hand corner — usually this is where you'll see the site logo or title image. The second place is dead center, no scrolling up or down. The human eye and brain have conspired to make these two places the most important, so how can you take advantage of this? For starters, you can put your title or logo in the top left-hand corner, and your comic as near dead-center as you can.

Here's Scott's front page for "PvP." As you can see, he's following the rule perfectly -- top-left is reserved for his Webcomic's logo, and high on the page at dead center is the day's comic strip.

- **Fewer clicks means more reader retention.** This is proven by Internet marketing studies. Any time you make it necessary to make an additional mouse-click to get somewhere, you lose a sizeable percentage of your audience. In fact, any time there's an interaction on a Web site, the more steps it takes, the fewer people will bother to do it.

Every click is an opportunity for the visitor to ask themselves, "How badly do I want to keep reading?"

Let's say you have an archive system in which, somewhere near your strip, there's only one button that says "Archive." When the user clicks this link, they get taken to an archive page where you list every single strip by date and title. To read a previous strip, the user has to go to this archive page, and click a link to a strip. And after he's read that strip, he has to click "Archive" to return to the archive page to select another one. Now realize: the user is spending 50% of his time reading comics, and 50% of it navigating to comics. That's a terrible return on their time investment!

Now let's say your archive system has arrows above and below the strip: First, Previous, Next, Last. The user can navigate the comics without leaving sight of a comic. 100% of their time is spent with your site's content in view, and it's a much more rewarding browsing experience for them.

I like to see comic-archive navigation arrows below the comic. Above and below is fine, too. But those arrows need to be as close to the comic as possible. Navigation arrows on the sides always leaves me cold.

I agree about arrow on the sides, but if you've got a tall format strip (like a full-page), consider putting navigation arrows both above and below the comic itself. The arrows on the bottom are for people who've read the strip, and the arrows above are for people browsing for a strip in particular, who already know this isn't the one they want (so why make them scroll down to move backward or forward?).

True. I hadn't considered vertical comics — in which navigations buttons are better on the sides. Also, if you're not using standard iconography for these arrows (single arrow, pointing right for "Play;" double arrow pointing right for "Forward;" double arrow pointing left for "First strip;" and single arrow pointing left for "Preceding") then you need labels so people can easily interpret them.

• Vary content to keep visitors around for longer. Providing ways for your readers to spend more time on your site browsing is a great way to build retention and up your sales when the time comes to open a store. The simplest way to do this is with a blog. Keeping a blog or journal below your strip lets readers keep up with news, announcements, or fun stuff you post for them a few times a week. The more often you blog, the better your results will be. So remember to leave space in your design for it!

Function Over Form

In browsing your favorite Webcomics, you may be looking at their site designs to see if there are any concepts you'd want to use for your own. And you may have noticed by now that most Webcomics share a certain amount of functionality.

The comic is usually front and center. You can count on navigation arrows near the comic image. There's usually a banner ad above the strip, and maybe a tower ad down one side. And there are links to an "About" page, the store, an archive calendar, and there may even be a convenient storyline dropdown field to help you find one of your favorite story arcs. Why all the similarity among vastly different comics by very different creators?

Why? Because it works. It works, and it's been adopted by the majority. Ask yourself if that gaudy interface you've been dreaming up will help a visitor's reading experience — or if it will just get in his way. There are some truly inventive, creative, and flat-out insane site designs out there — after all, there is room for infinite variation on the Web,

and there will always be room for improvement — but give me navigation arrows any day. If I don't already know how to navigate a Web site when I get there, I'm probably not going to invest the time to learn.

Neither will most people. Keep it simple, and keep it clear.

In newspaper design, we have a phrase: "above the fold." It described the newspaper's front page when folded over to fit into an honor box. All of the day's most important news had to be "above the fold" so people could see it as the newspaper sat in the box — with the intention of selling more papers.

Web site design has to take "above the fold" into account, too. Although, in this case, the term might be changed to "above the scroll." Your Web site should be designed in such a way that all of your most important content should be seen by the reader without having to scrolling down.

Of course, everyone's monitor is set to a different aspect ratio, so you'll need to follow your Web stats on this and try to play to the majority, but in general, I still try to keep the antiquated 800x600 pixel ratio in mind.

800x600?? Brad, are you tailoring your design for the grandmother surfing the web on her 1989 Tandy computer? Personally, I'd shoot for 1024 x 768 as the new minimum.

The comic should be dominant, and the top of your blog should be above the scroll. Any other updated content needs to appear up here, too. If these things are not appearing, you need to rethink your design. That might mean smaller logos and icons — or it might mean a complete site overhaul.

If you've got a web site that's 900 pixels wide and someone with an 800-pixel-wide resolution visits, they'll get a horizontal scroll bar in their browser. This is commonly called "H-scroll" and is frowned upon in web design; it's kinda ugly and inconvenient. But it's true that everything is headed towards larger and larger resolutions. You'd be hard-pressed to find a monitor that defaulted to even 1024x768.

Restricting the Reader

HTML is used for the meat of the majority of pages on the Internet, and it follows a set of rules users are comfortable with. There are other means of displaying text and images and handling how the browser works with them – Adobe/Macromedia Flash is one, and Javascript another. On an HTML page, users can right-click (or Apple-click) on an image, and save it to their computer. Some Web sites try to restrict this by using Javascript that catches a right-click and presents a "for shame" dialog box. You can even keep the user from directly loading an image at all if you load it into a Flash viewer for the user to peek through.

I urge you, in your design, not to get restriction-happy like this, because I already know two instant workarounds: View Page Source and Print Screen. As is the case with copy protection on computer games, the protection technology doesn't stop the thief, and it annoys and wastes the time of good-faith users.

Flash viewers can make even high-resolution images look grainy and pixelated, and they don't let users save which page they're on without extra programming. And if you're worried about someone saving your comic strip to their computer and posting it elsewhere, put your URL in the corner. You'll probably see some traffic out of it.

— *Kris*

Both "Starslip Crisis'" and "PvP's" Web sites are between 900 and 1,000 pixels wide. As long as you stay between those widths, you should be fine. It'll be a little while yet before everyone's running 3,000-pixel-wide screens. (Maybe two, three weeks from the time of this writing.)

Advertising Spaces

What do you choose to put on your Web site, and where? You're going to need a place for your strip, of course. Your title or logo, that's for sure. Navigation arrows close to the strip itself, and probably a blog beneath it all.

But don't forget to make room for that potentially important revenue stream, your advertising banners! It's a sad feeling when you look at your beautiful new site design, then end up smacking your forehead because you forgot to leave room for a leaderboard at the top and a tower ad down one side.

In case you were wondering, ad banners on the Internet are standardized. Here are the most common sizes, given in pixel dimensions (width first, then height).

• **468 x 60, or Banner.** This little guy has been around the Internet for ages. It was a big standard in years gone by, but with the advent of bigger and bigger screen resolutions, it's looking a little small these days. So ads have made way for the...

• **728 x 90, or Leaderboard.** This is a wide banner that's best suited to sitting at the very top of your site, in a prominent position like directly above your comic strip. It's the ad image that will grab the most eyes, so chances are you'll see your best performance from your leaderboard.

• **120 x 600 and 160 x 600, or Towers.** These are tall, skinny ads that take

Caught in the Flash Point

Adobe Flash (formerly Macromedia Flash) is an incredible vector program that can add animation, sound and interactivity to any Web site. On a Web page, the Flash player can vary in size from a tiny button to the entire screen. With it, you can develop almost any interface you can imagine, unchained by the stricter rules of HTML.

Unfortunately, all that freedom makes it easier to make a bad Web page. Flash doesn't follow the same caching rules as HTML, and this becomes a problem in two ways:

• It's possible for the user to navigate deep into some all-Flash menu system on a single Web page, then navigate to another page completely. If this was HTML and they hit the Back button, they'd be back where they left off. But since Flash doesn't have a built-in history of where the user went, they'll get dumped out at the beginning again and have to find their way back. Very annoying.

• Equally annoying is the Flash splash page. A splash page is any page that appears when you first arrive at a Web site. It's usually very show-offy with sound and lots of fancy-looking moving parts to hype up the site the visitor is about to see. But Flash doesn't remember if they've watched the splash page before. So every time the reader visits that site, they have to sit through the splash page again. If they're lucky, the Flash animation will have a button that says "Skip Intro," but having to click this to continue is just another obstacle.

• The same problem shows up with loading screens. In Flash, if the animation size is large, you can have the user wait through a loading screen until it's ready to play. But that loading screen has to cycle through each time the user hits the page, even if the Flash file is already loaded! If you're making your reader sit through a loading progress bar to use simple site navigation, you're going to lose them.

It is possible to program an internal history in Flash, but you need to know how to set a Flash cookie in ActionScript, Flash's internal language.

Flash can punch up a site visually, but for large-scale site design and navigation, stick with HTML.

— *Kris*

advantage of the vertical space you'd find on pages that require a lot of scrolling up and down. Towers are best placed left and/or right of your blog, below your strip, but I can see a scenario where it'd be cool to put one beside your strip, if it was a full-page.

• **Buttons.** There isn't really a standard button size yet, but I've had a lot of luck with these ad units. They're usually about 150 x 50 in size, and what I've done is place ten of these on my site, and charge $15 to $20 for 30 days of advertising.

While you may not have a lot of ad revenue at the beginning of your Webcomic, you'll probably want to have them in the design to make things easier down the road. Project Wonderful at www.projectwonderful.com has done very well with its ad auctioneering of all size advertisements and buttons.

Hosting

Around the year 2000, before the dot-com bubble burst, hosting your work was an expensive proposition. You could expect to pay upwards of $30 a month to put a modest-sized site on the Internet, $70 for domain name registration, and don't ask what they'd make you pay if you exceeded your bandwidth limit for the month.

Nowadays, a domain name costs less than $10, and you can get reasonable hosting for about the same. Bandwidth overage is still a pain, but it's not anywhere near the sticker-shock carnival of days gone by.

Let's look at some of the terms that get thrown around when talking about hosting.

Disk space. This is the amount of space the host is offering you for file storage. Your comics can't be seen by readers unless they're on the server, and comics take up space. You'd be safe with 1 GB for a long while, but if you're worried, buy more. Disk space is ridiculously cheap nowadays, and it's not the limiting factor in hosting.

Bandwidth. Bandwidth (or transfer) refers to the amount of data that gets served by your site in a certain amount of time, usually one month. A site with very few visitors doesn't use up much bandwidth, but one with hundreds of thousands of visitors uses up a lot. Bandwidth used to be costly, but at the time of this writing, my host was offering 5 terabytes (abbreviated TB, about 5,000 gigabytes) of monthly transfer for $6 a month.

But how much bandwidth will you need? It's dependent on the file size of your comics, how many blog entries you have, whether or not there's sound and video on your site, and other factors. But you'll be decently covered if you're just starting out with 50 to 100 gigabytes (GB).

Things have gotten better since the early days of Webcomics as far as transfer goes. I did a video parody of the Apple "Switch" ads once. Remember those? Someone stands in front of a white backdrop and talks about how great their new Mac is? Penny Arcade linked to it, and — as you can guess — a lot of people tried to download a large video file at the same time. I went over my bandwidth limit for the month in one day. And the overage charge was something like $10 for one gigabyte. For making something a lot of people liked, I was billed $120. It's much less likely to happen today, but you should still be aware of your host's policy on overages. (By the way, I wasn't forced to pay the $120 to keep my site up — the other option was to let my host shut my site down until the end of the month, when my bandwidth was replenished again.)

Shared and dedicated hosting. Web-site hosting falls into these two classes. Shared hosting is much cheaper — it means that a (usually large) number of Web sites share a single server's resources. Just because you're sharing doesn't mean you don't have a lot to yourself, though: I'm currently paying around $20 a month for 500 gigabytes of

disk space! (Right now all my sites take up only 10 GB!)

The biggest issue with shared hosting is sharing the server's CPU (or processor) with all the other hosted sites. Very occasionally, I'll install a script that requires a lot of processor overhead, and my host will contact me asking that I remove it or modify it so it doesn't use up so much CPU time. On shared hosting, if someone's hogging the server's CPU, everyone's scripts run at a snail's pace. But that's relatively uncommon, depending on the host. It's happened to me twice in eight years.

Dedicated hosting is much more serious. You're paying for the entire server, all to yourself. This also gives you near-total control over how your server is managed, what script languages it supports, and best of all, all the bandwidth and processor time belongs to your site alone. However, you can probably expect to pay between $300 and $600 a month for all that luxury and customization. And unless you know UNIX or NT server, you might even need to hire a server administrator! Chances are, you won't need to worry about dedicated hosting for your Webcomic for a long time, if ever.

Archive Scripts

Things change quickly on the Internet, so it's hard to write a guide to archive management for your Webcomic without it becoming outdated. If you're reading this in holocube format from your iPhone Neuro, you can skip to the next section.

Pity Kris for even having to write this chapter. The shelf-life for any technology-specific advice is about 6-12 months. By the time you get this book home, the singularity will have happened.

I have a background in software development, and one of the first things I did was put together my own archive management system. I've looked at a lot of scripts in the last eight years, so while programming your own is an option, there are enough free ones out there that you shouldn't have to. And remember, don't get overwhelmed! A lot of this stuff is straightforward. Sometimes you just have to ask the right people for help. I'll be as non-technical as I can.

For all of these scripts, you'll need to have a little familiarity with installing either Perl or PHP scripts. Perl and PHP are two programming languages commonly used to write scripts for the Web. Most hosts allow both of these kinds of scripts to run on their servers, but, if in doubt, ask tech support about what versions of Perl and PHP they support. I'll get a little into installing scripts later in this chapter.

Dynamic vs. Static Pages

Let me explain a distinction between a lot of different archive scripts: Some display

Unmetered Bandwidth

Some hosting companies offer what they call "unmetered bandwidth," which sounds like "unlimited bandwidth," but it isn't.

All it means is that the upper boundary on the bandwidth you can use every month is fuzzy (called a "soft limit").

The hosting company will start to get anxious if you're consistently over that soft limit, and after a few months they'll write you to say that you have to figure something else out for your hosting. Hosts that offer unmetered bandwidth usually explain what that exactly means on their sign-up pages, so be informed!

I'd rather have a hard limit I'm certain about than risk overstepping some unknown line. Unmetered bandwidth isn't really that much cheaper than metered anyway!

— *Kris*

the pages with your comic on them *dynamically,* and others generate those same pages *statically.*

A script that generates pages dynamically has to run every time a reader looks at one of your comic pages. Typically, the script keeps track of a directory with all your comic image files and their associated update dates, and a page template that you give it to show how you want all the comic pages to look. When a user hits your site to look at a comic page in your archive, the script grabs the comic from the requested date, plugs it into the page template, and returns it to the user's browser. So it runs all the time.

The good thing about dynamic page generation is that, if you change your page template (maybe to update the look of your site), it immediately gets applied to your entire archive. This kind of dynamic generation can occasionally require a lot of overhead on your server (WordPress and Drupal, for example, can sometimes be pretty resource-heavy).

This isn't bad in and of itself, but personally I get a little paranoid that something will go wrong with my host's Perl or PHP installations - something I have no control over. If those are down for any reason, then no one can see your comics.

Static page generation does the same thing as dynamic, except it only runs once per day, rather than whenever a reader hits your site. During that single run, the pages are all generated and saved to your server as HTML files. HTML gets served to users whether or not Perl or PHP are running, so even if Perl and/or PHP are down, visitors can still read your comics. On the downside, if you want to change your page template, you'll have to run your static script and do a total site update, which can take a few minutes, depending on how many strips there are.

While I'd rather be safe and know that my comic archives are saved as HTML directly on the server, rather than being generated on the fly, take my paranoia with a giant bag of salt — it's extremely rare that Perl/PHP interpreters go down. Zillions of blogs use dynamic pages every hour of every day with no trouble! Static scripts are actually a lot harder to come by, so your best bet is a dynamic script.

Script Features to Watch For

When looking for a script to use, or even a hosting service for your Webcomic (I'll talk about them at the end of this chapter), you'll want to be aware of the following features.

- **RSS.** RSS stands for Really Simple Syndication, and it is really simple. When your site updates, either part or all of the contents of that update gets written to a specially formatted text file on your site. This is called an RSS feed, and it can contain your last ten comic strips, your last couple blog entries, and so on.

 Visitors can subscribe to this RSS feed using either their browser or an "aggregator," which checks every so often to see if the feed was updated. So a reader doesn't even have to check your site to see if it was updated. Some cartoonists frown on this, since the readers don't have to visit your site, don't see ads, and might miss out on merchandise announcements. To me, it's all about building a ritual for the reader, so anything that gets them to read my strip consistently is a good thing.

- **Mailing lists.** Most scripts won't let you manage a mailing list, but it might be something you want to include in your design.

For example, I use Dada Mail, a web-based e-mail list management system, to send out a monthly newsletter to readers who have expressed interest. Dada Mail runs on any hosting account that can execute custom CGI scripts, and will handle all your signup, opt-in/opt-out options, and will make sure your newsletter conforms to all the main e-mail formats (i.e., plays well with Hotmail, Yahoo mail, G-mail, and POP accounts).

• **Blogging.** Discussing the nuts and bolts of integrating a blog into your Webcomic would require another chapter to go through all the options. There are literally dozens of ways to do it, from server-side includes to script-driven solutions to using a LiveJournal account as your Web site.

I'll assume you'd rather not do that last one (as it can be good for a sketch journal, but a little amateurish for a Webcomic site), so I will mention two to help you out. WordPress (www.wordpress.com) is excellent blogging software that there's been Webcomic development for (I'll mention it in the next section), and Blogger.com is free and lets you manage a blog on your own site without installing anything. I've used Blogger.com for years at many of my Webcomic sites.

A By-No-Means-Comprehensive List of Archive Scripts

Hey, who likes long chapters with no images and just reams and reams of sprawling text? I sure do! Rub your eyes, get a cup of coffee. Slap yourself once or twice. Take a couple cleansing breaths and get ready for another bulleted list!

Like Dave said before, technology moves fast. Luckily Webcomic archive scripts haven't moved quite as fast as the rest of the Internet. I've had my eye on a number of these programs for a few years now, so chances are you'll have your pick of them even if you're reading this in the far-flung future year of 2009.

That's the year the 1992 movie "Freejack" happened in, starring Emilio Estevez and Mick Jagger.

• **Autokeen Lite.** *Language:* Perl. *Page type:* Dynamic. *Cost:* Free. *Difficulty:* Easy. A stripped version of Webcomic collective Keenspot's archiving system, Autokeen Lite is a little workhorse. I used Autokeen for the first four years of "Checkerboard Nightmare" with no difficulty, and the template/tag system is pretty intuitive. You can find it at www.keenspot.com/downloads.

• **WordPress.** *Language:* PHP. *Page type:* Dynamic. *Cost:* Free. *Difficulty:* Moderate. WordPress isn't Webcomic software, it's blog software — but if you post a comic every day instead of a rant about losing your girlfriend, you've solved your archive management problem! WordPress is a wonderful script for blogs, and it is well-supported and maintained by a huge community of bloggers.

The script does a lot — from archiving to calendar generation to RSS-feed generation — which is great for giving your readers a way to follow happenings your site. And anything that WordPress doesn't do, you can probably find a free plug-in someone wrote to do it. Grab it at www.wordpress.com.

Webcartoonist Tyler Martin of Mindfaucet.com created a theme for WordPress called ComicPress, in version 2.0 at the time of this writing. ComicPress formats your WordPress blog to behave more like a Webcomic site than a blog that happens to have comics in it. Recently Scott switched to using ComicPress with WordPress, and it really impressed me - enough to where I'm considering switching my comics to use it!

- **Drupal.** *Language:* PHP. *Page type:* Dynamic. Cost: Free. *Difficulty:* Moderate to Hard. Drupal is similar to WordPress, except it's intended as more of a total blog community solution, with support for multiple users and many different content categories (inexplicably termed "taxonomies" in the Drupal world). Look it over at www.drupal.org.

Personally, I think it's a little too complex and undersupported to be useful as a good Webcomic archive manager. If you're looking in this direction, try WordPress and ComicPress first.

- **TextPattern.** *Language:* PHP. *Page type:* Dynamic. *Cost:* Free. *Difficulty:* Moderate. I'm including TextPattern (www.textpattern.com) for completeness' sake. I saw a couple examples of it, and while it's simpler than Drupal, it's overly complex for the task at hand. It'll build a killer blog site, but it's just not geared for the special design concerns for a Webcomic site.

- **ATP Autosite.** *Language:* PHP. *Page type:* Dynamic. *Cost:* Free. *Difficulty:* Easy to Moderate. Autosite is another update script, albeit one I have little experience with. But John Allison's strip Scary Go Round (www.scarygoround.com) uses it, if that helps! It's at www.atp.cx/?a=downloads.

Domain Names

So you have some web hosting and even a script to install. You need one more thing to get your Webcomic up: a domain. Your domain name is crucial for the visibility of your Webcomic. Without one, well, your site won't be on the Internet. But without a one that's easy to remember, your site might end up lost on the Internet.

For the uninitiated, domain names start with *www.*, have a unique string made up of letters, numbers and hyphens (like *starslipcrisis*), and end with a domain extension like *.com*, *.org*, or *.net*. You have to register names with companies called domain registrars, and the registration fee can vary anywhere from a few bucks to thousands of dollars. (Don't panic — a brand-new domain name that you invent will run you a few bucks. No need to buy a pre-existing one!)

Your domain name is the handle to your Webcomic. It's a name you'll be including on your flyers, any advertising you buy, in your e-mail signature, and in your pitch at conventions. It's kind of a big deal.

Domain names, and who gets them, are managed by companies called domain name registrars. Head over to a registrar and use their domain lookup. Just start entering names to see which ones are available, and which are already taken. Remember: You want a domain name that's **easy to spell, easy to remember,** and **as short as possible.**

Yeah, that's easier said than done. I have spent days laboring over the right names for domains. You don't even want to know how long it took to arrive at "Halfpixel." (Okay, Erica came up with it.) Here are a few tips to point you in the right direction.

If you're playing the Chapter 6 Bulleted List Drinking Game, do another shot.

- **Good domain names are short, catchy, and conjure a mental image.** "Starslip" is probably the strongest one I ever came up with, along with "Halfpixel." Both names have punch, are recognizable and unique, and have a visual aspect to them (stars, pixels). You want everyone who runs across that name to be intrigued, and have it stick in their mind.

But then, "Starslip" fits my strip title, and Halfpixel is just a catchy word. What if you already settled on a strip title that's not as zingy, like "Bear Forest?"

• **Go for the obvious first.** Try bearforest.com, and if that's taken, try bear-forest. com or bearforest.net.

• **Still no luck?** You're online - how about bearforestonline.com? You're a Webcomic, so try bearforestcomics.com, or bearforeststories.com. Heck, try inthebearforest.com, or bearsupatree.com, something related to your strip — something memorable.

For five years, I worked as a senior writer for Mattel Toys, and my main task was naming hundreds of new toys every year. If I can impart one lesson from those years: Create a name with as few syllables as possible. Short = memorable.

Be careful when getting clever with naming — especially spelling. You may find that bearforest.com is taken, but bearforrest.com is available, and that's not far from your preferred domain, right? Well, first, you're misspelling "forest," which most other people won't remember to do, and your pitch will sound like this: "Visit Bear Forest at bearforest.com, except put two Rs in 'forest.'" That's clunky and no one will remember to do that — they'll go home, try bearforest.com, end up somewhere else, and forget about it.

Or worse, you'll end up spelling out the entire domain name for everyone. Over and over again. All the time.

Hyphens are allowed, but use them sparingly — they're also easy for readers to forget to include. Brad's strip, "Evil Inc," is at evil-comic.com, which he speaks aloud as "evil hyphen comic dot com."

Ideally, when you speak your domain name, there shouldn't be any question in the listener's mind as how to spell it. (In our example, it's hard not to know how to spell "bearforestcomics.com," but if your Webcomic was called "Totally Bear," you might end up with people mistakenly going to totallybare.com. Oops.)

Yes, we'll wait while you race to the computer to look up totallybare.com. It's a compulsion, isn't it?

The authors of this book are not responsible for the contents of the Website totallybare.com, which may or may not exist at the time of this printing. To learn more, visit your local library or ask a trusted adult.

Anyway, let's talk about different domain extensions for a second. The extension .com is the most common, so if you can grab a dot-com, do it - but there are other options. There's absolutely no functional difference between the extensions. (There

Registrars

How domains work can be confusing, but don't get confused about how much to pay for domain registration. In this day and age, if a domain registrar wants more than $10 to register your domain name for one year, go with someone else.

I discovered GoDaddy.com a few years ago, and I've been very satisfied. Dot-com domains hover around $7.95 for one year of registration.

Registrars offer all kinds of add-ons and extras, but don't bother. Back in 1999, when I first registered nightlightpress.com, Network Solutions wanted $35. And today, they still want $20, and there's absolutely no difference in service between them and many other cheaper registrars.

— Kris

was supposed to be, once, but no one ever bothered enforcing it.) Hip new domain extensions are showing up like .us.com, .info, .biz and .tv. They tend to be a little pricier ($25-35 each), but if you've got to have bearforest.*something*, you could do it.

> Something else you might want to check out is other domains that are one character off from yours.
>
> You might find that readers looking for your site could end up somewhere they DON'T like if they make a typo. I know that the Penny Arcade guys have warned me not to forget the hyphen in their domain name (www.penny-arcade.com) because the other version leads to something ENTIRELY different altogether.

Personally I only like domains that doesn't have .com at the end, because ".com" is so strongly associated with the Internet. Sure, .net and .org are in the big three, but your reader will have to perform a mental check at first: "Was that .com, or .net?"

> I'll be honest: I'm that person. Anytime a URL ends with .net or .org, I type it incorrectly on my first try. If you can, go with a dot-com.

Something to remember: Domain registrations expire! When you grab bearforestcomics.net for $8.95, that only gets you one year of registration. That's one year of having that domain point at your host server.

When that year is up, that domain goes to the highest bidder, and suddenly your readers can't find you anymore! It's a Webcartoonist's worst nightmare.

Good registrars will send you warnings before your domain expires, so you know when to put more coins in the meter. I usually buy two years at the same time, but when the time limit starts drawing closer, **don't forget to re-register.** Even the most obscure domain names get bought up by spammers when they expire, and that means you'll *never* get your old name back if you lose it.

Take heart. If you re-register on time, no one can take it away from you.

Hosting Your Webcomic, Step By Step

I'm proud of you, soldier. We've covered a lot of high-level topics, and you have a good basic understanding of what's necessary to get a site on the Internet. But rather than let you fend for yourself, I'm going to go the extra ten miles and distill the steps of hosting a Webcomic into one all-powerful Bulleted List. If you're still playing the drinking game, have a friend drive you to the hospital.

1. Draw your Webcomic, create your site design. This is best gotten out of the way before embarking on the steps of buying hosting and finding an archive script to install. It's the core of your Webcomic: your content.

2. Find a host. If you're not sure where to start, search for hosting review sites on the Web, or ask some Webcartoonists where they're hosted. (I'll save you the trouble of asking me - I've been at Dreamhost.com for about four years, and they've been wonderful. I recommend them wholeheartedly, but there are cheaper options out there for a first-run Webcomic.)

3. Get a domain name. At most registrars, around $10 will get you one year of domain registration. You'll also get a login and password so you can manage your domain name. Remember this for Step 4!

Some hosts will handle the domain registration for you - if yours does, you can skip

There are a lot of ways to embed sound and video on a Web site, but remember the following:

1. Make the sound player obvious and easy to find, in case the visitor wants to stop the playback.

2. Make sure the sound player actually has a Stop button, so the visitor actually has the option to stop it.

3. Make sure the sound player isn't set to "autoplay," which means it immediately plays by itself once the page is loaded.

4. Don't embed sound on a web page.

Adding unwanted video and sounds (especially music) to a web page turns a visit to your comic strip into an intrusive, jarring experience for readers — many of whom may be visiting your site from work and will not appreciate being "outed" by loud music. Keep things simple, and let your readers choose what they want to listen to while browsing your site.

— *Kris*

Step 4, but I recommend reading it for a deeper understanding of what's going on.

4. Here comes the tricky part, but it's not that tricky once you get the big picture. You've got a domain name, and you've got a hosting server. But they're unrelated for now, totally separate from each other. How do you connect one to the other? Well, let's discuss how the Internet works for a moment.

The Internet is made up of different servers. These servers all interconnect in different ways, and exchange information in different ways. In order to find each other, the servers are each assigned a unique Internet Protocol address — or "IP address." IP addresses are four numbers separated by periods - Google's IP address is 216.239.51.99, for example. If you enter that into your browser instead of the domain name, you will get to Google.com.

But it's not easy for humans to remember a string of numbers. Domain names act as mnemonic devices for those ugly IP addresses. Somewhere on the Internet, on a Domain Name System server, or DNS server, there is a special entry that says "if anyone asks for Google.com, send them to 216.239.51.99." Whenever you use the Internet and enter a domain name, your service provider asks one of these DNS servers what the IP address for that domain is. When you type "google.com" into your browser, the DNS server secretly tells your browser to visit that IP address, and you don't have to deal with the numbers.

So! To get your Webcomic about grizzly bears visible from bearforestcomics.com, we have to tell a DNS server where to point. When you sign up with a host, they'll ask what domain name you want associated with your account. Once you provide it, your host will give you a list of two or three nameservers. Usually, they look something like *ns1.myhost.com* and *ns2.myhost.com*.

You take these nameservers, and you log into your registrar (from Step 3). There will be an option in their menu to change your domain's nameservers. Find it, and provide your registrar with those nameservers you got from your host.

Once saved at your registrar, the new nameserver information has to get bounced around to every DNS server on Earth, so they'll all know that "bearforestcomics.com is at 11.22.33.44." This takes anywhere from 36 to 72 hours. During that time, if you enter your domain name in your browser, you may or may not get to your host. But once a day or two has passed, you should be able to see your site at your domain name, and so should everyone else.

Your site is properly hosted now!

5. Now that your site is hooked up with its domain name, you can begin installing scripts. I can't walk you through the whole process (nor do I need to; most scripts have thorough

installation instructions), but I can give you two things to check if you're getting the dreaded "500 Internal Server Error" error.

• **Check your script's permissions first.** Web servers keep track of "permissions" for each file, that say who's allowed to read the file, who's allowed to write to the file, and who's allowed to execute — or run — the file (if it's a script or program). The permissions system uses some low-level binary to work, but you don't need to worry about that. Your FTP client will probably display permissions for a given file in easy-to-understand checkboxes. Make sure your script has permission to execute for everyone, and check the Execute permissions for User, Group, and World.

• **If that doesn't help, it's time to look at your server's error logs.** You'll have to ask your hosting company where to find them. Inside your error.log is every error your site ever generated, including the ones you just encountered. Sometimes the errors are useful, like "missing semicolon on line 32." Other times the error is "Premature end of script headers," which isn't helpful at all. Whole books have been written about this topic, so I'll stop while I'm ahead. Talk to your server admin or visit the tech support forum for the script you're working with.

Alternatives to Hosting a Webcomic Yourself

All right. I knew it — I scared you off. You took one look at all that and got paranoid that you'd mess it up and break the Internet. Well, I know for a fact you're wrong, but I'll play along. Maybe you're not ready for the big leagues. I'm a little disappointed, but Rome wasn't built in a day.

While being a Webcartoonist requires some knowledge of the Web, you don't have to know all the ins and outs of servers and registrars and IP addresses. Dave disappoints me daily with his lack of Internet ability, but what can you do? Look at that guy! That scamp! *He's a little widdle Mr. Webcartoonist, yes he is!*

...

There are both free and pay Webcomics hosting services. These outfits will host your comic, provide you with an archive system, a calendar and occasionally even a blog.

The downside is that you often don't get to use your own domain name (except as a forward, meaning you can set your domain to bounce a visitor to your comic's page elsewhere), and the site design usually isn't very customizable. Plus, the host gets to run their ads across your site in exchange for hosting it. Still, if your goal is to get your work up and visible with as little technical know-how as possible, here are some options.

• **Comic Genesis (www.comicgenesis.com).** Formerly "KeenSpace," this free hosting service is run by Keenspot.com. It uses Keenspot's archive system, which is pretty intuitive, and

you do have near-complete control over your site design. Not a bad deal for the novice, and many, many novice webcomics are hosted there, numbering in the thousands.

• **Drunk Duck (www.drunkduck.com).** Drunk Duck used to be an independent hosting service, until it was purchased by Platinum Studios in their bid to gain a foothold in the Webcomics scene. Drunk Duck is a lot more community driven, with voting and comics rankings built in. Hosting is free, and the main page provides news and comic spotlights to popular or breakout new Webcomics.

• **Smack Jeeves (www.smackjeeves.com).** Another relatively long-standing, if off-the-beaten-path free host, boasting more than 10,000 comics hosted.

• **Webcomics Nation (www.webcomicsnation.com).** Intended as a bridge between the beginning Webcartoonist's need for hosting and the more upwardly-mobile Webcartoonist who needs features like RSS and "tooncasting," Webcomics Nation has a free tier and a pay tier with more services. The pay tier is $9.95 a month, and the free one is, well, free.

Congratulations! You've made it through probably the least fun chapter to read, and I'm willing to bet the least fun chapter to write. Come to think of it, all my chapters are the most technical and the least entertaining. I guess that's what I get for being the smart one!

I thought I was the smart one. I must be the good-looking one.

Hold up there, hot pants. We clearly established in Chapter Three that I was the good-looking one.

Hold on, guys. I think we're all smart, good-looking and full of can-do attitude with our hearts as full as a *baby's wish on a butterfly's sigh.*

Secondary Pages

There are 6 secondary pages that should be presented prominently near the top of your Webcomic's home page: Cast, About, Contact, Forum, Store and Links.

Cast: This is a page devoted to introducing the cast of characters who are major players in your strip. Include an illustration of each and a short paragraph that describes their personality.

About: This can be combined with the Cast page. It talks briefly about the central concept that drives the comic.

Contact: This can link directly to your e-mail address or it can link to a page through which a person can send a message.

Forum: This is not so much a page as it is an entire sub-site through which your readers post discussions on your work and related (and often unrelated) topics.

Store: A page where all of your merchandise is gathered and described. People should be able to buy your merchandise directly from this page.

Links: This page is a list of links to other Web sites. This is a nice tool to have at your disposal when you are offering a link exchange with another comic. Just be sure to mention that the link will not be going on the main site (or will be moved from the main site to the Links page after a certain amount of time).

— Brad

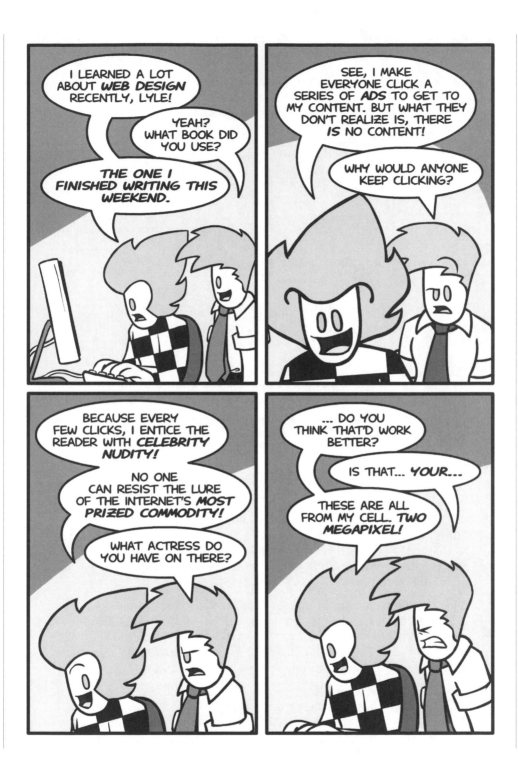

In The Hot Seat...

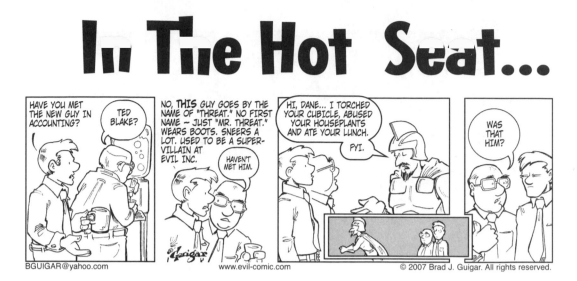

HAVE YOU MET THE NEW GUY IN ACCOUNTING?

TED BLAKE?

NO, **THIS** GUY GOES BY THE NAME OF "THREAT." NO FIRST NAME — JUST "MR. THREAT." WEARS BOOTS. SNEERS A LOT. USED TO BE A SUPER-VILLAIN AT EVIL INC.

HAVEN'T MET HIM.

HI, DANE... I TORCHED YOUR CUBICLE, ABUSED YOUR HOUSEPLANTS AND ATE YOUR LUNCH.

FYI.

WAS THAT HIM?

I like trying to use the typical four-panel, newspaper-comic-strip area in as many different ways as possible. I think this one works very well in doing all of those things. Plus, I *hate* when people use "FYI" in a sentence.

Ha! And "abused" your houseplants! What a great word choice. Not "ruined" or "broke"..."abused"! The right diction can make or break a strip, and a word choice like "abused" makes it all the better.

The little panel is so necessary. We need to see Mr. Threat striding off. It also spares us from having to see Mr. Threat's codpiece.

Brad's the master of the tucked-away fifth panel. This is going to sound so lame, but I actually would've gone with a different hand pose in panel three. The "FYI" use, which is so brilliant, feels like it needs a different pose than a palm-up hand.

I don't like the way that the guy in the last panel is squinting his eyes in disgust. I feel like it's too vaudevillian. Brad, I don't think you need that to reinforce the joke. It would have been better if he had been still staring off at Threat, eyes open.

As far as the pose and the vaudevillian squint to bring the joke home, I don't mind either. I think arms crossed and an omnipotent glower would have worked better, but this strip is Brad's humor. And I like that I can identify those elements in his work, and that I can come back tomorrow and get another one I like the same way.

I like the composition of the second. open panel here. Leaving co-worker one's dialog outside a bubble really works. Co-worker two's bubble jumps out more because of it. I would have had trouble making all that fit and look at nice. I also like how one of the guys has his back to us in panel one. Showing some characters from behind really draws a reader in.

It's good that the characters are doing something while they set the joke up. In so many other Webcomics, the two characters are just standing there looking at each other while they stiffly lay down the foundation for panel four. Having them go about their business is a great way to combat that kind of dullness, and it also conceals the direction of the joke so it has more impact when it does arrive.

...Brad Guigar

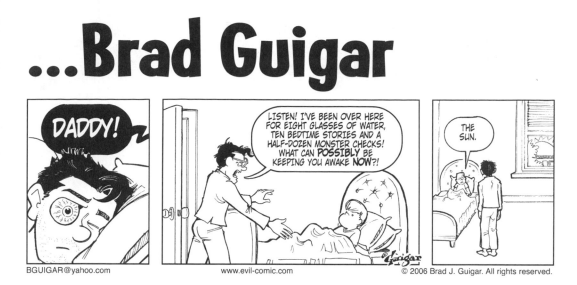

BGUIGAR@yahoo.com www.evil-comic.com © 2006 Brad J. Guigar. All rights reserved.

When he was about three, my oldest son had a particularly bad bout with night terrors. Night after night, he would wake up in the middle of the night, calling for my wife and I. Obviously, the nightmares were bad, but it was also one of those moments as a father that you cherish. It's the closest a guy like me gets to being a superhero. As soon as I entered, the fear of monsters and boogey-men disappeared. It's a particular fave of mine — for sentimental reasons.

SCOTT

Your son must have the tidiest room of any three-year-old on the planet. That last panel shows a room that has a bed and a window in it. That kid doesn't even have a lamp — let alone a teddy bear. It was the first thing I noticed about the strip. I love the use of the reverse-colored word bubble in panel one. Black bubble with white text. I've **never** thought to do that but it gives the dialog such weight. I think the last panel would have worked a bit better with a closer shot so that the window could have been bigger. You have bushes and trees and the sun all in that small window and I had a hard time seeing what it as at first.

KRIS

It's a great strip and my favorite panel is the first one with the giant eye. That is the keyframe in an animation where the eye pops open to way bigger than normal for a frame or two, then shrinks to normal size. I agree with Scott about the tiny window. I think it could even be left the same size, if there were some very thin light rays streaming out from the sun and into the bedroom. I was going to suggest adding a curved shadow to the wall in panel two, if only to throw the reader for a moment (I came in wondering why there was no darkness in the bedroom), but I'm not sure that'd work come panel three. Where would the darkness go? The corners? Edges of the bed? And you certainly wouldn't have wanted to draw cast shadows.

DAVE

Interesting. My suggestion would've been to do an over-the-shoulder shot on Captain Heroic — with his shoulder and head seen in silhouette – looking down on Oscar and a large, sun-streaming window It's kinda fun to see how differently we all would've framed this shot.

KRIS

Actually a cast shadow on the floor from Captain Heroic's legs, away from the window, would have worked. It wouldn't show in the second panel, and it would imply "light source" from the window.

Branding & Building

You've developed your comic strip and built up a bit of an archive. You've found your inner voice and you've been working hard on your draftsmanship. It took a week, but you learned the basics of building a Web site and created a simple but pleasing home for your work on the Web…

…and then nobody came.

Unfortunately, you can't just put your Webcomic on the net and hope that people will find it and make you a superstar. You're going to have to do all the work. Word-of-mouth is important, but you have to take an active role in promoting your strip.

Fake It 'Til You Make It

The first two years of "PvP" were awful times. I was working a full-time job and spending nights and weekends working on a comic strip that was going nowhere, losing its audience and losing my interest.

I came to a crossroads where I had to decide what to do. Would I quit "PvP" or would I relaunch the strip and rededicate myself to it?

Luckily I chose the latter, and I took on a new outlook towards my success: I'm going to fake it until I make it. I want to be a successful cartoonist who loves what he does and makes a living doing it. I'm not there yet, but I'm going to present myself as if I am.

That meant upping my standards of production and presentation. My daily work had to always be my best work, I had to maintain a regular schedule and when I addressed my audience, I would always do so positively and professionally.

Suddenly, I found that people took "PvP" more seriously. They appreciated the strip being on time and seven days a week. They got excited with me as I posted about new projects and appearances. I had successfully re-branded my image with my readership.

And it paid off for me.

Nobody is going to make this happen for you. You're either going to lift yourself up by your own bootstraps or cartooning will remain a part-time hobby of yours. Putting your work on the Net and hoping that people care about it will not be enough.

If I sound like I'm being a little harsh, it's only because I understand the problem creative people face when it's time to promote their own work. I know that sometimes it's hard to sell your stuff. It's sure easier to let the work speak for itself. But until you can hire a business-minded individual to promote and market your work for you, it's *your* job. And you *have* to take it seriously.

Creative Life

The creative person is both; more primitive and more cultivated, more destructive, a lot madder and a lot saner, than the average person.

— *Frank Barron*

Don't Apologize

Never apologize for making as much of a living as possible from your art. If you wanted to be a fine artist for the sake of art itself, you could do that quietly in your home studio. That's not enough for us. We don't want to just make our art. We want to earn a living from it and we can't do that without branding and promoting our work. We can't do that without selling ourselves.

Selling yourself is *not* selling out. Selling out is abandoning your principles just for a paycheck; it's not striving to earn a living from your art. Don't let anyone tell you otherwise. This is your blood, sweat and tears. Most importantly, this is your *precious time*, and you should want to be compensated for it. There is nothing more noble than wanting to provide a decent living for yourself and your family. You can achieve that by doing something you hate or something you love.

So get over that immediately and never look back.

Personal Branding

Let's talk a little about branding. Like I keep saying, the comic strip is a very personal expression of art. We're not just selling our characters or our strip, we're also selling ourselves and our outlook on life. Because of that, a lot of the branding we do will be branding ourselves as much as our strip.

Branding is all about perceived value. It's a promise that you're making to the visitors of your site that their time was well spent and that it's worth it to return again. If you can brand yourself a value to your readers, they will, in turn, pass that information along to their friends, sometimes directly via an e-mail or link, and sometimes indirectly by wearing one of the T-shirts they bought from your Web site.

Once you establish a value to your audience, you'll find that they'll go out of their way to support your brand financially. They'll purchase your merchandise, click on your advertising and even donate their hard-earned money to your tip box.

This isn't about having a flashy logo or a clever catchphrase. This is about associating good experiences with your product and yourself. It's about delivering a real value to your customers who will associate that value to your name and your work.

Once you cultivate and establish a personal branding, remain conscious of it and don't do things counter to it. Look at the guys at Penny-Arcade.com. Gabe and Tycho have established themselves as the last honest voices in the videogame review arena. They've established a real value to their Web site: No-nonsense opinions. They don't even allow advertising on their site that is counter to their branding or would compromise their principles. They've established a relationship with their audience that they maintain and respect. That's positive branding at work and it's paying off for them.

On a smaller scale, our own Dave Kellett is an excellent case study on positive personal branding. Dave's comic, "Sheldon," is an all-ages strip that would easily be appropriate for family newspapers. Dave maintains a positive and friendly attitude on his site and in his posts. Dave has reached and cultivated a loyal audience and customer base with this branding. His readers know that his Web site delivers positive, friendly entertainment. If Dave were to start posting adult material or take a negative slant in his posts, he would be working against a successful personal branding.

Everything about your Web site should be tied into the brand of your comic. Your comic has a theme — an underlying philosophy — that directs the story. This is a combination of subject matter and outlook. Your site — and all of your communication — should be directed by that theme. If you're doing a Webcomic about three frogs in a pond, for example, your site, store, blog — even your personal communications with readers — should have an element of frogginess about them.

It's a way of standing out in a crowd. And, since you're sharing the Net with several thousands other Webcomics, being identifiable is a very good thing. Without it, you might just, well, croak.

Remember how I mentioned in Chapter 5 that Brad and I had a difference of opinion on punchline writing? That was *totally* one of Brad's.

Positioning

I've been thinking a lot about the idea of positioning in the market of Webcomics. Traditionally, when companies examine positioning, they look at what share of atten-

Who's Coming From Where?

If you're not paying attention to your web stats, you're missing out on valuable information. Install Google Analytics, Extreme Tracking, or use your server-based stats program to see which comics of yours are bringing in the traffic, what juicy links are sending them there, and how long that traffic sticks around. It's immensely helpful information to see what's working...and what's not.

— Dave

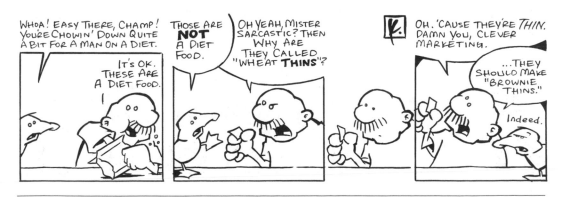

Competing with other Webcomics

Do not bother just to be better than your contemporaries or predecessors. Try to be better than yourself.

— *William Faulkner*

tion their product has in comparison to their competition.

So the question is: Do Webcomics compete against each other? Because if that's the case, we need to really think about how we're going to position our strip in the market to maintain headspace in the collective consciousness of our consumer base.

A lot of people feel that comics don't compete with each other, and that we can all exist side-by-side with each other. Most readers won't "choose" one strip over another. People read what they like. And comic strips are not time-consuming. They're a quick and disposable form of entertainment. You can breeze through 10 strips over your morning coffee. It costs you nothing to add one more strip to your morning ritual.

But I like to consider the fact that most people, from a behavioral standpoint, probably only visit 7-10 sites in their daily Webcomics-browsing cycle. If you're on the bottom cusp of being in that cycle, positioning suddenly becomes very important.

And although readers aren't forced to choose reading one free strip over another, they are certainly forced to choose which strip they're going to spend money on. Discretionary funds are limited. If a reader can afford to buy one book and one T-shirt this month, you want it to be from *your* store.

So maybe we, as cartoonists, do need to think of our fellow cartoonists as "competitors" and start worrying about our Webcomics' positions in the marketplace. Where do we fit? What are the ideal attributes of a successful strip and how to we change our positioning to match that? And how do we do that without compromising our art?

And thus we find ourselves at the big dilemma of the Webcartoonist. We wear two hats: creative and business. Sometimes our two halves are not so compatible. And this brings us to what I call "The Dance."

The Dance is the delicate balancing act between art and commerce: Staying true to your art but keeping it marketable at the same time. If we examine market trends and find that an ideal position for our strip would be to appeal to a younger crowd, but we prefer to create strips for an older audience, what do we do? Do we change the art to service the business? Or do we sacrifice

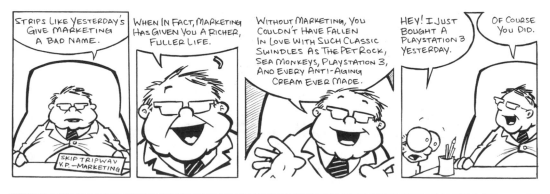

some opportunities to make some extra cash to keep the strip pure? And considering that we're remaining vigilant to retain our positive branding, we might find that we're turning away a decent chunk of cash in favor of the bigger picture.

I've refused advertising from certain advertisers because they go against my strip's branding. Multiplayer online games have generated a huge market of people who sell virtual property, but most people who play these games are against such service providers. If I were to accept advertising from those companies, I risk alienating my readers and losing more money down the road.

> When you accept ads onto your site, it's one of the few times you let someone else's branding — someone else's voice — speak on your site. Be sure you're comfortable with the voices you let in, and the way they conduct themselves. Allowing pop-up ads, pop-unders, ads with sound, and (depending on your audience) "not-suitable-for-work" ads can damage the implicit bond of trust you've worked hard to build with your branding.

One thing we can do to help us better position ourselves in the market is to examine the data we do have about our audience and use that to cultivate that reader base and appeal to new readers by giving your audience what they want.

Web surveys are a great way to learn more about your readership. There are open-source, Web-survey code packages that you can install on your own server. Online services, such as www.surveymonkey.com, provide surveys at an affordable price.

A recent survey of my own audience revealed that I had a lot of female readers — as well as male readers in serious relationships. Because of this I started offering my T-shirts in ladies' sizes. It worked out great. I sold more shirts because suddenly my female audience was able to buy in their preferred size and style — and my male readers saw an opportunity to buy something for their ladies and include them in their interests.

I found a better way to position and market my strip to my audience without compromising the strip, my branding or my principles.

Worrying about market positioning is something I do all the time, and Scott gave me a good piece of advice. He offered me a slot in his advertising system, and I labored over what kind of banner ad to design. "Starslip Crisis" is about a fussy art-loving curator captain, a pathetic alien bootlick, and a drunk ex-pirate trying to run an art museum while entrenched in an intergalactic war. So here I was trying to figure out a way to convey all that in a single banner ad.

Scott said, "You're overthinking it. Here's what you put: 'Set phasers for fun.'" And he was right: the goal is to drive people to the Web site in the first place. If my positioning is too complex on the sell like that, it's going to turn people off. If they decide they don't like the strip after they get there, then I did all I could. But if my branding wasn't fun on the surface, they wouldn't have clicked the link in the first place.

Building Your Traffic

The most frequent question I get from aspiring cartoonists is "How do I increase traffic to my Web site" (even more than "Where do your ideas come from?"). The most frequent answer I give in return is "Getting the traffic is easy, retaining it is hard."

The most effective way to get new traffic to your Web site is to have a higher-trafficked site link to you. How you accomplish this varies on your ability to network, what you can afford on an advertising budget, and a little bit of luck. And if you do nothing to retain a large portion of your new traffic, your efforts are wasted. More important than making a push to get new traffic is working to keep a good portion of the traffic you get.

Content is king, boys and girls, and ultimately people will come back if they find your content compelling. That's why we're bothering to worry about everything contained in our previous chapters. So if you skipped right to this chapter, stop. Back up and read the rest. Because none of this matters if there's nothing compelling on the site.

This is where consistent, on-time, high-quality work pays off. My advice is to focus like mad on your Webcomic. If the comic itself is great, the traffic will follow. For example, do you remember that old saying "Luck is being prepared when opportunity arises"? Well, having an excellent webcomic with a big, entertaining archive is all the preparation you need when the opportunity of a juicy link sends thousands of people your way.

Networking

You can learn a lot from your peers, and you can learn even more from cartoonists and professionals who have established themselves in the marketplace. Most cartoonists have message boards they frequent, and with programs like Skype, iChat and other VoIP and IM clients, networking with other people in the business is easier than ever.

The first place Webcartoonists look to network is among other Webcartoonists. We're all working towards the same goals, and many of us have other creators we look up to and admire. Most Webcomics have sections on their site linking to other comic strips online. Cartoonists form large collectives and interlink between each other.

None of that is bad, but I want you think bigger than that.

The Webcomics community is a great place to start networking, but it should be your first stop as you slowly make larger expanding circles into other markets. Webcomics are full of like-minded-individuals who are in the same boat as you, and because of that, they're open to link exchanges. You can also benefit from getting to know other cartoonists and having someone to "talk shop" with. By befriending other Webcartoonists you might find people you could split the cost of a table with at a convention or glean a new way of working.

But don't stop at Webcomics. We have a finite number of people within our circles of traffic. After a while, interlinking becomes incestuous and ineffective. Take a look through your archives and see if any of your strips or gags might appeal to people of certain interests. Most likely, there is a popular Web site dedicated to that interest that might find your strip funny. Send e-mails to Web masters, post links to your work in message boards. Do what you can to bring your work to the people who have the best chance of identifying with it.

A great place to network is at conventions. Make the time to introduce yourself to the people who run and promote the shows you attend. Offer yourself to participate in panel discussions or give demonstrations. The more people you meet and befriend, the larger your support and resource network grows. You never

A Note On Networking

The friendships you cultivate among other cartoonists will, in time, prove to be one of your most powerful assets in growing your Web-comic audience.

First, because these are kindred spirits, who understand the omnipresent and never-ending deadlines that come with a life in comics. So the support you get from them will be a life-saver in those times when you want to give up, throw in the towel, and be done with it.

Secondly, the link-backs and promotional exchanges you get from your fellow cartoonists can be a great source for new readers to find your work.

— *Dave*

know will be able to advise or help you down the road or who you'll be able to help.

Sometimes you find yourself in a situation in which you want to meet a person, but you're having a difficult time broaching an introduction. This especially can happen when you're trying to meet someone you greatly admire for the first time. Sometimes, I find that when you can't find the words, it's easier to let your work speak for you. On several occasions, I got to know people in the industry I admire by simply waiting patiently in line and offering them a copy of my book as thanks for all their inspiration and art. Sure, sometimes your book ends up never making it back to their hotel, but sometimes you make a new friend and admirer.

Advertising

The most effective, low-risk advertising is getting a plug in another popular Web site's blog. That is hands-down the best advertising money can (or can't) buy. It's grass roots marketing, and it's incredibly effective because it comes across to the reader as a personal endorsement. Of course, getting people with popular blogs to link to your site isn't always easy, and sometimes you want to try your hand at paying for advertising. There are several ways to go about this cheaply.

Project Wonderful: Run by fellow cartoonist Ryan North, Project Wondeful (www.projectwonderful.com) is a bid-based advertising program. Instead of setting a fixed price for advertising, Project Wonderful clients sell advertising using an auction system. You simply bid on the current daily price of the ad and if you have the highest bid, your ad runs. Project Wonderful has been very effective, low-cost advertising for many Webcartoonists.

Google Adwords: Adwords allows you to create a text-based or visual ad for your Web site, assign it keywords, and then your ad will appear on Google search pages that correlate to your chosen keywords. But that's not how I would recommend using it.

Many popular Web sites fill their extra advertising inventory with Google adsense filler. So when a paid campaign isn't running, Google ads fill up the extra pageviews. If you see a site running Google ads that you want to advertise on, click on the text link in

the bottom right of one of their banners that reads "Advertise on this site using Google adwords." Most of the time, Google's ad rates for that site are much lower than you would pay for the same number of pageviews directly from that site.

Site-to site ad buys: If you really feel that advertising on a particular site would benefit your strip and bring in a sticky readership, investigate making an informed ad-buy on their site. Most Web sites have a link or email to obtain a media kit and ad rates.

A quick tour of promotional tools for your Webcomic

Content You Produce:

• Blog

• Forum

• Opt-in E-mail Newsletter

• Twitter Updates

• Livejournal/MySpace/Facebook pages or groups for your comic

Contributions You Can Make Elsewhere:

• Politely, and with all etiquette in tact, join the community of other forums (with requisite forum signature)

• List your Webcomic on "top sites" and "top lists" contests and directories

• Create buttons, banners, wallpapers, icons for social networking sites and offer them up for free

• Pay for advertising on other sites, networks, or forums

Real-World Promotions:

• Convention appearances

• Flyers (on campuses, at conventions, at your local comics store, etc.)

• Public talks and panels

• Networking with other cartoonists

And always, always, always keep in mind that the single greatest thing you can do to build and promote your Webcomic is to produce the best possible comic. If you combine quality work with the viral nature of the Web, a lot of your marketing work is done for you.

Interacting With Your Audience

One of the greatest things about Webcomics is the immediacy, frequency and intensity of your interaction with readers. You can talk to them, and they can talk back. Maybe this sounds unique to you, and maybe not. But traditionally, a print reader saw your comic strip, and that was it. They had to infer your personality and your worldview from the hints dropped in your characters or storylines. And if they wanted to interact with you, they had to send a letter to the labyrinth mailrooms of a publisher to be forwarded on to you. It was hard to be a fan, and was even harder for you to steer your fandom.

But Webcomics are a complete reversal of that story.

Cartoonist, Meet Audience

With a Webcomic, you have the opportunity to not only capture a reader with your work, but with the personality behind the work. You can talk to your readership directly with blog entries, forum posts, personal e-mails, and podcast or vidcast installments. You can organize meet-ups, steer your readers to causes, engage them with contests and quizzes and share in endless permutations of two-way conversations. There's no middle man, and no filtering or editing of your ideas through journalists or interviews. It's just you speaking directly to your readers.

This is an amazing situation for an artist. It's a situation that carries an implicit potency. By interacting directly with your audience, you can create passionate, passionate, *passionate* readers. And that should be your goal, above all other marketing, P.R. and sales goals. Because everything else follows from the passion your readers feel for your Webcomic. And that is the best possible reason to cultivate your relationship with them.

You want to remove every barrier to fandom, and create evangelists for your Webcomic. You don't just want fans, you want folks who will actively go out and spread word of your site to all corners of the Web. You and your Webcomic are a small-time operation, remember, so you can't afford to have readers who just…"read." You want them to link to you, blog about you, and sing your praises to family and friends and forums. You want fans who will not only read the comic, but who will lead discussion in your forums, volunteer to help out with projects on the site and even plan their vacations to show up at your personal appearances and conventions! You want passionate superfans who live, breathe, and share your Webcomic throughout their lives, and with everyone they know.

Does this sound like I'm being hyperbolic? I'm not. Keep in mind you have no big-buy ad budget for your Webcomic nor do you have a team of marketers getting the word out for you. All you have is your current audience and your ability to work with them to spread the word about your work.

You can ignore that potential tool and build up your audience slowly, enjoying lukewarm reader feedback and tepid sales in your store. Or you could create a powerful, personal, emotional connection in your readers — and in so doing, give them every

Giving Back to Readers

We make a living by what we get, but we make a life by what we give.

— *Winston Churchill*

It Adds Up

We must not, in trying to think about how we can make a big difference, ignore the small daily differences we can make which, over time, add up to big differences that we often cannot foresee.

— *Marian Wright Edelman*

reason to want the Webcomic to flourish and grow as if it were their own project. That's because, in the mind of the passionate reader, it *is* their project. That's what you want. That's the mindset of the evangelist reader.

How do you encourage that emotional connection to your Webcomic? I'll go into specifics, later on in the chapter, but here it is in the simplest strokes: Be accessible, be entertaining, and be kind.

Be Accessible

One of the best things you can do to support the growth and sustainability of your Webcomic is to be accessible to your readership. Create a personal, emotional connection with them by giving them direct access to the artist they read. Whenever you blog, or respond to your readers forum posts or e-mails, you're not only giving them more entertainment value, you're giving them a more immediate, more personal attachment to the Webcomic... through you.

Because, let's be honest: When people are reading your Webcomic, they're really reading *you*. So give them more of what they came for. Build on the day's Webcomic with a little extra commentary in your blog, linking to funny parallel ideas or past comics that strike a similar tone. Respond to reader comments and questions in your forums and e-mails with a little extra joke or insight that only you can give them. It adds value to their experience, and ties them to the comic in ways that generate concrete results.

Make your accessibility the philosophy of your Web site. Don't just put an e-mail link that says "contact us" on the site. Who's "us?" This isn't Citibank customer service! You're a Webcomic, a cartoonist... and your readership knows exactly who they want to contact. Make it "E-mail Dave." It's just one more way to cultivate that personal relationship, and that sense of friendly approachability.

And once your reader e-mails start to come in, make it your job is to answer every single one you get. Can that be a pain? Absolutely yes – especially as your readership grows. But think about it. When it comes time to ask readers to buy a book, who is more likely to plunk down money: The reader who got a personal

response from you or the reader who got bupkis? You're asking your readers to support your comic financially, and you can't even be bothered to answer their simple e-mails? Who are you, Picasso? Get out there and answer your reader mail! It's the least you can do!

Let's look at it from a business perspective. Remember the truism that it's cheaper to keep the customer you already have than to gain new customers? Well here is a custom-made opportunity to do that. Here is a customer reaching out directly to you. Keep their readership, their business, and their emotional tie to the Webcomic: Answer their e-mail!

Be Entertaining

Your site, your blog, your forum posts, your e-mails and your public persona are all — on some level — an extension of your Webcomic. And people come to your Webcomic to be entertained and forget the troubles of their day. Keep that in mind the next time you sit down to blog about how nothing is going right in your life. Your readers are already bogged down with their own problems — they don't need yours. They already have to deal with their mom's illness or their late rent check or their failing relationship. They don't come to your site to hear about your troubles on top of all that.

I've seen countless Webcomic artists make that mistake again and again. In their comic, it's all happiness and setup-setup-punchline! But in their blog, it's "oh-woe-is-me-my-cat-died-and-I-burnt-my-toast-and-I'm-ugly-and-no-one-loves-me-and-I-think-I-have-a-toothache." Who needs that? More importantly, who wants to read that? I don't, and I guarantee that none of your readers do. Sure, we can sympathize with a tough moment in your life, and we all know that you're going to have them. But your Webcomic is not the venue to air your worries about your life's failures. It's an entertainment site! Or, at least, it should be. Be entertaining!

And if you must, must, must blog about your woes and worries, for God's sake, make it funny. Take a page from every stand-up comedian who ever lived, and turn your misery into laughter. If you don't, you eventually start to sound like the whiny kid that no one wants to talk to. And that, my friends, drives away more readers than you're comfortable losing.

The Art of Interacting

Any activity becomes creative when the doer cares about doing it right, or better.

— *John Updike*

Be Kind

Have you ever walked up to an artist or writer whose work you really loved — only to have them be a jerk in real life? It's disappointing as all heck, and it kind of sours you on their work. You can't help but connect the artist to the art in your mind, and when one takes on a negative connotation, it carries over into the other. Keep that in mind when you're interacting with your audience. If you're a jerk, it will be remembered.

But on the flip side, if you make a conscious effort to show kindness to your readers — repeated over countless years, dozens of appearances, hundreds of blog posts and thousands of e-mails — it will have a huge, positive impact on how your readership views your Webcomic. They'll associate your kindness — both consciously and subconsciously — with your art. And when you are kind to your readers, they will be kind to your Webcomic — and to the business around your Webcomic. It's not just the Golden Rule I'm preaching, here, it's good business.

Over time, you'll find that the mood you put out through your comic, your blog and your interaction comes to be reflected in the audience you've attracted. If you write a wise-ass, snarky and mean-spirited comic, your readers will tend to be wise-asses, snarky, and mean-spirited. Whenever I hear a Webcomic artist say "My readers are jerks," I have to hold myself back from saying "Well, *you* attracted them."

See, there's a slow filtering process that happens with a Webcomic readership. And after a few years of filtering out this type or that type of reader, you inevitably end up with a reader that reflects your basic personality. Think about that the next time you're

Mailing Lists

Another way to make sure your audience gets a steady, regular dose of you is to run a mailing list.

Think of a mailing list as the bridge between you and the user who hasn't taken to using RSS yet, but is a devoted enough reader to want your strip in their inbox every day. E-mail is still a much, much more accessible medium for many people, despite RSS aggregators being built into most browsers. (Frankly, I don't use RSS either.)

Your mailing list can contain either a link to the day's strip, or the image itself. It can also contain some commentary from you about the strip, or other news like goings-on at your site, or new products in your store. Adding a little value like behind-the-scenes commentary will provide readers with an incentive to sign up.

A mailing list helps your reader retention, too. New or infrequent visitors to your Webcomic will find it delivered to them every time you update, making it much easier for them to keep up with the strip — and become more invested.

— *Kris*

tempted to say "My readers are lazy" or "they don't support me" or "they never have a kind word to say." Are they a reflection of you?

The readership you build up over time will be a reflection of the work and the words and the sentiments you put out there. You're a human being, and will fail from time to time, but try to put out kindness whenever possible.

> Boy, is this ever important at a comic convention! Let's face it, those things can be a bit grueling. It's not easy to be "on" during the entire stretch. But it's important to try. When people ask you how it's going, your response should always be positive and excited. I don't care how much your feet hurt and how hungry you are. That attendee wants to hear that you're having a blast. Don't let them down.

Building a Community

It's hard, on the Web, to get a sense that you're among a crowd. When you're on CNN.com, for example, you don't think to yourself, "Right now, there are 400,000 people also reading this site! Woo hoo, I'm with the in-crowd!" That never occurs to you. Why would it? You can't see anyone else, and they can't see you. If anything, it's more of a solitary sensation as you silently click around the Web alone.

But think of those moments where you do get a sense of crowds on the Web and how you suddenly perk up and find your mind stimulated. On forums — where you see people sharing ideas and arguments — you start to construct responses in your mind even if you don't post. On Facebook or MySpace, you start to construct quick jokes or comments that you never actually post on someone's wall. On blogs with comments activated, it goes from being a one-way lecture to a two-way conversation. And rather than being a passive reception of information, your brain starts to fire with all sorts of possibilities for communication and interaction.

Humans are social beings, and respond most intensely to "social" arenas. Take this into account when you build your site: Build a community for readers to interact. Encourage in them the sense that they're not alone in reading your site, that your site is a welcoming, energetic, fun community of like-minded people.

The Unreachable, Untouchable Artist

You can make more friends in two months by becoming interested in other people than you can in two years by trying to get other people interested in you.

— *Dale Carnegie*

Forums are the quickest way for you to do that. In here, you talk to readers, readers talk to you and readers to talk to each other. It extends the conversation from the comic and the blog into their own lives, and it makes the experience infinitely more powerful as a result.

Another less obvious solution is to literally let readers see each other. Set up a page on your site or on a third-party picture-sharing site (like Flickr) with photos submitted by readers. Include reader pictures in your blog. Let readers add their pics to a Flickr group devoted to your Webcomic. Let them see that they're among a group — and here are the concrete faces to prove it.

Still another technique to create community can be found in the way you brand your readers. Is there a tagline, a title, or an icon that readers can rally around and call their own? There's a reason why nations use flags and songs and memorable poems to cement feelings of nationhood and nationality. It's shorthand for belonging — for identity. Use that in creating the community around your site.

For example, a few years back I started calling my readers "Sheldonistas" as an off-hand joke. But it kind of clicked with readers, so I kept using it. Is it silly and unnecessary to brand my readers "Sheldonistas?" Yes. Are there readers that will think the word is lame? Absolutely yes. But does it help cement a sense of belonging for my readers and give title to the feelings that they have for the strip? Yes, and that's the point! It's for the superfans, for the passionate readers. It summarizes the belonging they feel on

Forum Etiquette

When running your own forum, there are two cardinal rules.

First: Hold on loosely, but don't let go.

If you cling too tightly, you're gonna lose control. (William Shakespeare.) Your forum is a place for readers to get together and discuss things that interest them, namely your Webcomic. But the conversation shouldn't be limited to your work — I used to get frustrated when it seemed like my forum visitors talked about everything *but* my strip. But rather than clamp down on that now, I encourage it! If my forum becomes a gathering spot for people and a positive experience, then why wouldn't I want that associated with my Webcomic?

Second: Be an active participant.

Your forum is another place for you to get to know your readers, and for them to get to know you. If you're active, you can help guide the forums. No one's talking about your latest strip? Start posting daily threads with titles like "Strip for 12/7/2007: Watermelons?" and a link to the strip to encourage discussion.

Plus, being active will let you keep an eye on the needs of your forum-goers. If there's a spammer, you can ban them before they cause too much trouble. If there's an argument, you can step in and cool it off. Being part of your community is key to having one.

— *Kris*

the site. It's shorthand for the community and identity they choose to belong to, and for the passion they feel about your work.

> I also experimented with "forum sigs." These were special graphics I designed (with my comic's logo as part of the design) that were personalized with a caricature of the forum-posted who had asked for it.
>
> I even hosted the graphic on my server and encouraged people to use their sigs in other forums — as long as they used my HTML code (which just happened to include a link to my Web site).

Dealing with Critics

On the opposite side of the coin, you will from time to time have to respond to the direct and indirect barbs of a critic. You're living a public life, putting your art out there for everyone to see. Sooner or later, that invites criticism. Some of it will be fair criticism and some of it will come out of nowhere. Responding to it well can diffuse a situation before it blows up and can save you a great deal of artist angst in the process.

First, let's get something straight. You and I are both artists. We're both sensitive and kind of insecure. Maybe we've had moments of quiet desperation in our formative years. And when we're criticized — especially publicly — that hurts. It hurts a lot, and it triggers all sorts of reactions from our inner kid. Like you, I will also forget 10,000 words of praise and focus on the one angry or insulting bit of feedback I get. We can't help it sometimes: We're artists.

But here's my challenge to you: Rise above that. Be stronger in your own sense of worth as an artist and as a person. The barbs will cut far less deeply, if you do, and you'll be able to follow the next bit of advice all the easier. And here it is: Be nice and be polite to your critics.

Forum Etiquette, Part 2

When you're setting up a forum, the forum software you're using will probably let you create as many subforums as you like. (phpBB and vBulletin are two very common, free, excellent forums.)

Do yourself and your community a favor, and resist the temptation to make a zillion subforums for every possible topic: General, Chat, The Strip, Fan Fiction, Personal Stories, Art, News, Sports, Politics, Music, etc.

Sure it keeps discussions organized, but most likely you'll end up with a bunch of mostly empty forums, one or two with a single post in them, and a slightly-less-active main forum.

Rather than creating organization, you've just created distraction — and the sad illusion that there's a whole lot of nothin' going on at your Webcomic. And that can deter people from posting! One forum is plenty to start with.

— Kris

It's not that different a response from the one I advocated for fans, is it? And yes, yes, I can already hear you saying "Geez, Dave, could you be any more of a patsy? Be nice to my *critics*? What kind of Polly-Anna pushover do you want me to become?" The answer is, I don't. I just don't want you to waste time, or energy, or your creative well-being on anything that isn't worth it. I have every much as strong a desire to fire back a point-for-point e-mail or forum post as the next person who's being attacked... but the end result gains you nothing except higher blood pressure. Unless there are some darn good p.r. reasons, arguing and exchanging vitriol with a critic is a waste of time.

There are four types of critics that you'll encounter, and each one can be diffused or made impotent by kindness and politeness:

> 1.) **The Accidental Critic.** He's the guy who actually loves your Webcomic, and he doesn't realize that his word choice or written tone comes across as mean criticism. You'd be surprised by how many people fall into this category. They love you, and they love the comic, but they chose the worst possible words to express it.
>
> This is the same person who uses *all* the wrong words when they're trying to pick up someone in a bar. And now they're doing it to you via e-mail. A kind word or a polite correction or restating of facts on your part, and they'll probably e-mail right back with effusive praise. Seriously. This happens all the time.
>
> 2.) **The Corrector.** This, too, is a person who loves the Webcomic, but for 10,000 personality issues that aren't worth going into, she feels she has to correct you on every real or imagined error. Did you reference String Theory incorrectly? She'll let you know. Did you use the word "effusive" incorrectly, according to some obscure Victorian usage that even the Oxford English Dictionary doesn't catalog? He'll let you know. Did you not realize that today's comic miscategorized the high intelligence of cats, as made evident by their own cat, "Mrs. Kisses?" They'll let you know. (And they'll send pictures to prove it.) Again, these are well-meaning readers. They're just a little lonely or a little Type-A about useless details. A kind, polite response should do the trick.
>
> 3.) **The Lost Cause.** He doesn't like your work, he doesn't like you, and he doesn't have any hesitation in sharing that with you. Should you respond to his criticisms point-for-point? No! Why waste your time on him, unless you like fighting for fighting's sake? Listen, this is a reader you never had. You never captured him, and you're not "losing" him now. You won't possibly gain them as a reader using

Comments On/Off

Most blogging software allow readers to make comments on your posts. This can be a great way to interact with your audience and get their feedback. But there is also a possibility that allowing comments on your site will breed a real negativity that could alienate a lot of people.

If you allow commenting on your blog, pay attention to the comments. If you find the atmosphere is too negative, you might want to turn commenting off for most or specific posts.

I personally feel that a blog should be a personal and singular voice. I don't allow commenting on my blog posts. I usher commenters into a separate message board or forum for discussions. My blog is my statement to the world. If people disagree, they can take it to the boards or start their own blog.

Give commenting a chance and see if it's right for your site. If not, don't be afraid to turn them off.

— Scott

an angry response, so why not roll the dice and try kindness on them? I've had e-mails, years later, from readers who said a kind response to their angry e-mail made them reconsider the strip and give "Sheldon" a second chance.

But if you try this approach, you have to know going into it that that's a rare, rare occurrence. So if you can't muster a polite response, just delete their e-mail, and forget it as soon as possible.

4.) **The Jerk.** This needs no explanation. You know who he is, and can smell him comin' a mile away. He trolls your forums, he pesters you with repeated e-mails, and you're left wondering why he can't just let it go. If he hates your Webcomic so much, why can't he just walk away? Who knows?

Short answer: Some people live very small lives.

But once again, kindness and politeness might get you a surprising result. It's unlikely, but it's possible. Here, your best possible response is probably to ignore them completely. Deprive a fire of oxygen, and it goes out on its own.

There is a subset of Webcartoonists who think that drama is a viable way to get traffic. You post something insulting on your blog, your readers run with it, some people get worked up into a lather about it, they argue on your site and in your forums, and maybe if you draw the ire of another Webcartoonist, you'll have his readers visiting to see what the fuss is. There's no such thing as bad press, right?

For all the effort starting an argument with a handful of people takes, you could be building a positive relationship with the rest of your readers. The last thing you want is for people to see your site as a place to unload all their negativity. That's why it's so important to rise above that and kill that movement with kindness. It can be overwhelmingly attractive to finish a fight with someone, or point out where a reader who will "never read your comic again" is wrong, but it's a total waste of your time. Plus, if new readers see that your blog is full of arguments and insults, it's a turn-off and they'll probably have a dim opinion of you and your work, regardless of how good it is.

The Superfan

If you're doing your job right, and providing consistent, on-time, high-quality entertainment, your critics will be few and far between. In fact, as the years progress, and your Webcomic's community grows and establishes itself, you'll find yourself presented with the anti-critic: The Superfan. These are the readers who think you do no wrong,

The Superfan

All of my attempts
to understand,
cater to, and
cultivate Superfans
has been built
on Kathy Sierra's
excellent, excellent
blog, "Creating
Passionate Users."
Do your career
a favor and dive
into her work at
headrush.typepad.
com.

— *Dave*

who think your work is unbridled gold. These aren't just people who bring you gifts or artwork or home-made cakes at conventions — and trust me, that happens — these are Superfans who would give you their house, if they could. They are wonderful and kind and passionate and everything you want in a fan. You wish you could clone them.

From time to time, these Superfans will volunteer to organize projects around your Webcomic. They'll spearhead entirely new initiatives that you never even thought of, and they'll suggest ten more initiatives that they could start, after that. They are a flurry of energy and volunteerism and ideas. They are the culmination of all the work you put into being accessible, entertaining and kind. They have reached the point you wish for all your readers: They consider the Webcomic's success or failure to be their own.

Let that happen. Encourage that to happen. Steer it, guide it, co-opt it when you see it happening. And then, as befitting your artist's personality, reward their kindness with kindness in return. Shower them with the gifts that mean the most to them: Free books, free sketches, free original art. They crave your work, your time and your personal touch. You won't always be able to give them those things, but when you can, do — and do it happily. It's a wonderful exchange of artist and audience.

But a word of warning: You cannot — and should not — abuse the kindnesses they give to you and to the Webcomic. Their volunteerism is a gift to you. Don't abuse it.

A Final Note on Reader Interaction

If you wanted to make bags of cash, there are infinitely better jobs than being a cartoonist. I know, I've had those jobs. But I walked away from much bigger paychecks for the joy, the interaction, and the satisfaction of talking to people every day with my Webcomic. Make no mistake: I work very hard to earn a great income with my Webcomic (as you'll see in the next chapter), but it's not "why" I do it.

The greater joy comes in the artistic expression of it, in the gift of entertainment we can give to readers all over the world. It's a momentary lightening-of-the-load that we can offer in other people's lives — and it brings on a great sense of purpose and contentment.

Creating your Webcomic gives you that sense of purpose. And interacting with your readers will make that sensation all the more powerful and real. Don't be timid about interacting with your readers. It's one of the big reasons you became an artist in the first place.

In the Hot Seat...

This is a pretty straightforward gag, and there's not an enormous amount of slapstick in Starslip Crisis, but here I was really happy with all the implied motion. Vanderbeam somehow missteps in panel one, he has his hand on the far wall in panel two, he's accepted his fate in panel three, and there's a nice visual in panel four.

— Kris

 I have to admit that this is one of those times where the daily use of sprite (copied or repeated) poses actually lessens the impact of a particular strip. I read Starslip every day, and this particular strip's sudden flurry of new poses and character angles caught me off guard. Don't get me wrong: The poses all work great. But the normal sprited poses are so ingrained in my mind that it becomes akin to a character's hair color: a sudden change in either is very noticeable, and took me out of the strip for a second.

 Sentences like "This will be inconvenient and painful" are a huge part of why I love "Starslip" so much. You have such a mastery over your characters' voices.

The onomotapeia in panel four is brilliant. "Thop!" Such a great, distinctive, atypical word. So much better than the lazy man's "Konk" or "Thunk." When have you ever seen a "Thop" used?

I absolutely LOVE Vanderbeam's expression in panel 3. He's no longer surprised or worried, just annoyed and frustrated. As if this has happened before. like we would get annoyed at hitting a red light. I know that Kris gets down on himself sometimes for the simplicity of his art style, but this panel really shows how much you can express with few lines.

 I would have liked to have seen "THOP" closer to the point of impact, but that's a very minor concern. Also, it might have been fun to break Vanderbeam out of the third panel a little to accentuate his "floatiness."

 The only reason "THOP" works placed where it is, is that it's tied to the only action in the panel. If there were other characters standing around, or someone writing something down, that sound effect might have looked like it was being made by someone else. But since Vanderbeam is clearly striking his head with a lot of force, I thought it was safe not to crowd the upper third of the panel.

... Kris Straub

Panel 1: ENGINE ROOM, LATE NIGHT.

A2-Z. HOLIDAY HAS YOU WORKING ON THE *SECRETS* OF THE STARSLIP DRIVE, AM I RIGHT?

AFFIRMATIVE.

Panel 2: WOULD IT SOMEHOW... BE POSSIBLE... TO *REVERSE* A PATH FROM OLD STARSLIPS, TO LOCATE A *PREVIOUS UNIVERSE?*

DEFINE "PREVIOUS."

ONE WHERE JOVIA IS STILL... ALIVE.

Panel 3: THINKING...

AFFIRMATIVE. THIS IS THEORETICALLY POSSIBLE.

HOW LONG WOULD IT TAKE TO *FIND* THE PATH BACK?

APPROXIMATELY 400,000 YEARS.

Panel 4: BEGIN.

STRAUB

I had to put this one in the hot seat because it changed how people thought about my strip, including me. In the first year of "Starslip Crisis," Vanderbeam has a thing for Jovia. During an attack on their ship, Vanderbeam saves Jovia, but very shortly afterwards, due to the innate problems with starslip drive, the crew ends up stuck in a universe where he didn't save her.

Finally, he discovers there might be a way back, but it'll take a half-million years. What else can he do but commit to it? It suddenly added depth to Vanderbeam, and gave him a purpose that drove a dozen other stories. Before this, Jovia was a really limited character. She became much more useful as an impossible goal to attain. It was a hard line to walk because otherwise, "Starslip" is all humor.

— *Kris*

That fourth frame is almost perfect in achieving it's goal. The wide-shot of distance, the darkness penetrated by a single ray of hopeful light, the featureless character that manages to say so much in a single word...it all sets that mood so perfectly.

One thing all cartoonists hate to admit to themselves is that the reader's eye mainly stays in the top 1/3 of the strip. A strip is read in seconds, and as the eye dashes across the text, it only occassionally darts down to take in the scene below. But a wise cartoonist offers little Easter Eggs for the reader who really looks. That tiny, easy-to-miss tear in the third panel is a great example of that.

So much about this strip is right that I don't know where to start. The fact that you keep Vanderbeam in shadow was a brilliant move. Better we imagine his expression ourselves. The fact that some of the more difficult lines for Vanderbeam to express have the "whisper" word bubble around them. The juxtapositioning of A2-Z's very happy expression during this painful moment expresses how alone Vanderbeam is during this moment. It's just brilliantly executed. This strip was too good to offer for critique.

This is a powerful, powerful strip. It's so beautifully done. For my taste, I would have liked to have seen a "pause" between the third and fourth panels — to let the "400,000 years" sink in — but that's a minor point. Major kudos for your use of solid black areas to compose such a powerful image. I don't think I would have had the courage to have attempted four consecutive silhouetted panels, but you pulled it off wonderfully.

Monetizing Your Webcomic

In some ways, here's where we get down to brass tacks. Up until now, we've been comfortably wearing the Artist Hat, talking about the artistic and promotional steps in making your Webcomic reach it's full potential on the Web. But now we're putting on our Business Hat, to talk about how to make our artwork… work.

It's time to talk about how you make money — and a living — from your Webcomic.

First, a disclaimer: There will be those who will tell you that artists can't handle the analytical, left-brain, cold-hearted thinking needed for business. And in broad strokes, that's true. The aptitude for business doesn't come naturally to those of us who gravitated towards the arts. Our tendency is either to avoid thinking about it or to want someone else to do it for us.

But here is the honest-to-God truth in life: If something is important enough to you and to your goals, then you can and will — and must — learn it.

And if making a living off of your Webcomic is your goal, you must master the business aspects of it. You must. And yes, it will take time — sometimes years. And yes, you will make mistakes. But you'll learn. And with time, and practice, and continual research and education, you'll move from complete naiveté toward a working knowledge of running your own business.

And here's a reassuring thought if you think you can't possibly learn how to operate a business. When you were in college, a lot of the business majors you went to school with weren't exactly rocket scientists, were they? The linebacker who was studying International Finance — but had a neck thicker than his head? He wasn't a brilliant reincarnation of Adam Smith. But he figured this stuff out, and is doing great as a middle manager at UBS Investment Bank. So here's my reassurance: If that 300-pound doofus can learn this stuff, you can learn this stuff.

And if you're still not convinced that you can, or want to, handle the business aspects of your Webcomic? Then I'd still advise reading through this chapter. In fact, I'd advise you also read one or two weightier books on entrepreneurship and running a small business. Because making a living from a Webcomic requires unabashed Capitalism, and an acceptance of art-as-commerce. And even if that makes your stomach churn, you need to dive into that world and understand how it works. If nothing else, that knowledge will help you communicate with the people you'll later *hire* to do your business thinking for you.

There's nothing worse than the artist who gets taken advantage of by a business partner or large company…only because the artist was too lazy or stupid to do the research going in. Don't be that artist. Educate yourself in business.

Artists & Money

When bankers get together, they talk about art. When artists get together, they talk about money.

— Oscar Wilde

Being A Do-It-Yourselfer

There will be plenty of you who will hire folks to handle aspects of your Webcomics business. I'm not immune: I've hired accountants, lawyers, graphic designers and layout artists for my work on "Sheldon." It's a necessary fact: you can't be an expert at everything. But before you hire anyone — or subcontract out for someone to handle your advertising, book production, merch, selling, shipping, or accounting — take some advice from my father: First, try it yourself.

Growing up, my dad would always have us kids next to him as he worked on a transmission, or built a deck, or installed new electrical wiring in the walls. And his lesson was always clear: Try a task, first, before hiring someone else to do it for you. See if you enjoy it, or if you hate it, or if you'd rather gnaw a foot off than do it again. Trying to lay out a book in Adobe InDesign or figuring out a shipping system will serve the same purpose as trying to fix a kitchen sink. It ensures that you...

> 1.) Truly understand a process.
>
> 2.) Know whether or not this is a task that *can* be handed over to someone else.
>
> 3.) Realize what it's worth to you to pay someone to do it for you. What's it worth to you to not have to handle advertisers? To not have to ship out T-shirt orders? Trying it yourself, first, gives you a greater understanding of the costs you're willing to pay.

This do-it-yourself attitude is particularly necessary in the world of Webcomics because Webcomics are low-budget, usually-single-person, entrepreneurial ventures. Whether you knew it or not, you're an entrepreneur. It's just you, as an artist, starting a business around your art and running the show — yourself. That, my friend, is an entrepreneur. You are running a small business centered around your Webcomic.

And if you do decide to hire someone to do something related to your Webcomic, be sure to get an invoice or a receipt. You may be able to deduct it from your taxes.

Unlike the days of newspapers, in Webcomics you won't come across a company that will "handle it all" for you, and let you be the "pure" artist you dream of being. In fact, I'd recommend wiping that hope from your mind. In the days when newspapers were king, a cartoonist could submit their strip or panel to a syndicate, and if accepted, was given the professional, marketing, sales, and legal services of a major corporation. And from an artistic perspective, that cartoonist had it made. They could draw their strip, collect their monthly check from their newspaper, book, and licensing sales, and rarely concern themselves with the business minutiae that most artists dread.

IP Farms

Be wary of the larger media companies moving into the Webcomics world. Most of these are nothing but "IP Farms" — out mostly to sign and control as much intellectual property as possible for future manipulation in other, more profitable media such as movies and video games.

These companies aren't interested making money off of Webcomics, per se, and aren't even out to build up their Webcomics business in and of itself. They're making money off of selling a percentage of their farmed IP into bigger money-making mediums. The money they can offer you may not be worth the control they

take from you over your creative properties. Get a lawyer to read their contract, and think long and hard before permanently signing over your rights for the comparatively small amounts of money they're offering.

— *Dave*

The Webcomics Business Model

In Webcomics, that lifestyle doesn't exist. There is no corporate wing under which you can perch and collect checks like a happy baby chick. Webcomics operate under a different business model from newspapers or traditional publishers, and it requires we reorient our thinking to adjust to it. *The essential model is to offer free-to-the-consumer, ad-subsidized content, which then trades on audience loyalty by selling books, T-shirts, merchandise and original art.* The closest parallel is to combine the separate businesses of commercial radio and record companies (See chart, below).

The world of entertainment is changing, and is in some ways moving past the mass-market entertainments of post-World-War-II life. Like all other forms of entertainment, comics are undergoing a weakening of audience concentration, as more comics divvy up a thinner, more spread-out audience. There are more forms of entertainment to choose from these days, and more artists and niche acts — and subcategories within subcategories. Do you like Bluegrass music that makes a commentary about sci-fi? Somewhere, somehow, there's a band out there writing that music, and selling it to a niche audience of 5,000 people. We're becoming a world of long-tail entertainment, where 60% of Amazon.com's book sales are for obscure, small-selling titles that appeal to specialized sub-groups and niche fandoms. And just as there are fewer platinum-

A Comparison: Music & Webcomics

Tradtionally, a newspaper cartoonist would submit their work to their syndicate, who would then sell it on to newspaper syndication, magazines and single-use reprints. There was never a "free" use of the cartoonist's work. Webcomics follow a different model. As I've come to think of it, it most closely mirrors the *combined* businesses of "free," ad-supported radio and consumer-purchased songs and albums.

— Dave

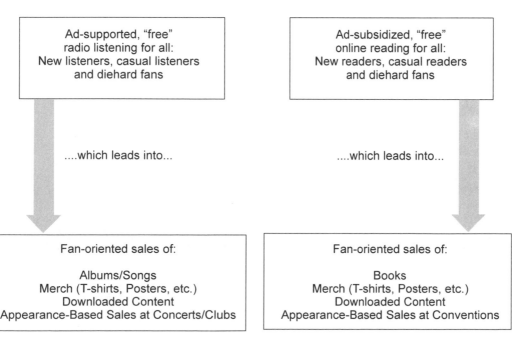

selling albums these days, there are fewer and fewer comics that capture the mass appeal of broad audiences. And in that world of spread-out entertainment, a single Webcomic can't produce enough income to work in the old syndicate model, where both parties took a 50/50 split. It just can't. It's not enough money for the artist, and it's not enough money for the corporate overhead. So wait, you're asking, how the heck do I make a living, then?

The answer: By not splitting the money.

The beauty of Webcomics lies in "disintermediation." Literally, the removal of the middleman. Webcomics don't rely on a publisher, a distributor, a syndicate, two lawyers, four salesman, an editor, a janitor, and a freckled-face guy to work the phones. Your Webcomic business will just be…you. So the potential income range of a "successful" Webcomic — $25,000 to $125,000, broadly — may not be enough to split with 19 corporate salaries, but it's enough to be *your* salary.

Let's look at it another way. You'll never have the audience size of even the smallest newspaper-based comic strips, but because of disintermediation, you don't need to. Your audience will be smaller, but if you've followed the advice from the last chapter, they'll also be more focused, more energetic, and more emotionally tied to your Webcomic and to you. And now, when this smaller, more enthusiastic readership is asked to buy a book or T-shirt — and there is no middleman in the process — you reap greater profit in that sale. And this is a level of profit that can make you a living, if you handle your business right. Traditional newspaper comic strips needed a readership in the hundreds of thousands to "work." Disintermediation means you can potentially start make a living from an audience in the low ten thousands — say, 10,000-30,000 readers.

Now that I've driven home that no corporation will swoop in to make this magically "happen" for you, and that success lies in keeping third parties out of the profit-sharing,

Micropayments

It seems like such a perfect concept. If you charge readers pennies for every Web page they load, they can enjoy your work cheaply and you can gather the cumulative effect of thousands of these small "micro" payments.

Unfortunately, it just doesn't work as well as the other predominant Webcomic business model which offers free content and monetizes through ads and merchandise.

For starters, every extra step you force a potential reader to make results in reader loss. Readers can't make micropayments until they subscribe to a service to distribute those micropayments. And this involves either dumping a lump sum of money into the service or authorizing the service to

access the user's credit card whenever a payment is due.

Let's face it, neither of those options is attractive. Dumping a lump sum of money into a micropayment service is counter-intuitive to the concept of micropayments itself! It's a macropayment that has to be made before the micropayments can be served out. And I don't know too many people who are very comfortable with the idea of giving their credit card access over to a company they're not very familiar with.

Furthermore, it takes reading several day's worth of comics before a reader can make the emotional investment needed before they consider themselves a fan. And only fans will spend money on your comic.

But in the micropayment model, the vast majority of archived comics are only available with a subscription. And there's the rub. They can't access the archives without a subscription and they won't want a subscription until they've accessed the archives.

You see, with free archives, a reader can visit the site, become mildly interested, hit the archives and become a fan. Sure, this is possible by reading the free daily update, but to pull that off, every daily update has to be really, really solid. You HAVE to do something to bring new readers back tomorrow because they can't see more than a handful of comics that you'd done earlier.

— *Brad*

let's get into it! How can you make money online? Is it advertising? Merchandise? Some mystery handshake? We'll tackle all that and more in the following sections.

Advertising

Let's start with the most immediate way to monetize your site: Advertising. Online advertising has had its ups and downs, and it will surely run through that cycle again. But it's easy to implement, easy to administer, and should start to bring in a few bucks even on smaller sites.

I'd recommend putting up ads from either Google Adsense (google.com/adsense) or Project Wonderful (projectwonderful.com) — or both. These are the same programs that Scott mentioned in Chapter 7, but we're now looking at it from the standpoint of the advertisee (as opposed to the advertiser). Based on Kris' advice from the Web-site design chapter, you've no doubt designed your site with ad space that fits the standard sizes. So you're good to go, there. Now, you just need ads to fill them. To get started, you'll want to create accounts at both Google Adsense and Project Wonderful. Both sites will ask you to set up the parameters of the ad sizes you want, how you'd like to get paid, etc. But after that, both systems work in fundamentally different ways.

Pasting Google Adsense's code into your site will bring up ads based on the words, phrases, and linkage to and from your site. It's a series of algorithms that, theoretically, will bring up the best and most interesting ads for your specific audience. The idea being that, if you have a Webcomic about surfing, you'll get plenty of ads about surfboards, surf wax, and wet suits. These ads pay out on a pay-per-click basis: so you'll get paid any time someone clicks an ad. But with Google, you'll have no control over what ads come up, or when, nor will know much about who paid what. It's pretty opaque, in terms of information: Google considers the algorithms, the bidding, and the entire process to be trade secrets, and they keep all that close to the chest. But it's a fairly trouble-free system, once in place.

Donations

You have a window of opportunity to ask for donations from readers, and it's usually when you're starting out and don't have your sea legs.

It can be a very helpful way to get you started when you don't have other means of bringing in money, but once you start earning real income from your Webcomic, asking for donations can actually prove counter-productive with your reader relations.

You can't expect your readers to carry you along with donations forever.

— Scott

Project Wonderful is a very different system from Google. Once you paste their code into your site, Project Wonderful will only deliver to your site those ads you've approved. It's all up to you. The advertisers compete for space on your site, and can increase their bid-price to get their ad on your site. In fact, that's the whole point of Project Wonderful: It lets the market decide what your ad space is worth. Unlike Google's pay-per-click system, advertisers here pay by the day (or a slice of a day), using the current market-value price. Your site stats will be transparent to you, to them, and to anyone else interested, and the market will decide what someone should pay to advertise on your Webcomic.

There are other basic advertising systems you could try out — including Microsoft's or Yahoo's Publisher Network — but I'd recommend starting with Google and Project Wonderful. Project Wonderful is beneficial because of the transparency of information and its Webcomic-specific focus, and Google works because of the overall pool of available advertisers. But for research purposes, I'd recommend running them both — to see which will payout higher for your site. It's not always clear if one or the other will be higher, so it's worth testing out.

Of course, a third option, when you're starting out, is to sell the ad space yourself to niche businesses or special-interest advertisers that share a parallel audience to your Webcomic. This can either be worked as a "sponsorship," in which an advertiser pays a fixed amount to get every ad on your site for a determined amount of time, or it can worked as a CPM (cost-per-thousand) arrangement, in which an advertiser will pay a fixed amount for every thousand ad views they get. Selling directly to advertisers can be a more lucrative arrangement for a Webcomic, but it's

Product-on-Demand

You may notice I'm not writing about product-on-demand services like Café Press or Zazzle. Product-on-demand, for those unfamiliar with the idea, are online stores that will print up a T-shirt, a bag, a hat, a calendar…but only when one is ordered. There's no inventory, and there's no storage. When a reader wants one of your shirts, they just click 'n order…and one is specially-made and shipped out to them. All you have to do is upload your design, and sit back and collect checks.

Sounds great, right? It is, in concept. But the concept breaks down in practice, for two simple reasons. 1.) There

is simply not enough profit-sharing, on your end, for you to make a living off of product-on-demand services, and 2.) The quality, I'm sad to say, is sometimes weak-sauce.

But I'm not dismissing it outright. There is a moment in your business when a product-on-demand service can be useful to you: and that is when you're first thinking about doing merch for your webcomic. Using a product-on-demand service for a month or two is a great way to test the waters. It lets you see if your readers are even ready to plunk down money to support your webcomic, or if they even want a hat with your most

popular characters or punch-lines printed on it. If you put your best product ideas up on Café Press, and nothing sells, then it just saved you a few thousand bucks of a wasted merchandise investment. But if you put up a design, and it starts selling at a level that would make self-produced merchandise profitable, then you know it's time to dip a toe into producing your own stuff.

You'll never make a living off of product-on-demand services, but for the first-time Webcartoonist who's never made merchandise before, it's a great way to test the waters.

— Dave

also a much more labor-intensive process. Note that I'm not saying it won't work for you; I'm just saying it'll be much more work.

Once the size of your Webcomic gets up to a half-million monthly page views or more, you may want to consider joining a larger ad network which will sell space for you. These can include networks as different as Burst, Tribal Fusion, AdsDAQ, IndieClick and Federated Media, but the basic idea is the same: They sell your ad space to third parties, and the monies are shared between the ad network and you.

Merchandise

Once your readership is up in the tens of thousands and you're ready to take the financial plunge of selling your own merchandise, the first thing to do is … research. Exciting, right? But it's true. You don't want to suddenly wake up one morning and say, "Today I'm printing 10,000 books up: I'm sure it'll work out fine!" — and then be broke three months later. The truth of the matter is, the smaller your Webcomic audience, the more carefully you need to plan. Your smaller audience means a smaller margin of error when it comes to business mistakes. You want to slowly, consistently, carefully build up your experience in the creation and selling of merchandise. There's a learning curve to it. So do yourself a favor, and always make your first step thorough research. What do I mean by research? Three things:

(1.) Research what works in the market.

(2.) Research the products and producers you want to work with.

(3.) Research the financials: Crunch your numbers repeatedly!

Researching the market isn't tricky. Take a few months and investigate the "biggies" in the world of Webcomics. What do they sell? How do they sell it? What types of sales or promo offers do they use? What types of products clearly crash and burn, and go in the "Oh-dear-God, we're-never-offering-that-product-again" sales bin? What is clearly selling like hotcakes? If you follow their store offerings for a few months, and read their blogs, and watch their forums, and pick up on key word choices in both, you'll be able to spot patterns, and learn from the successes and failures of others.

Then, make an investment in your research. Order a poster from the "Penny Arcade" store. Order a shirt from "xkcd." Buy a book from "Achewood." And ask yourself these questions: What was the purchase process like? The customer service? How long did it take to ship? What kind of container was it shipped in? What labels and packing materials were used? What was the e-mail follow-up like? What's the quality of the product itself? If you were a normal customer, would you buy from them again?

And finally, how do these stores compare to Amazon or Dell or other online superstores? Those bigger stores set the standard for customer trust, ease-of-use, and repeat purchases. Do the Webcomic stores you're tracking meet the grade? These are important questions, and their answers can spell the success or doom of any Webcomic's online retailing. Making a few key research purchases from existing Webcomic stores, and paying attention to the details, can teach you a heck of a lot…for under $100.

As you investigate Webcomic stores, you'll see a few key items coming up again and again: T-shirts, books, stickers, buttons, posters, original arts & prints, plush dolls, and digital offerings (such as wallpapers, e-books, and print-at-home materials). Looking over that list, here's what we can learn almost immediately: they almost all have a low per-unit cost — five dollars or less — and most are compact, durable and easy to store

Offering Pre-Orders

A great way to make sure you don't order more inventory than you can sell, and raise capital to pay for production of your merchandise, is to offer pre-orders to your readers. Be sure to inform your readers that the item they're paying for is a pre-order and when they can expect it to be shipped. If your merchandise flops, and you don't get enough orders to justify going through with production, you'll have to refund the money to the few people who did try to support your work. Most online payment services offer refunds within a month's time, so this isn't too much of an issue.

I've had great success with T-shirt pre-orders. I always know exactly how many shirts to order and don't end up with a bunch of inventory I'll never move. Plus, my bank account never takes a hit to float the capital for making the shirts. My readers do that for me.

Pre-orders are a great risk-free way to offer merchandise to your readers, but *stay on top of it.* Make sure you research your production and shipping costs so you can charge your readers appropriately and meet your promised ship date. If you have to cancel the merchandise production, promptly refund any orders you did get with a thankful apology.

— Scott

and ship. It costs you money to produce your items, to store your items, and to ship them. Keeping your costs studiously low on these three fronts is key, and it ensures a healthy bottom line. So it's not an accident that you'll see most Webcomics producing the same 3-10 types of goods: They work.

Realize that some of your merchandise will have a shelf life. For example, many Webcartoonists get very excited about producing a calendar branded around their comic. However, few people buy a calendar after January. If you get your calendar out in November (and you'd better), you're looking at about 8-to-12 weeks of potential sales. Furthermore, don't limit your merchandise's shelf life. For example, never include a year on the cover of a book ("The Best 'No Shoes For Tuesday' Comics from 2007!"). With a year printed on the cover, sales decrease sharply after that year has passed.

Additionally, you'll want to do further research into the work and theories of genuine experts, by diving head-first into business literature. Read anything and everything you can on small business operations and entrepreneurial start-ups. We've listed out some good reads at the end of this book. Do yourself a favor and thoroughly read them.

Your final research step, before you dive in to producing merchandise, is to crunch your numbers and see what your costs are, as well as your potential losses or profit. To get a ballpark image of how a new product might do, you'll want to determine the following:

(1.) Your cost-per-unit

(2.) Your break-even point on a full run of that product

(3.) Your potential profit if the run sells out

(4.) Storage costs (monthly or annually if it's a hard-to-store item)

(5.) Shipping costs per unit

Say you're doing a new T-shirt. Your per-unit cost is the sum of all the costs to you (total cost of all the unprinted T-shirts you're buying + the total cost of screen printing those shirts + the shipping and handling fees to have these printed shirts delivered to you), divided by the number of shirts produced.

Doing It Right

It takes as much energy to wish as it does to plan.

— *Eleanor Roosevelt*

Repackaging

The key to monetizing a Webcomic comes in repackaging. When I create any particular comic, I try to get paid for it at least three ways. 1.) From paying ads next to the strip, 2.) From book sales, when that strip joins others in a collection, and 3.) From sales of the original art. You can further extend that repackaging concept into t-shirts, bumper stickers, posters and more. But I always shoot for those basic three. The idea is to draw a comic once, but get paid for it multiple times.

— *Dave*

Your break-even point is the number of shirts you need to sell, at full retail price, to recoup your investment (i.e.: Your per-unit price, times the quantity produced, divided by the retail price of one T-shirt).

Your storage costs are a simple number to arrive at: Ideally, if you're storing at home, you have a zero or near-zero cost. But if you're using a public storage company or renting space from a family member or business, it's just a matter of figuring out much it would cost you per month to store x-number of T-shirts.

Your potential profit is the full quantity produced, times the retail price, less your production and storage costs. (Note: you'll never reach this idealized profit number, since there will be a fraction of your items that are damaged, a fraction that you give away as gifts or P.R. items, etc. But it's a helpful number to see whether a new product gives an adequate return-on-investment.)

Your shipping costs are the sum total of the costs to ship out one item to a reader. It includes the packaging materials, the labeling (the label and the cost to print the labels), the postage costs, the time required to package it and ship it, and the travel expenses to and from the post office. You'll obviously be charging this cost to the consumer, but it's still helpful to figure out before you order. Why? Because it'll tell you if your new-and-much-loved item will cost too much to ship — and so will suffer in sales. It'll also force you to reckon with how you'll be shipping it out and what shipping materials you'll be forced to use (and also keep in storage!) in order to ship it out. For example, a book and a T-shirt can, for the most part, be shipped out using similar shipping ma-

A Note On Government

The book in your hands will be distributed to much of the English-speaking world, so the legalities of your own business will vary hugely based on where you live. But let me give you the two-cent version. Regardless of the nation you're living in — regardless of the city or state you call home — when you start to operate a business, you immediately trigger a whole new set of laws, tax systems, and governmental filings. Whether you'll be operating as a sole proprietorship, partnership or a corporation,

you'll want to keep your business finances completely separate from your personal finances, and you'll want to make sure you're following all laws which apply to your business. So take this as gospel: If you're serious about operating your Webcomic as a business, make sure you're complying with all applicable laws and taxes. And if need be, spend $500-2,000 to have a lawyer and an accountant make sure you're on the right path.

— *Dave*

terials. But a poster, print or original art needs to be shipped out far more carefully, under umpteen layers of protection. Factoring those costs in during your planning will save you later on.

Now granted, this is not MBA-level business. It's bare-bones math scratchins. My hope is that you not only run these numbers but go more in depth with your forecasting. Unfortunately, I've learned from experience that many Webcartoonists don't even forecast the basics before plunging into some new product — and then they wonder why they've lost $3,000. My hope is that you're smart enough to run these and more detailed forecasts to determine whether a product is worth pursuing.

Ordering Merchandise

But wait, you're asking, which merchandise should I go into first? My answer is, the one that can make you the most money. Sound like a lame answer? It's not. You need to remove emotional considerations from the equation, ("Awww, but I'd wuv to pwoduce 40" plush dolls! Dey'd be so cute!"), and single-mindedly pursue the products that have the greatest potential to make you the greatest profit.

And as you're making that determination, you have to take into account your comic, your audience and your own business acumen. The bottom line is no two comics will have the same type of audience that spends their money on the same things. The alt-indie, young-hip-and-poor audience might respond best to T-shirts, while the tech-oriented, I-get-paid-a-lot-of-money-but-don't-date-much audience might respond best to role-playing games based on your comic. Build your store with products that make the best sense to your comic, to your audience, and to your bottom line.

If it's your first product, you're best off taking the plunge with an item you can produce in smaller numbers…say, 50 to 500. Usually, this means avoiding books or plush dolls, and opting for T-shirts, stickers, or buttons. Their investment costs are comparatively low, and you're not left holding a gazillion of them if they end up not selling. And of these, T-shirts are generally the best first choice, as their $4-6 cost-per-unit is nicely balanced out by a retail price of $15-20.

When you're ready to place an order, crunch different per-

Movin'

A Webcartoonist can work from anywhere. And if you live in an expensive city or region, making a move to a more affordable locale is a consideration. I know a half-dozen Webcartoonists who have made a go of their business by moving to a smaller, quieter, more affordable town.

A Webcomic isn't localized to this or that city: The entire English-speaking world is your potential audience. And a server farm is just as accessible from Kansas as it is from New York. There are considerations, of course: The consistency and reliability of your high-speed lines, your access to shipping services, etc. But if you're not tied down by geography, and if your research shows a better life elsewhere, a move could be the right thing for you.

— *Dave*

mutations of your costs to see what level of risk you're willing to take to achieve the maximum possible profit. If you order 500 shirts rather than 50 shirts, does your cost-per-unit go way, way down? But does the added risk of having to sell 500 shirts give you ulcers? Then order the 50. You're trying to build a viable business, but you have to do it at a level of risk that works for you. Taking a longer view though, you'll eventually have to start taking risks. Allow yourself a few business baby steps to learn the ropes, but know that you'll eventually need to accept larger and larger investment risks – or the profit rewards won't be enough to sustain your business.

When placing your order for your first batch of T-shirts, buttons, stickers, etc., make sure you've branded them with your URL. These items should not only be a profit center for you, they should also be walking billboards for your site. They tell other folks not only where they can buy an identical T-shirt but where they could seek out the Webcomic it came from! But a word of warning: Keep your URL on the smallish side. Folks aren't buying the T-shirt for its massive URL that takes up 50% of the space.

And one last note before you submit your first purchase order: Make sure you talk this over with your loved ones. Review the financials with your spouse, your family, and the people who love you and will be sharing in the stress of this. You'll need their emotional (and possibly financial) support if this doesn't sell, and you'll need their help fulfilling orders if it does. Do your relationships a favor and talk through the full implications of your new business venture.

Store

As I mentioned before, storage is a big consideration as you move into merchandise. Whether you have a few hundred T-shirts or a few thousand books, you want to make sure you're not stepping around dozens of boxes every morning just to get to the bathroom. And depending on how much you order, you may end up storing your Webcomic's merchandise for weeks, months, or even for years. And if part of your

The Subscription Wall, Part I

Any time the four of us give a talk at a comics convention, the question always comes up: "Why don't you guys charge readers to view your work? You guys are fools if you don't: You're just giving away your content for free!" This usually comes from folks who've made their living in print, and can't imagine a different way of doing things.

Here's the truth of it: Online readers have shown again and again that they're not willing to pay for content online. There are 10,000 failed Internet ventures — and an equal number of angry venture capitalists — to back that up. Sure, a few subscription models have worked, like the Wall Street Journal Online (which, it's worth pointing out, is both a business tool and a tax write-

off), but those are the rare, rare exceptions.

Secondly, you enter into a Catch-22 when you try to cash in on your readership by charging them a subscription fee. For example: Let's say you have 10,000 daily readers. The instant you put your content behind a subscription wall, you'll immediately lose a majority of them. But great, you're saying, I still have 3,000 readers left, and they're each paying $10 a year. Great. Awesome. Good for you.

But now, over time, you'll have a slow attrition of readers who stop paying — for all the reasons people normally stop a subscription (lost a job, moved, have a new baby, forgot to renew, etc., etc.). Where do your new readers come from

to take the place of those who are leaving? More to the point, how will you ever *grow* your readership? Remember: Your content is now behind a subscription wall. People can't virally share with friends how good this or that comic is, nor can forums point new readers to check out this or that storyline in your archives. It's all locked away.

Oh, I know! New readers will fall in love with the free "sampler" of 30 comics you generously put up on your site! I'm sorry to say it won't work: Gaining a new, loyal comics reader takes a lot more than that, especially if you're asking them to commit first by plunking down cash. Trust us: As much as we'd love them to, subscription walls don't work.
— Dave

planning was to keep all that in the middle of your living room, then you need to make better plans!

To help you out, I'll give you a rough idea of the storage space you'll need to account for. These will vary, of course, based on the sizes you order, but it's a useful ballpark:

- 100 T-shirts will fit in a box roughly 30" x 30" x 30".

- 1,000 bumper stickers or buttons could potentially fit in a box 1/4 that size.

- 2,000 books will fit on a 4' x 3' wooden palette, and sit about 4' or 5' high (and weigh anywhere from 800-2,500 lbs).

- 50 plush dolls will fit in a box roughly 40" x 30" x 20"

If you're living in an apartment, your storage limitations are obviously greater. Depending on what you're ordering, you'll need an extra room, a large closet, or a unused corner of your place. And if you're a house-dweller, you hopefully have the added benefit of a garage or an unused room. If you're storing at a for-pay site, you'll want to make sure it's close to your residence and open when you need access. But in all cases, you need to make sure your storage is clean, dry (especially for books and T-shirts), organized, and can be locked up. Take note of every warehouse you've ever seen, and keep items raised up off the floor, in case of spills or pipe bursts. And for God's sake, be conscious of the load-bearing abilities of your floors! Don't store thousands of pounds of books on the second story of a 1920s farmhouse or on a house with a raised wooden foundation. Even if it you're "sure" it can handle it, why test it?

Organization won't be a problem at first, when you have one T-shirt, or a selection of buttons. But as your store grows in volume and variety, you'll want to invest in a workable organization solution. Costco, Sam's Club, Home Depot and Lowe's usually have steel shelving that can hold a few thousand pounds of books for under $75; meanwhile IKEA has some great low-cost solutions for baubles and T-shirt storage. If you're clever, you can organize this shelving to "flow" into your shipping center, which we'll talk about in a minute.

Selling

There are a dozen options in selling items through your site, but all of them share two basic elements: A Web page showing and describing your items for sale and a merchant system that can process their payment. The first one is easier to master: a quick photo, a clever paragraph of copy, and BAM – you're product is up for sale. Make sure your store copy hits a tone that matches your site, though. Is your site goofy, but your store is suddenly very serious? Match the tone! Remember: The point of your Webcomic is to entertain, and what people are really buying is an extension of that entertainment into the rest of their life. So continue that fun-loving mood into the buying process.

THE ARTIST: WORST SALESPERSON IN THE WORLD

Accurately describing your products is still a must — this is a business transaction, after all — but why not introduce a joke or two? Make your store an extension of your Webcomic, and it will make it easier for folks to crack their wallets.

The second part of the equation is your store's merchant system — how folks will pay you for your stuff. Sure, you can go super-low-tech and have folks mail you personal checks, but this is an immensely cumbersome, slow, and sales-killing process. Any extra time folks are given time to consider their purchase — and checks certainly require extra time to fill out and mail — results in a loss of sales. Nope, what you'll want to do is set up an immediate, electronic means for folks to pay.

The most common means to achieve this is to use a middleman such as Paypal or Google's Checkout cart system. These companies process payment from your customer's credit card, e-check, or stored-money account. They take the money from the customer, remove a cut (usually in the 2-3% range, plus a flat $.30-or-so fee) and give the net to you. The beauty of this is that you don't have to set yourself up with a traditional, merchant account to accept credit cards, and it transfers the risk of rejected credit cards off your business and onto PayPal or Google.

Once your business grows to a significant volume, it may be worthwhile for you to begin accepting and processing credit-card payments yourself, using your own merchant account. If you shop around, you can get your credit-card processing rate down to 1.5%, plus a flat per-order fee of $.10 – .30. Is it worth it? With much higher sales volume, yes. Just crunch the numbers as your business grows: you'll know the point where it makes sense to make the shift. When it comes time to do it, you'll have to get your company approved by a merchant card processor to accept credit card payments. Then, you'll have to install on-server commerce software like LiteCommerce or X-Cart, or use remote-server software like Volusion.

These programs track inventory, order dates and addresses, calculate shipping… they're a lot nicer than keeping track of it all by hand. Other outfits like Yahoo! also offer small business storekeeping for a small fee per month, so installing shopping cart software on your site isn't entirely necessary. But, if you can do it, why not take total control of your store and pay nothing for it?

Pricing

Setting prices for your store is a two-part consideration. First, how much did it cost you to produce the item? If you did your research well, you found the lowest-cost or

near-lowest-cost producer to make the highest-quality product. Now, you need to set a price that both gives you the maximum profit, but which also produces the highest volume of sales. It's a delicate dance. The quickest and easiest guide is to see what your competitors are charging. How much is a T-shirt at the average Webcomic store? How much is a book collection on Amazon? Take a long, hard look at what the market can bear, and set your prices accordingly. But know this: You can always come down in your prices with sales, promotions, and temporary or permanent price reductions. Raising prices is much harder to do. So if you're taking an educated guess with your first set of prices, err on the side of higher prices.

Your first store products, as I mentioned before, will probably be T-shirts, buttons, or stickers. You can produce them at smaller quantities, and so there's inherently less risk to them. But over time, you'll want to create a store with three levels of products:

> • Low-price, entry-level items (stickers, buttons)
>
> • Mid-price, mainstay items (books, plushes, T-shirts)
>
> • High-price, aspirational items (limited edition books, toys, prints, and original art)

Each of these serves a purpose in your store, and each caters to a different level and type of reader in your audience. New readers and casual readers will gravitate toward the first, while serious and hard-core readers will naturally be drawn to the second two. The goal, of course, is to move your readers up the chain toward the limited-edition, higher-price, higher-profit items. Selling five pieces of original art for $100 each makes you as much money as selling 33 T-shirts at $15 each. Which would you rather do? The truth is, both! But you'll need a wide variety of items to capture different readers in different moods.

When your store is in place, and your prices are set, you'll want to start crafting a sales and promotional calendar for the

The 10% Rule

How many of your readers will actually buy a book, a T-shirt, or a bumper sticker? Conventional wisdom among Webcartoonists is that 10% of your readership (5-10%, playing it safe) will actually crack their wallets. It's a useful metric to keep in mind when you start pursuing different kinds of merch.

— Dave

The Subscription Wall, Part II

You create your Webcomic, and with each new installment 10,000 readers are entertained. What's better, they're telling friends about your work, new readers are diving into your archives, and your readership is growing.

Here's where a subscription wall might — *might* — be of use.

Keep all existing work on your site free (including your regular updates), but offer additional, unique content for those who are willing to subscribe. There may be a core audience who is willing to pay up for a little something extra.

— *Dave*

upcoming year. This calendar will take into account holidays, new product launches, convention appearances, and the slow-sales summer months. Your calendar will make sure that there is a new sale, promotion, or product in your store every month out of the year. You can't produce one T-shirt or book a year and expect to make a living off of it. Similarly, you can't make a living just off your Christmas sales. You need to plan out your store to provide income all year-round. Put another way, you need to give folks a reason to visit and revisit your store throughout the year.

For truly special items, such as one-of-a-kind sketches or original art, or last-of-their-kind T-shirts or books, you may want to sell them on eBay rather than your own store. Most of your items will be standard commodities, with fixed prices and sales. But for the specialty items that will inevitably come up in your artistic life, move the sale to eBay, and let your readership bump up the price by bidding. You may be surprised by how high the prices will go on rarer items.

One final note about selling: You must be logical, analytical, and cold-hearted in managing your stores. Don't cater to your inner, sweet artist. Cater to your inner, grim businessperson. Never be afraid to cut or avoid unprofitable ventures no matter how cute they are or warm-hearted they make you feel. Would your artist side love to do a highly articulated, plush doll despite your business side telling you that you'll need to sell 3,000 before you'll break even? Let your business side win. Do you have a T-shirt you love, but no one else seems to want to buy it? Put it on sale, recoup your investment, and discontinue that line. Be logical, cold-hearted, and consistent in your business decisions. Your artistic side will hate it, but your business side will love being able to pay the bills. Of course, this is the exact opposite for how you should treat your Webcomic itself! There, always let your artist side win!

Shipping

If you put up your store and get no orders, your heart will sink, and you'll start talking yourself into a panic. But you'll find the same thing happens if you do start making plenty of sales. Now you have to ship out all the dang things! How do you do that?

My advice is to start small. Make your "starter" shipping process as simple as possible. When an order comes in, just

print out a packing slip, put it in a store-bought padded envelope along with the product, hand-label the package (or print it out on a little Avery mailing label), then head down to the post office to mail it off. It won't be all that different from how you'd send out a normal package or gift from your house to a friend. There's no need to invest in a bunch of shipping equipment until you're sure this will be a viable income stream. And this initial, bare-bones type of shipping will be a good learning process in the different types of mailing classes, international requirements and packaging limitations. The Post Office has some arcane rules — many too complicated to explain here — and starting with a bare-bones system will help you learn them as you go.

As your store starts to expand, though, you'll start to notice problems that need to be addressed — all of which revolve around your costs, your workload, your space, and your time. For one thing, the store-bought envelopes you've been using don't do the greatest job protecting your merchandise. A few customers have e-mailed saying the product got damaged in transit…and now you're left refunding or replacing it. Additionally, the cost of all those 10-packs of padded envelopes are starting to add up at Staples' or Office Depot's prices. They're just too much per unit. And labeling by hand or with Avery stickers is a pain, too. It's all just too much time and too much trouble. Then, as a final coup de grace, standing in line at the Post Office for 20-40 minutes is reeeeeeally starting to chap your hide every time you need to ship.

So here are the two companies you need to become familiar with: Shipping-supply companies and online-postage companies. Both will simplify your shipping process and make your life much easier.

There are dozens of large shipping-supply companies I could recommend to you, but I'll stick with the one I'm most in love with: Uline. They have great per-unit costs on bulk shipping supplies; have every permutation of box size, envelope size, flat-

Fulfillment Centers

There are companies – large and small – who will do your shipping for you. "Huzzah," you're saying, "why didn't you just tell me that?!?"

Well, remember, every other party that you involve in your Webcomic's store is another chunk of profit you're giving up. And with fulfillment, it can sometimes be a pretty big chunk.

Fulfillment Centers may indeed be the best solution for you and your lifestyle, but I'd advise not starting out with them. Early on, your store's volume won't be high enough to make that profit-cut workable for your business. As you grow, though, it could very well be the service for you.

— Dave

pack and bubble mailer imaginable; have speedy delivery; and can even work on 30-day payment terms. When you've grown tired of using all-purpose, store-bought bubble envelopes that cost a $1.80 apiece and don't really work for the merchandise you sell, go to Uline.com.

Then, sign yourself up at one of the online postage companies such as Pitney-Bowes, Stamps.com or Endicia. Personally, I would recommend Endicia, as it works with both PC and Mac systems, but I've heard equally nice things from Webcartoonists who use Stamps.com. Endicia has a wonderfully intuitive interface: It lets you log and track old orders; lets you save your shipping settings so you don't have to constantly re-enter data on different types of packages, weights, and items; it lets you bypass the old, clunky international customs forms that required a hand signature; and it even sends out notice and tracking e-mails to your customers so they know their order is on its way! And very conveniently, the print-postage-at-home feature lets you bypass standing in Post Office lines: Just drop it off at the counter and you're right back out the door. There is nothing so enjoyable as making eye contact with someone waiting in a 30-minute line, as you dash in and dash out.

Your print-at-home postage service will require a specialized thermal printer and corresponding labels. I've had no complaints using a Dymo LabelWriter 400 Turbo with "Three-Part Internet Labels" (30383 or 30387), but I've also heard good things from folks who use a Zebra-brand printer with the 4" x 6" "One Part" labels.

When you're shipping out orders, try not only to do the job right — try to go the extra mile:

> • Make a pledge to ship out all orders within a few days, and stick to it. Who wants to place an order, and then have it arrive umpteen weeks later?

> • Make sure that the product is adequately supported and protected by the shipping supplies you use — don't just toss it in an envelope and go.

> • Include a packing slip. It's a small thing, and one easily forgotten by many Webcomic stores. But it's one of those things that makes buying online feel more pleasurable when the package arrives.

> • Go over-and-above to make the customer feel special when they open your package. Can you dash off a sketch or a signature in a

book? Or include a sticker (that costs you $.05) as a surprise? Can you personalize the packing slip with a quick note of thanks? Then do it. All those little things will not only make a happier (and returning) customer, it'll help cement that goodwill we talked about in the last chapter, and encourage new evangelists for your store.

• And on that note: why not slip in a flyer or coupon for discounted future buys? It's much easier to keep a current customer than capture a new one: Cement that relationship while encouraging additional buys.

• Finally, do the right thing if the Post Office makes a mistake with your shipment. It's not your fault if the package got lost or ruined, but your customer doesn't care. All he or she knows is they bought a product and now it's not right. Get a customer for life by mailing them another one for free, or refunding their money in part or in full. Remember: this is one of those reasons why we kept our costs-per-unit low!

Not only are there millions of entertainment options for folks to choose from online — there are millions of things to *buy*. And if you're going to get folks to buy from you, especially with the small audience you'll be starting out with, you need to do these extraordinary things to separate yourself from the pack. Make buying from your Webcomic something awesome, and people will want to do again.

Diversifying Your Portfolio: Multiple Revenue Streams

Like any good money manager would tell you, it's never a good idea to have all your eggs in one basket. Diversification of income from multiple revenue streams is absolutely key, if your business is to survive and grow through varying economic periods of boom and bust, and through the various financial cycles that your own readership will go through. In short, take a look at all the income streams I've mentioned above, and build your business to incorporate a bit of each. If your business relies 90% on T-shirt

sales or advertising, that's a business model that will falter at some point in the future. So, just as you would with a mix of stocks, bonds, mutual funds and international investments, balance out your store's "portfolio." Build a Webcomics business that incorporates merch, advertising, books, art, convention appearances and more.

Some Last Thoughts On Selling

Running your own store isn't for everyone. I know that. And I feel for you if it's a gut-wrenching experience, or if it's not working out. I'm an artist, too, and I can understand if the whole process of selling befuddles you, or makes you nervous, or if you suffer from an endless series of loss-making mistakes. I've been there. And in part I share your frustration that, in Webcomics, this has proved to be the main path toward make a living.

So here's my last bit of advice on the subject, and it's tough-love: If you've put good money after bad into your Webcomic business, and it's just not working out… stop. Some artists, and some Webcomic titles, just aren't cut out for this business model. And that's OK. I'm not cut out to be an architect — as much as the younger me thought that might be nice. There comes a time when we all have to step back, reevaluate, and make a tough decision as to what we're best suited to in life. Know that *this doesn't in any way make you less of a cartoonist*. That's critical to remember. It just means you'll have to carve out a different path — your own path — in trying to make a living from Webcomics. And to help you find that different path, let me quickly mention a few additional sources of revenue that you could pursue with your Webcomic.

If your Webcomic appeals to a very specific niche audience, try to work yourself into speaking engagements at their events or gatherings. Two great Webcomics, "Unshelved" and "PhD" (Piled Higher and Deeper), appeal to librarians and grad students, respectively. They've both made great side-businesses of giving paid talks and presentations to these groups. Even better, both Webcomics build on that income by selling books and merchandise right after their talks. It's a brilliant double-whammy! If this is something

that interests you, and you have a specific niche you could appeal to, you can start down that path by giving talks at your local library or Rotary Club meetings. Those smaller talks are a good testing ground for your presentational skills, and may, in the case of some libraries, provide you with a few bucks in speaking fees.

An additional quick source of revenue is immediately familiar to any graphic designer or artist alive: Freelance work. In your case, freelance work that involves your cartooning skills. There are entire books devoted to acquiring freelance work, billing for it, and the ethical and business considerations around it, so I won't do much other than mention the possibility here. And I'll share one tiny warning: never use your characters or your unique intellectual property in the freelance work you do. When you produce freelance work, the final product is rightly owned by the company or person who paid for it. You don't want to make the mistake of having them "accidentally" owning your characters or intellectual property. Use your cartooning skills, but not your cartoon characters.

And of course, there are still the traditional means of making a living from a comic. Newspapers may be shrinking in numbers, readership, and in individual page-count-per-edition, but they'll still be a viable business for another decade. Syndication is still a possibility for 2-5 new artists a year. Comic book publishers, too, are not where they were in their heyday, but there are still livings to be made, there. And traditional magazine cartooning can still supplement your revenue streams. If you can make any of these work for you, they're all worth considering.

But if your desire is to monetize and make a living from your Webcomic, then take another look at the business model used by the majority of "successful" Webcomics today: *Ad-subsidized sites selling self-produced merchandise, using the least middlemen possible.* You, certainly, can walk your own path, if you have the next great idea to monetize your Webcomic. And I encourage you to experiment and pursue different opportunities and revenue streams as they arise: The landscape of the Web changes faster than this book can be reprinted, and there will undoubtedly be new possibilities next week that weren't there before! But however you monetize your Webcomic, all I ask is this: Thoroughly do your research, fully explore the risks and rewards possible with your new business venture, and then plan for the worst while you work your absolute heart out to achieve success.

Books

Wait a minute. You're a Webcartoonist and you want to print a book? On dead trees?! What are you — some kind of irony-hungry Luddite?

Um...No. You're a good businessperson.

At the dawn of the Internet Age, the death toll began ringing for print publishing.

Again.

It happened when radio boomed. And movies were absolutely supposed to kill print — TV, too.

Instead, print publishing has experienced a tremendous boom. Technology hasn't killed the printed word — it has made it possible for almost anyone with a computer to get into the game.

And that's good news for you, my friend, because once you've established a healthy fan base on the Web, you can start earning money selling them books. And you're going to find out that people will spend money on book collections of comics they read on the Web.

Not bad for a Luddite.

Book Learnin'

First, let's cover some terms and concepts involved with the publishing world. You're going to have to make a lot of choices about your book, so it's best to speak the language.

Spine: The end of the book into which the pages are attached. Often, if the spine is large enough, the book title, author and publisher are printed on the spine.

Perfect binding: In this binding process, glue is used to hold all of the pages together in the spine of the book. Perfect binding is preferable to the other binding option — saddle-stitching — that is available to you, but most printers won't perfect-bind a book unless it meets a certain page count. Most soft-cover books use this technique.

Perfect binding: Pages are glued into the spine.

Saddle stitch: In this binding process, pages of a book are held together with staples in the spine of the book. This should be used only for books that don't meet the requisite page count for perfect binding. Most

Saddle-stitch binding: Pages are stapled into the spine.

superhero comic books and children's coloring books use this technique.

Stock: Paper type. Paper is often described in points and/or pounds and with modifiers such as "matte" or "glossy." The

"Imagine a pub-
lisher who recog-
nizes that the way
to attract readers is
to give them qual-
ity cartoons... and
that the way to get
quality cartoons
is to offer artists a
quality format and
artistic freedom.
Is it inconceivable
such a venture
would work?"

— *"Calvin and
Hobbes" creator Bill
Watterson, unaware
that he could have
been talking about
Webcomics*

number of points describes the thickness of a sheet in thou-
sandths of an inch, so .010 would be 10-pt. stock. Pounds are
determined by the weight of 500 20x26" sheets. A matte finish
will reflect less light than a glossy finish. In general, I like a
heavier, glossy stock for the cover and a lighter, matte stock
for the interior pages. Your printer will give you a list of paper-
stock options. If you're having a hard time deciding, ask to see
samples.

Publisher: Handles all of the production work involved
with getting a book out to the public such as printing the book,
establishing an ISBN/bar code, distributing to retail outlets,
etc. They pay the initial printing costs and pay you when the
books sell as a "royalty."

Royalty: The money that you, the author, receives from the
publisher. This may be a flat rate or it may be based on a per-
centage of the wholesale or retail price.

Printer: Don't confuse a printer for a publisher. A printer
prints your book. Then the printer sends the book back to you
to do with as you may. When you've accepted the shipment of
books, your relationship with the printer ends until the next
book project. The exception to this rule lies with printers that
also offer services (usually storage and distribution) for a fee.
These services should not be considered part of the typical
printer's responsibility, however.

Unit cost: Covered in detail in the preceding chapter. In
this case, it's the amount of money, per book, that it costs you
to print your books.

Cover price: The total amount of money that is charged (at
retail) for one of your books.

Run (Also, press run or print run): The number of books
that you order from the printer.

Distributing: Shipping packages of books to a retailer or
to another distributing agency.

Order fulfillment: Processing the order (including accept-
ing payment by credit card, Paypal, check, etc.), keeping track
of inventory, keeping track of overall sales, and packaging and
shipping the product.

Are You Ready For a Book?

Collecting your comics into book form is a big step. It re-
quires a big investment of time, energy and money. But it can
result in a significant source of income. Let's take a look at
some factors to consider when you're deciding on self-publish-
ing.

Do you have enough comics for a decent-sized book? My
rule of thumb is to assemble the comics into yearly offerings.
Each book will contain about a year's worth of comics. This

gives you plenty of time to process the image files and design your cover. And it also keeps your readers from being inundated with sales pitches from you.

Interestingly, popular newspaper strips traditionally gathered their yearly output into three annual books: Two smaller, 8.5" x 9" books; and one larger, 8.5" x 12" "Annual". The Annual, cleverly enough, combined the two smaller books along with a few pages of additional content, and voilà! Three books sold to the same reader, using the content for two books. Am I recommending that? Heck no...I always found it skeevy. But I give a hearty thumbs up to the idea that you could produce two 112- or 128-page books a year if you have 365 comic installments.

Do you have enough readers to justify a book? Chances are, you're offering your comics on the Web for free. (Dave just got done talking about business models in the preceding chapter, so you're aware of the hardships involved in launching a Webcomic on the subscription model.) As a result, you have to realize that the vast majority of your readers are passive. They come to the site, enjoy your comic, and move on. They may not feel as if they're part of a community (yet) and they haven't developed a passion for your work (yet). I always estimate that about ten percent of my daily readers will support any merchandizing project I offer. And I'm prepared to accept that my estimate may be somewhat high.

Do you have enough content to offer in a book? A collection of your strips is a perfectly fine offering, but readers often become more willing to purchase a book if it offers them something they haven't experienced before on your Web site. Perhaps you might consider a bonus story — or a section of commentary or background information that you provide. You might include images from your sketchbook. And you might even take those individual strips and find a way to package them that presents them in a whole new way for your readers.

Soliciting Quotes from Printers

Finding a printer who can produce the highest-quality book at the lowest price is key in self-publishing. To do that, you'll want to solicit price quotes from different printers, who will tell you how much it will cost them to produce and ship your books to you.

When soliciting quotes, make sure you submit the same book specs to all the printers. For example, don't have one printer quote their price on a 80-page, 4-color book using 80-lb paper, and the next printer quoting an 88-page, 1-color book on 80-lb paper. Additionally, you'll want to keep in mind that North American and Asian printers sometimes use different specs or terminology to describe their paper — so look online for conversion charts to ensure your asking for the right thing.

With both price and materials, you want to make sure you're comparing apples to apples.

Here are some printers from whom you can solicit quotes. Transcon and Lebonfon do the most comics printing in the North America, so there's a wealth of experience in those print houses to help you through the process.

1.) Transcontinental (Canada) www.transcontinental.com

2.) Lebonfon (Canada) www.lebonfon.com

3.) Donnelly (US) www.banta.com

4.) Brenner Printing (US) www.brennerprinting.com

5.) Diya (China) www.diyausa.com

Also: If you've never used a particular printer before, try asking for samples of their past projects, or for samples of the cover and text stock they'll be using to make your book. It never hurts to double-check quality.

— *Dave*

Self-Publishers vs. Publishers

There are a number of companies that publish short-run books. They cover many of the incidentals such as the ISBN and often assume the duties of storage, distribution, and order fulfillment. You may be very tempted to give your book over to such a publisher. It's certainly easier than self-publishing, and you might even reason that the lower royalty you'll receive is offset by the money you'll save in storage fees, shipping costs, etc.

Before you enter into an agreement with a publisher, however, do your research. Find out who else has done business with this publisher previously, and get in touch with them. Note, I didn't say "ask the publisher for references." Of *course* the publisher is going to send you to people who have good things to say. Do your research. Then, ask the publisher's clients a few questions:

(1) Are you happy with the quality of your book?

(2) Are you happy with the amount of time it took to have your book printed and ready for sales?

(3) Were you surprised by any parts of the contract that weren't immediately clear?

(4) Are you getting paid regularly — and accurately?

(5) Are you planning to stay with this publisher for the next five years?

(6) Would you recommend I do business with this publisher?

Invoices

Your invoice is a bill you submit to an organization that asks for payment for your services. Invoices typically include the following information:

(1) Your company name and the word "INVOICE" at the top
(2) Invoice number
(3) Your billing address, including phone number, e-mail, URL
(4) Your shipping address
(5) The date of the invoice
(6) The date payment is due
(7) Any identifying numbers, such as your EIN (Employer Identification Number) or Tax I.D. number
(8) Any identifying numbers required by the other part (i.e., their PO (Purchase Order) number)
(9) A brief description of the goods or services performed, itemized
(10) The total amount payable.

This next part is a little trite, but I print one of my comics at the bottom of an invoice — especially if I'm sending an invoice to a comic shop. I think it makes my invoice a little harder to drop to the bottom of a pile.

— *Brad*

Greystone Inn comic strip
86 North Beech Street
Philadelphia, PA 19130

Invoice

Date	Invoice No.
06/11/07	46

Bill To
Diamond Comic Distributors
Attn: Accounts Payable
1966 Greenspring Drive #300
Timonium, MD 21093

Ship to
Diamond Comic Distributors
Attn: Accounts Payable
1966 Greenspring Drive #300
Timonium, MD 21093

P.O. No.	Due Date	Date of order	Order No.	Project	EIN
200704	07/11/07	05/09/07			20-2467

Item	Description	Qty	Rate	Amount
Lightning Lady, Best of GI	Graphic novel	133	5.45195	725.11
	Purchase Order # 200704			
	EAN: 978141			
	DCD ITEM NO: APR0737			
Order is complete!		Total		$725.11

You might add up all the variables and decide to enter into a business agreement with this publisher. Or you might decide that you'd be much better off if you learn to do this yourself. You'll make a better profit. You'll become a better businessperson. You'll be in complete control of your future. And you'll have a skill that you can put to use for the rest of your Webcomics career.

To be fair, you should take a long, hard look in the mirror before you undertake a self-publishing project. Here are a few things to keep in mind:

(1) This is going to require a lot of extra work on your part.

(2) You're going to have to learn as you go, and you have to feel comfortable asking a lot of questions.

(3) Unless you purchase a service, you're going to be storing, distributing, packaging and shipping these books yourself.

The Case for Self-Publishing

Brad's given a great explanation as to why you should start with a POD service, but now I'd like to sell you on the merits of self-publishing. There's more risk, more hassle, and a much trickier learning curve with self-publishing, but I strongly believe that the alternative can't provide you with a living.

There's just not enough profit-per-unit in POD. And if your audience size isn't large enough to entice a traditional book publisher, then you'll have to consider self-publishing as a route to larger profit potential. To Brad's point, though, take a long, hard look in the mirror before you do. "Larger profit potential" can become "Larger-loss-making potential" if you handle it incorrectly.

There is a difference between a "printer" and a "publisher", and in the case of self-publishing, you are the publisher.

It's you who coordinates the production files and layouts, you who solicits quotes from various printers, you who pays all the bills, and you who accepts delivery of palettes of books. POD prints up books one-at-a-time. Here, you're ordering thousands in one throw. All of this means more paperwork, more research, and an up-front investment.

What type of book should you do? The short answer is a 4-color cover, 1-color (black) interior, trade paperback.

You'll want to avoid hard covers or 4-color interiors, as those will bite into your profit margin (though that might be unavoidable, if your work absolutely, positively relies on color).

You'll also want to avoid "shorter" books -- say, books that are 30 to 90 pages. Shorter books come with a lower perceived value in your readers' eyes, and so command lower prices. That, of course, translates into smaller profits for you.

A 32-page comic book may cost next to nothing to produce, but if your profit margin is only $1 or $2 per book, how many of those puppies do you have to sell to make a living off of them?

In comparison, going with with a 4-color cover, 1-color interior, trade paperback can get you a profit margin of $11-14 per book. That's the route you want to go.

Of course, I can now hear you thinking, "Why not make an even bigger book of 250 pages? Surely that will get me even larger profits!" Well, yes, it will, but it's a diminishing return on your investment. Once you get in the 150-to-300-pages range, there's only so much more cost your audience will bear.

My advice? Stick to the magic page-range used by most traditional comic-collection publishers: Between 100-150 pages. It will provide the best return on investment for a print run of your size.

Which leads us to our final consideration: What size print-run should you do? Again, you'll have to compare the numbers quoted to you by your printing company against your expected retail price, but here's a general guideline: If you can't sell at least 500 books, don't self-publish.

A run of 2,000 trade paperbacks, costing you, say, $2.75 a unit, will mean a $5,500 investment. If you're selling those for $15 each, you'll need to move 366 of 'em, just to make your money back.

— *Dave*

Spine-Side Curving

Open up a book to its middle pages. See how the pages curve in towards the spine of the book? Anything that is printed in this "curve" area may be difficult for your reader to read. We've all read poorly designed books in which we had to pry the book wide open to see what's going on in this area.

And then we're surprised when pages start falling out because the binding has been damaged!

I like to leave between 0.25" and 0.5" on the spine side of each page to account for this curvature. For an odd-numbered page, this is the left-hand side. For an even-numbered page, this is the right-hand side.

— Brad

Print-On-Demand

Print-on-demand (POD) services, such as Lulu.com and lightningsource.com, take a little bit of the sting out of the above decision-making process. As the name implies, print-on-demand means that the book does not get printed until a customer purchases a copy. It is then printed, packaged, and shipped directly to the buyer. The POD agency keeps a portion of the cover price, and you earn a royalty for each copy purchased.

I've done several books through Lulu.com, so much of this chapter will be based on my experience with them. You'll want to research all of your options and learn as much as you can about each before you make your own decision.

(I'm going to call them "POD agencies" since they can sometimes act as a publisher and sometimes as a printer.)

Print-on-demand has a tremendous advantage over traditional printing: You don't have to buy a huge number of books, store them, and fulfill the orders. You simply upload a PDF of your book to the print-on-demand service and they print one for every customer.

Obviously, the cost-per-book is higher than if you were ordering a couple thousand books from a printer. But that is offset by the fact that you're not paying for storing, selling, packaging, and shipping the books.

Many POD agencies will offer a discount if the author buys a large number of his or her own books. This can offset the higher unit cost of your books, making it possible to buy books in bulk to sell yourself — for example, at a comic convention. This is a good way to maximize your profits at a public appearance, since you won't be spending money on packaging or shipping.

Buying your own books in bulk from a POD agency also enables you to approach smaller retail outlets such as comic shops and mom-and-pop bookstores and sell them a small number of books to be sold in their store.

Print-on-demand is perfect for a cartoonist who is just start-

ing out. It's an easy way to get books into the hands of a small number of people (say, a couple hundred).

I found that I had to abandon POD publishing when I started offering my books to retail outlets through a distributor. Unfortunately, the higher unit cost of POD books made it impossible to turn a profit after the traditional 65%-off-cover discount. We'll talk about distributors a little later in this chapter.

Setting Your Price

It is crucial that you do a little math before you set a cover price.

Your cover price has to be set high enough that you still make a profit once all of the costs are subtracted. These costs include (but are not limited to): Unit cost, shipping from the printer, storage fees, POD fees (if applicable), and wholesale discounts.

Let's take them one at a time.

Unit cost: Unit cost is the cost of printing your books divided by the total number of books. You may want to factor in the entire cost of printing — including incidentals such as paying for your ISBN and shipping the books from the printer to your house or storage facility.

If the printer's shipping fee isn't already included in your unit price, you should account for it now. Take the total dollar value and divide it by the number of books you have printed to get a per-unit value.

Storage fees: If you're paying to store the books, include this on a per-unit basis, too (Cost divided by number of books).

POD fees: If you're working with a POD agency, any money the agency takes out in the transaction, per unit, should be accounted for in your cover price.

Order-fulfillment fees: Any money that you put into packaging (boxes, bubble-wrap, tape, etc) and shipping the books to customers or distributors should be accounted for — and divided by the total number of books to give you a per-unit number.

Wholesale discounts: If you'd like to see your book in bookstores, comic-book shops and other retail outlets, you need to understand that they buy the books from you at 60-65% off the cover price. Therefore, your cover price must be high enough that you need to cover all of the costs listed above — *after* you subtract 65% off the cover price.

Of course, if you're starting out and you're not attending a significant number of conventions and you're not offering books to retail outlets, then much of this is going to be overkill for you. For now.

Proofs

When you're paying to have a run of your book printed, it's a pretty serious investment. Early on in the process, after you've send your master files to the printer, they should either send you a physical or digital proof of the book. The proof is like a prototype, and lets you know what you're going to get in bulk after they do the printing.

Look over that proof carefully! You don't want to be sitting on 1,000 copies, all with an error or printing mistake on page 91. When I did my first "Starslip Crisis" book, I got a digital proof — a PDF file showing what their press would print out. In it, I noticed a barely noticeable "snowy" effect on Vanderbeam's clothes and hair.

I thought, "Well... that shouldn't show up in the actual print," but I'm so glad I reinvestigated. Turns out I was using a color just slightly lighter than true black for the fills on Vanderbeam! I went back, fixed it, and resubmitted the files.

I don't know whether that snowy effect would have shown up or not... but better safe than sorry. Make sure you inspect your proof.

— Kris

But there will come a time (because you're that good) that you will grow your Webcomic to the point that these issues become very important to you. And when that time comes, you need to be ready.

ISBN

If you're going to sell your book through retail outlets, you're going to need an ISBN. The International Standard Book Number (ISBN) is a 13-digit number that uniquely identifies one title from one specific publisher — allowing for more efficient marketing of products by booksellers, libraries, universities, wholesalers and distributors.

To my knowledge, the only legitimate place to purchase an ISBN is through R.R. Bowker at ISBN.org — in groups of ten, 100 and 1,000. Beware of Web sites that claim to be able to sell you an individual ISBN. You may end up with an ISBN that fails to identify you as the publisher of your own book.

A set of ten ISBNs costs $245 plus a $30 registration fee.

You may not reuse an ISBN for another title. And you must use a new ISBN if you re-publish your book later in a different format (for example, a hard-cover edition of a softcover book).

Bar Code

Of course, securing your ISBN is only half of the battle. Selling in the retail market means you have to have a bar code on your book. The bar code — or UPC (Universal Product Code) symbol — is the ISBN number transferred into vertical lines that can be read by a scanner and identifies the title, author and publisher of the book.

As you're purchasing your ISBN, Bowker will try to sell you bar codes at $25 apiece.

But you might choose to use one of the many free bar-code generators on the Web. Google "barcode generator" and you're liable to find several (http://www.tux.org/~milgram/bookland/ for instance).

You can also purchase software to do it on your computer. I've used Intelli's Barcode Producer 4.6 (for Mac) and I've been very happy with it. It's available for about $150.

DAVE

When you create your bar code, you will be asked to assign a cover price to the book. If this cover price changes before you publish your book, you must create a new bar code. If you look at a bar code, you can see the cover price included in the code. It's the five-digit number that starts with the number 5. The four digits after that is the price, in dollars and cents. If that number starts with a 4, it represents the price in Canadian currency. If it's 59999 or 49999, the price is over $100.

Book Construction

A book can have any page count as long as it's divisible by four. Some printers — especially POD agencies — are the exception to this rule, since they use a high-quality photocopier for their printing process instead of a printing press.

Every page in a book is printed on half of a very wide sheet of paper ("stock") that is folded in the middle. For example, if your book measures 8.5x11", it was printed on stock that measured 17x11". Every sheet of stock in a book holds four "pages" — two on the front and two in the back. As a result, your book's total page count must be a factor of four — or you will wind up with blank pages.

Pull the pages out of a newspaper to see exactly how this works.

Impositions

On the *off* chance you're asked to submit your files to a printer in "page pairs" or "impositions" let me give you a brief overview.

Instead of pages in numerical order, your document will be set up to reflect the sheets of stock with two pages on each sheet. (Turn the page for an illustration.)

To figure out what page gets pairs with what, use the formula T+1-P. "T" stands for the total number of pages in your book. "P" is the page number you're trying to pair.

If it's a 44-page book, and you're trying to find the page pair for Page 36, the equation is 44+1-36=9. Page 9 pairs with Page 36.

Just remember, even-numbered pages are always on the left and odd-numbered pages are always to the right of the imposition.

In a 12-page book, the first imposition would have Page 12 on the left and Page 1 on the right.

— *Brad*

Back cover — Spine — Front cover

On Criticism...

A book is a mirror; if an @$$ peers into it, you can not expect an apostle to peer out.

— *G. C. Lichtenberg*

Most printers will accept single-page files and distribute them appropriately in the printing process. In other words, as you're designing your book, you simply design a multi-page document at the page size (not the overall stock size), and create the pages in numeric order (Page 1, Page 2, Page 3, etc.).

Cover Design

If you read the sidebar on impositions on the preceeding page and your eyes glossed over, rest assured, most printers accept book files in which the pages a redesigned individually in numeric order in which the pages are renumbered.

But there's one imposition that you're not going to be able to escape: The book cover. The book's cover must be designed as a single unit including the front cover, the back cover and the spine.

As you're designing this, keep in mind the back cover will be on the left, and the front cover will be on the right. The spine — obviously — goes in the middle.

Unfortunately, this imposition won't be as easy to set up as simply doubling the width of your page size.

The front and back covers will be the same dimension as your page size, but how wide should you make the spine?

As you might have guessed, there's a formula for that, too (as long as we're talking about a paperback book). Divide the number of pages in your book by your interior paper's PPI (pages per inch) value. The PPI usually appears on the printer's estimate or quote. If not, ask the printer for it. If your book has 200 pages and you are printing it using a paper with a 400 PPI, then your book's spine will be 200 ÷ 400 — or 0.5 inches.

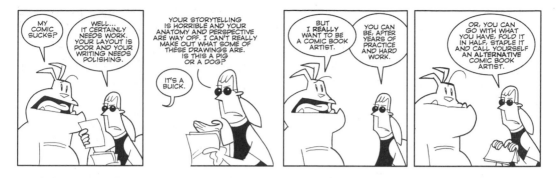

The total width of the imposition will be the width of the page size, times two, plus the width of the spine. The total depth will simply be the depth of the page size.

Beyond that, ask your printer to give you measurements for any "bleeds." A bleed is an area around the perimeter of a printed piece in which the image is extended. During the printing process, the stock gets trimmed, and the image gets cut somewhere in the bleed zone. As a result, the image in the final product extends all the way to the edge of the stock.

Formatting Standards

If you're planning to offer your book through retail outlets, you should be aware of the industry standards you'll be expected to maintain. Some retailers may refuse to carry your books if these standards are not met.

(1.) Cover must have correct 13-digit ISBN.

(2.) Bar codes must be provided in black and white, 1.833" wide by 1" high.

(3.) Book must have a Title page.

(4.) Book must have a Copyright page with your correct 13-digit ISBN. The Copyright page must come after the Title page.

(5.) Margins must be at least .5" on all sides. Your left margin must be equal to your right margin, and your top margin must be equal to your bottom margin.

Wholesaling

You can get your books into stores without acting through a distributor. You can sell to the stores directly at a discount.

The best way is to sell the retailer the books wholesale (usually 50-65% off the cover price). They stock the books in their store to sell at full price. They make their profit, and you make yours (provided you've set your cover price appropriately).

Another way to approach a retailer is to sell them the books "on consignment." In other words, you give them the books, and you only get paid if/when the store sells your books. That means you have to follow-up with the store and keep accurate count of how many books are in each store with which you've entered a consignment deal.

When you attend a comic convention, don't miss the

tremendous wholesaling opportunities available to you there. A few minutes before the floor opens, visit the retailers who are exhibiting there. Offer to sell a few copies to them at a discount for them to sell at the convention. If they sell well enough, the retailers may want to stock the books in their store(s). So make sure you give them a business card.

— *Brad*

(6.) Page numbering must be correct. No page numbers may be skipped. You can have a page without a page number on it, but it must be counted and consistent.

Put the bar code on the back cover in the lower, right hand corner. If the ISBN isn't printed above the bar code, include it in the following format: ISBN-13: XXX-X-XXXXXXX-X-X. You may also include the cover price above the bar code in the following format: $XX.XX USD. In the upper, left-hand corner of the back cover, place your full cover price.

Storage

If you decide to buy books in bulk from a traditional printer, you're going to need to plan for storing them. You'll be receiving a few hundred – perhaps a couple thousand — of these books. It represents a significant investment, so it best to provide for their safety until they're in the loving hands of your readers.

Before you look into renting space at your local self-storage building, do the math. What is your expected profit, per book? How much does self-storage cost? Do you expect to sell so many books each month that you'll make enough profit to cover this expense with plenty left over? If not, retail self-storage may not be for you.

More likely "self-storage" for you will mean storing the books yourself in your house or apartment. First, clear out an area in a cool, dry section of your house. This needs to be large enough to hold all of your books in the boxes in which they were shipped. Stacking them off the ground in sturdy shelving is recommended — especially is there's any danger of water damage from below (a water heater nearby, for example). If there is danger of water damage from above (a leaky roof or water pipes overhead, for instance) then consider draping the boxes with heavy, plastic tarp. Plan for the worst, and be prepared for any eventuality.

And expect the unexpected. If you carry house insurance or renter's insurance, con-

Importing Comics into Quark XPress or Adobe InDesign

If you're importing a large number of files into Quark XPress, I heartily recommend using an XTension called Badia ContactPage. InDesign users have an even easier time of it, since Adobe builds that function directly into their software. Steve Troop, who creates Melonpool at www.melonpool.com,

developed the following system.

If you have CS3, you already have everything you need. If you have CS2 or CS, download this script: http://www.melonpool.com/ImageCatalog.zip

Place the unstuffed script here:

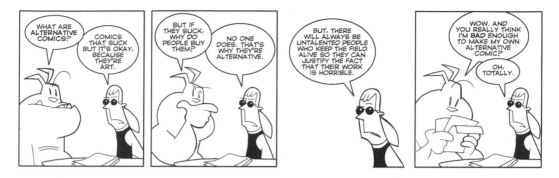

tact your agent and discuss this. Your insurance should be adjusted to compensate your investment in the event of something catastrophic like a fire or tornado. You've worked too hard to let a little thing like a hurricane take you out of the game.

Distributors

Dave has already told you how to sell merchandise directly to your readers from your Web site in the preceding chapter. But you might decide to try to market your book to people who haven't read your comic yet. And that means making your books available in stores. To do this, you can either approach the retailers directly or act through a distributor.

One option is to work with a freelance distributor. For example, when I first started out, Tony Shenton (http://snackhack.com/shenton/) got my books into a significant number of comic shops. I still distribute through him even though I now distribute through Diamond Comic Distributors as well.

Diamond, of course, is the only game in town if you want to get your books into comic shops. They also distribute to bookstores as well — through their Diamond

Applications -> Adobe InDesign CS2 -> Presets -> Scripts

(1.) Define your page size and margins: File -> Document Presets -> Define
A pop-up menu will come up. Click "New." When finished, name your Preset and click "OK."

(2.) Create a "New Document." Unlike when you've created new documents in past, you'll now see under the "Document Preset" dropdown at the top of the menu with your new preset in it. Make sure it's selected and click "OK."

(3.) A new document will open with the specs for your book and a single page. You can close this.

(4.) Create a folder on your desktop and move the files you'd like to import into it.

(5.) In InDesign, go to Window -> Automation -> Scripts and select the one labeled "Image Catalog."

(6.) The script will prompt you to find the folder with your comic files in it. Once you select it, click "Choose."

(7.) After a long pause, it will give you a menu in which you can select the number of strips per page and the number of columns.

(8.) You may have to experiment with the horizontal and vertical offsets to align the comics correctly (a good reason to run the script with

a small amount of test strips first). The numbers should define the size and placement of the strips on your pages, as well as the margins from your Preset.

(9.) Make sure the boxes for Proportional, Center Content and Frame to Content are checked.

(10.) Turn off the "Labels" checkbox unless you want the file names to appear under each comic.

(11.) Click "OK."

To see Steve's entire tutorial in further detail, visit: http://www.melonpool.com/ComicTutorialCS3.pdf

Books imprint. Ingram Books has a very helpful list of bookstore distributors on their Web site: http://www.ingrambook.com/new/distributors.asp

In working through a distributor, you sell your books to the distributor at a wholesale price (usually 60-65%) and the distributor sells the books to retail outlets.

You must submit your book to be accepted by the distributor according to the guidelines they provide on their Web sites. At the Diamond Web site (diamondcomics.com), click on Vendors in the left-hand margin and then click Getting Started in the left-hand margin of the resulting page.

Operating through a distributor requires careful bookkeeping and attention to detail. They will give you a protocol manual that should be followed carefully. This will include instructions for labeling your packages, preparing invoices, and packaging your books. Take plenty of time to understand these requirements before you sign any contracts.

A few words of warning before entering into an agreement to distribute to a bookstore: Unlike comic shops, which buy their inventory outright, and pay upfront for their merchandise, bookstores retain the right to return unsold books to the publisher. That's you. If the bookstore bought the books upfront, you may have to buy your own books back. (In whatever condition they're in!) If not, you'll get paid for the books that

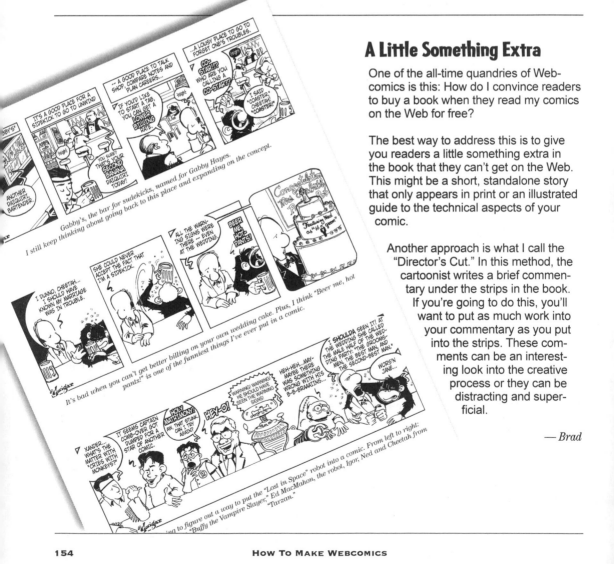

A Little Something Extra

One of the all-time quandries of Webcomics is this: How do I convince readers to buy a book when they read my comics on the Web for free?

The best way to address this is to give you readers a little something extra in the book that they can't get on the Web. This might be a short, standalone story that only appears in print or an illustrated guide to the technical aspects of your comic.

Another approach is what I call the "Director's Cut." In this method, the cartoonist writes a brief commentary under the strips in the book. If you're going to do this, you'll want to put as much work into your commentary as you put into the strips. These comments can be an interesting look into the creative process or they can be distracting and superficial.

— *Brad*

sold and the unsold books will be returned to you. In either case, you may have to cover the shipping costs both ways.

Read that contract carefully, toonhead!

Publishing a book collection is a significant achievement. Your fans crave it. Reading all of your work in a collected setting renews their zeal for your work. And it's a powerful feeling of accomplishment for you. It's a milestone that tells you that you've come a long way, and you have what it takes to go the distance. Take a moment to truly appreciate what you've done when you finally hold your book in your hands.

And then get working on Volume Two.

Storing Books

A batch of books have the charm of both weighing a lot, and yet still somehow managing to be constructed of the flimsiest material on earth.

Simply put, paper products can be a pain-in-the-neck to store. You'll definitely want to keep your books up off the ground (either on palettes or shelving), or well clear of potential leaks and pipe bursts. Additionally, you'll want to make sure you don't have low-level humidity permeating your storage space.

Given enough time, that water will do quite a number on the books' paper. (Quick product suggestion: "Damp-Rid", sold at home-improve-

ment stores, is a great way to remove humidity from the air.)

Cement flooring is your best bet to hold the weight, as it can take quite a punishment for extended periods of time. That's not to say your wooden-floored house or cartoonist's studio can't take the weight...but do you want to risk it? 2,000 books can conceivably weigh a ton or more. Instead, find a dry, flat, well-lit storage space in your house, garage, art studio or rented storage, and make sure your books are accessible and safe behind a locked door.

— *Dave*

In the Hot Seat...

This is an interesting strip to discuss from a structural standpoint, I think. It's certainly not the funniest strip I've ever created — far from it, in fact. But visually, I'm proud of the layout and flow. It was a conscious attempt to write a longer, "wordless" strip, which is one of the trickiest things to do, I think. I'm curious to hear what the other guys have to say about it.

— *Dave*

 The eyes have it in this strip. All the talking is done in Arthur's eyes. His determined squint in panels 3 and 4 provide a great contrast to the widening shock of panels 5, 6 and 7. Without the eye-work, this strip would have failed completely.

And offsetting the panel where Arthur breaks for the surface lends to making that moment even more frantic and panicked. I wouldn't have thought to do that.

 I agree. That panel made the entire comic for me. But it left some uncomfortable negative space above the next panel — which I might have suggested enlarging to cover.

Dave, I've been meaning to ask you this: Why don't you ever have Arthur use his wings as hands? He's always pointing with his feet.

Arthur's an egotistical character, with a lot of bluster. And I think the less that I anthropromorphize him, and the more that he remains this little 8-pound duck, the more his bluster comes off as ridiculous.

 For me, this strip gels in the last two panels, meaning the last Arthur pose on the rock and the scene in the deli. Arthur's doing that blank, lost-in-realization stare, and you don't need dialogue to hear him in the last panel going "uh, lemme get a, uh, half-pound of the salmon right here… and… ooh, snapper. Maybe get a little of the snapper…" and the butcher is all waiting patiently for the order. In fact, the butcher's mild, abiding expression is strong, too. He's not clobbering us with a camera look of "What's this *duck* doing here?! Crazy!" He's just doing his job.

Don't forget the excellent composition in that last panel. The black shadow against the white background (light coming in from a window?) focuses all of the attention down to the key action: Arthur's foot and the fish he desires.

...Dave Kellett

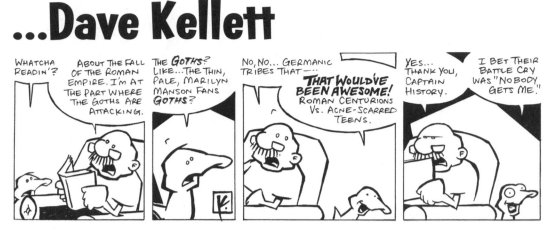

This is a fairly straight gag, as far as strips go, but there are a couple of aspects worth talking about. First, the eyes. It's such a small thing, but I'm kinda happy with the different representations of mood that Arthur's simple eyes display. Secondly, this was one of the first strips that I started playing with "fonts" in my hand-lettering. It's a technique I've slowly gotten better at...but I think this early attempt still holds up. Let's see what everyone else thinks.

— Dave

Honestly, I think you could do *more* with your eyes. See in Panel 3, how you had to move Gramp's eyes over to the side to make it appear they were following Arthur? Why not ad some little tails to them, or draw the outline of the eye like in panel 4?

Hmm. That's a good point. I can't disagree with that.

One thing you do that I can never pull off is letting the word bubbles bleed into the top of the panels and go open like that. I try that with "PvP" and it always looks horrible. I think it only works if you hand draw the bubbles. Computer generated ellipses are too perfect and makes it confusing.

Kris, is there a way to make that effect work, using computer-generated bubbles? Is it just a matter of "roughening up" their lines?

I know how to do it in vector, but in Photoshop you'd probably have to apply, like, a real slight Ocean Ripple or Glass filter, then mess with the levels so you didn't have any see-through grays — just a hard, wavy line. That's how I'd do it.

I have the smallest of nitpicks to offer: I would have rather seen a "woulda" instead of a "would've" in the third panel. "Would've" is kind of hard to get my head around — even though it's the more grammatically correct. However, it does nothing to deter from your punchline — which is awesome.

Dave is great at the blank stare. There is an affectation on Homer in "The Simpsons" where he's not really paying attention, and they draw his eyes kind of the opposite of crossed — shooting away from each other, and it just implies "lost in meaninglessness." Arthur is doing it in the second-to-last panel, and there have been a couple times where Dave combined it with a goofy smile and absolutely no dialogue. You look at it and there's Arthur, spaced look on his face, and the lack of dialogue *demands* that you acknowledge this. Like he won't leave until you *fully* accept that he is being a daydreaming idiot right now.

That said, Dave, you really lose me when you interweave word balloons from two different people. I like how your balloons get absorbed into the panel border, but when Gramp's and Arthur's balloons coalesce in panel three, it looks like they're *both* saying all that dialogue.

Comic Conventions

Comic conventions are a tremendous opportunity to promote and monetize your Webcomic. These are Your People, toonhead, and when the fair comes to town, you need to pack your stuff and open a stand on the midway.

This is an excellent opportunity for you to promote your comic to people with a predisposition to reading comics.

It's also a tremendous opportunity to network. Talk to other creators to share information. Talk to publishers to discuss possible business ventures.

But, most importantly, this is a time to spend with your fans. This is the kind of opportunity that cartoonists rarely get: Look into their eyes and feel the enjoyment that your work has brought someone. And listen to their suggestions — and, yes, their criticism — when it is offered.

If you're not rejuvenated, excited, inspired — and hoarse — by the end of the convention, you've done something wrong.

When To Go

If you have a Webcomic that is currently appearing on the Net, then you should go to your nearest comic convention — even if you're only going as a fan instead of an exhibitor. In fact, if you haven't already been to a comic convention, your first visit should definitely be as a fan. Attending the convention ("con" from here on, because I'm too lazy to keep typing "comic convention") as a fan enables you to take some time to learn the environment and the expectations you'll be dealing with as an exhibitor. Attend a few panel discussions. Ask questions. Take notes on what makes some booths more visually appealing than others. (Having a camera along on the trip is a must.)

© Brad J. Guigar

There are two reasons to exhibit at a convention: To promote your work and to sell things. If you don't have anything to sell, you may not find that putting the money into a table or booth at the con is beneficial to you. Or, you might look at that expense as the cost of promoting your work. Only you can make that decision based on your available funds.

Where To Go

Once you've made the decision to exhibit, there are two primary variables that should direct which conventions to attend: Location and theme. Choosing to attend a con by location is a common-sense issue. If there's a con nearby, it should be at the top of your list. For starters, it reduces or eliminates travel expenses — which makes turning a profit that much easier. Secondly, it's an excellent opportunity to network in your area. You may find out about resources, opportunities, and fellow cartoonists — all within easy reach from your front door.

Secondly, you should choose a convention by theme. If you create a "sword-and-sorcery" kind of comic, for example, then DragonCon in Atlanta, Ga., is a perfect convention for you. The majority of the exhibitors and attendees are immersed in this genre. If you're creating an anime-influenced comic, consider one of the many anime conventions. Further, you should widen your scope beyond comic conventions. Is there a tradeshow or convention with a theme that intersects with your comic? Consider exhibiting there. For example, a comic about a handyman might do well at the local Home & Garden Show.

When you're attending a convention that requires travel, you have to make sure that it's the right convention for you. Otherwise, you're going to waste your time and money. Do a little Web research before you commit and find out about the culture of that particular con. You might even ask other people who have exhibited at the convention in the past.

Another great way to get a "feel" for a con — besides reading all you can about it — is to do a Flickr.com search, using the con name as your search term. In addition to your fact-finding research, seeing pictures from past years gives you a clearer picture of whether this is the con for you.

Chances are, there are a number of comic conventions that take place close to your home. Check the back of Wizard Magazine for a listing. I also like the Convention Calendar at comicbookconventions.com.

Big or Small?

Is it better to attend a large convention or a small one? The large convention has thousands of fans, but you're likely to get lost in a sea of exhibitors and events. It's easier to stand out in a small convention, but there are fewer people to expose to your comic. So which should you attend?

I think a cartoonist's con schedule should have a healthy mix of both. You need to attend a few large conventions. You can throw out a larger net and flag down more people who haven't heard of your comic yet. You also have a greater opportunity to sell merchandise to non-readers at a larger convention. You'll need to be comfortable with self-promotion (more on that topic later), but it is possible to do very well at a large con.

The smaller con can also be a good opportunity. What I have found is that people spend more time at dealers' tables at a smaller con. They're less rushed. And, since a smaller con tends to attract only the hardcore fans, they're also more apt to spend money. Con theme is crucial here. Since there are a small number of people there, you'll want to make sure your comic fits well within the theme that they're showing up to see.

I couldn't agree more with you on this one, Brad. A healthy mix of large and small isn't only wise from a business perspective, it's wise from artistic and research perspectives. Differently-sized cons will teach you different things about the trends, personalities, styles, and fandoms that exist in comics.

I actually had restricted myself in the beginning to only exhibiting at bigger cons, but they can get expensive. You may do just as much business at a small con (if not more), while paying less for your booth setup. And if it's within driving distance of your city, you luck out there too. Not everyone lives in San Diego.

Exhibiting

The larger the con, the more likely you'll have a greater selection of exhibiting choices. You may find yourself trying to decide among a selection of different-sized booths, and you might even be faced with a completely different exhibition category called Artist's Alley. Your choice will be based on your convention goals — and your wallet.

Collectives and Syndicates

You can reduce the cost of exhibiting at a con by joining or forming a collective.

There are two kinds of Webcomic collective. The first is the online syndicate. Keenspot, Drunk Duck and Modern Tales are three examples of online syndicates. When you join the group, you gain hosting and tech support for your Webcomic. You also gain entrance into that syndicate's Webcomics community. This means that if the syndicate buys booth space at a convention, you may be able to exhibit there.

A collective has looser ties among the members. More often than not, the individual cartoonists are independent creators — handling their hosting and online stores independent of the collective. They might cross-promote and even sell ads as a group. Collectives often form from the need of sharing expenses such as exhibitor fees.

Most cartoonists join the syndicate because they need the hosting and get perks like exhibitor space as a secondary consideration. Collectives, on the other hand, often form out of the need for independent artist to share certain expenses.

— *Brad*

A booth at a convention is typically a small area demarcated with "pipe and drape." Pipe-and-drape, as the name implies, is a system of aluminum stands and tubes over which fabric is draped to mark out territory on the convention floor. The booth tends to be a table, a couple chairs, and some area for display behind the table. Typically, at the rear of the booth is a 7-to-8-foot drape stand from which you can hang banners and other kinds of light-weight displays. There are three standard types of booth: A linear booth, a corner booth, and an island.

Booths are arranged in straight lines leaving aisles in between for attendees to walk. It's pretty much the same layout as a supermarket. Linear booths are lined up, one after another, ending in corner booths on both ends of the aisle. Buying two adjacent corner booths sets up an arrangement called an "end cap." An island is a square-shaped booth in the middle of an aisle — with no other booths touching it. Sometimes a convention will sell half-islands, requiring you to purchase two halves to get the whole island (or "sharing" the island with another exhibitor back-to-back with pipe-and-drape separating the two in the middle.)

Corner booths, end caps and islands tend to get the most foot traffic at a convention. They're also more expensive. Some conventions allow you to buy different combinations of booths. For example, you might be able to buy a linear booth and a corner booth, resulting in an L-shaped area at the end of one of the aisles.

In general, booths cost more because that's where the greatest volume of attendees is concentrated. If you want to experiment with exhibiting at a booth, you may want to split it with a small number of other cartoonists. This works best is all of the comics fit under a similar genre or theme. You can present the booth as a group, using your signage and display materials to promote that central theme, and dedicate the individual, tabletop displays to present the works of the individuals.

The next time you go to a con, notice all of the booth exhibitors who are presenting as part of a group. In many cases, the sole purpose of those groups is to facilitate convention appearances. At the end of the day, the cartoonists go their separate ways to work on their independent projects.

Artist's Alley is the more affordable option in convention ex-

Con Strategy

On the first day of a convention — especially if you're in Artist's Alley — arrive as early as you can. Neighboring exhibitors will find it difficult to sprawl into your space if you've already demarked it. Just use your ruler and make sure you're not guilty of sprawl yourself.

In the time you have left over, prepare some sample convention sketches. You can often use these to prime sales as the convention gets underway.

Also, on the first day of the con, bring a box of a dozen donuts to share with your neighbors. It's a great way to get off on the right foot with your fellow exhibitors. Once you've plied them with a little sugar, you'll be able to count on them for anything as the convention wears on.

— *Brad*

hibiting. Instead of the pipe-and-drape booths found on the main convention area, Artist's Alley is a system of long tables — set end-to-end — in a corner of the convention floor. Again, the tables are arranged in such a way as to form aisles between them for attendees to move.

Typically, there is less room behind the Artist's Alley table for display — and often, no pipe-and-drape separator between a table and the table directly behind it. Artist's Alley has a reduced volume of foot traffic, but many of the people walking in Artist's Alley are there because they want to find something off the beaten path. Think of it as a small con that takes place inside a big con. There are fewer people, but the people who are there are more likely to want what you're offering.

Artist's Alley tables are usually sold by the half-table. If you have a lot of display items, you may want to pay the extra money to purchase a full table. In many cases, since you wont be sharing the table with anyone else, a half-table is plenty of space to exhibit — especially if you create some vertical displays (which we'll talk about later in this chapter).

Don't let the diminutive nature of the term "Artist's Alley" fool you. I can often make as much money in the alley as I can in a booth. And there are way more networking opportunities among fellow creators in Artist's Alley. Furthermore, what I've found is that the space I get at an Artist's Alley half-table is pretty comparable to the tabletop display area I get when I exhibit at a booth as part of a collective. And the cost tends to be about the same. The only difference is foot traffic. So, whenever possible, I share a booth with my friends under a collective. And when I can't, I'm more than happy to set up shop in Artist's Alley.

KRIS

Also consider that in Artist's Alley, you're going to be drawing a much more interested crowd. There's a reason why they're browsing Artist's Alley: They want to see the smaller creators. They're not as casual or jaded as the typical con attendee.

I exhibited at a medium-sized show in Dallas a few years ago, and rather than "slum it" in Artist's Alley, I split a more expensive booth on the main floor with two other cartoonists. It was a miserable show for us - the floor was full of movies, music, toy displays, and other distractions. We got completely lost in the shuffle. Meanwhile, the cartoonists I knew in Artist's Alley had a great weekend. It's something to think about.

But take note of any restrictions that your con might place on Artist's Alley selling. It's rare, but there are a few cons that don't let you sell certain products or price ranges from an Artist's Alley table. When that happens, it's usually to "encourage" small-to-midsize exhibitors to buy a more expensive booth.

DAVE

Business cards

You should invest in a short run of full-color business cards. As much as they are about selling, cons are about networking. You'll be meeting people and press that you want to be able to contact you.

Take some time to design an attractive business card. It should feature one of your characters or your comic's logo. Additionally, it should have all of your contact information including name, comic title, URL, e-mail address and phone number.

You can buy the business-card sheets that you can run through your inkjet printer and then punch out into little business cards.

But with a little research, you can find companies on the Web that offer beautiful, full-color, glossy cards at very reasonable prices, such as Vistaprint.com or Overnightprints.com.

— Brad

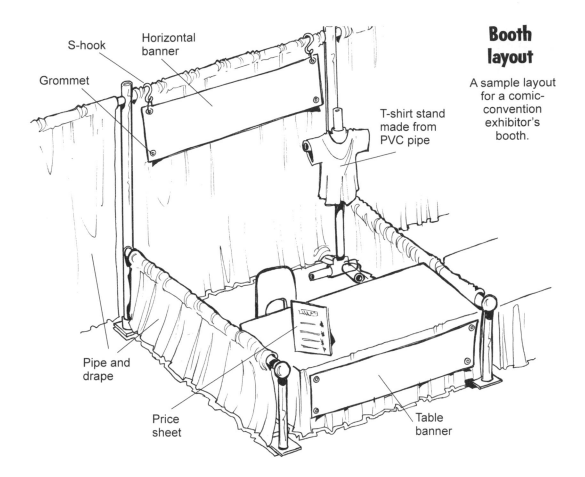

Booth layout

A sample layout for a comic-convention exhibitor's booth.

S-hook

Horizontal banner

Grommet

T-shirt stand made from PVC pipe

Pipe and drape

Price sheet

Table banner

Booth Design

If getting a booth at a con is like setting up a store, your booth design is your storefront. Considering the strip-mall setting of a convention floor, your store has a lot of visual competition. I figure the standard con attendee spends less than a second looking at a booth or table as he passes by. That's why your booth presentation has to grab him as he passes and make him stop.

The key to good booth design is getting your visuals up off the flat surface of your table. This goes for banners, signage, books, and anything else you'd like attendees to see as they pass by. It's OK to have merchandise lying flat on the table, but you have to

Stacking Books

If you have a stack of books on your table, stack them as high as you can.

This serves two purposes. First, it creates another vertical visual to attract an attendee's eyes.

Secondly, it creates a unique psychological reaction for the person who stops. People will be more likely to buy a book from a large stack than from a short stack. This might be because a large stack gives off an air of professionalism. It also might be because people have a subconscious resistance to take something that there's a shortage of.

Either way, adopt the PhD approach: Pile High and Deep.

— *Brad*

What to Bring

Be prepared for anything at a con. I recommend getting a tackle box and filling it with anything you expect to need, including:
• S-hooks
• Duct tape
• Safety pins
• Transparent tape
• Scissors
• Ruler
• String / Dental floss
• Drawing tools
• Eraser
• Sharpie marker (for autographs)
• Ballpoint pens
• Band-aids
• Facial tissue
• Breath spray / mints
• $10 in change
• Notebook / index cards
• Calculator
• Aspirin / pain reliever
• Any emergency medical supplies you need
• Spare business cards
• CD of promo files: Sample sheet, press kit, logos, etc.
• Food. Pack a lunch, a couple sodas and some snacks.

— *Brad*

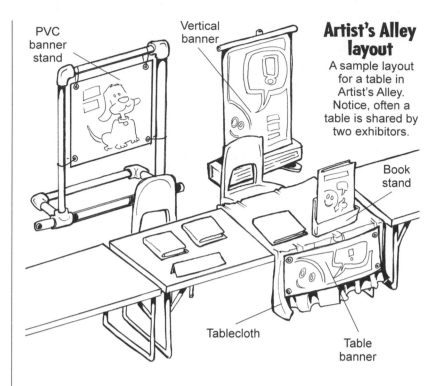

PVC banner stand

Vertical banner

Artist's Alley layout

A sample layout for a table in Artist's Alley. Notice, often a table is shared by two exhibitors.

Book stand

Tablecloth

Table banner

realize that people won't see it until they stop. Your visuals have to stop them before that can happen.

To that end, if you're selling books, go to an office-supply store and get some stands to put books in. The stands get your books up into the attendees' line of sight. It also reduces the footprint of your books on the table, enabling you to get more items on the table.

If you're exhibiting at a booth, you'll have the pipe-and-drape backdrop on which to hang displays. A great way to make use of this space is to have a horizontal banner printed. You can get a good banner printed on vinyl at almost any printer/photocopier store. When you're getting the banner printed, be sure to ask the printer to install grommets at all four corners and one along the top in the middle. Grommets are holes punched into the banner and then protected with metal rings (to keep the banner from ripping). You can use S-hooks (available at your hardware store) through the grommets to attach the banner to the top bar of the backdrop. If you don't want to buy S-hooks, you can make your own with some wire clothes-hangars and a set of wire-snips. The standard booth width is ten feet. I would recommend centering any text on the banner with a foot on either side. That way, if your booth is eight feet wide, you can fold both ends of the banner back a foot so it will fit. Just tape ends back one foot on either side and thread the S-hook through the grommets as usual.

You should also consider a table banner — which is like a standard horizontal banner only less wide (4 to 6 feet) — to accommodate your appearances in Artist's Alley. A table banner is designed to hang off the front of your table. Since this is a

GREAT COMIC-CON MOMENTS:

"WAITING IN LINE FOR THE BATHROOM"

UM... HOW ARE YOU GONNA...?

I..... I'M NOT SURE YET...

shorter banner, you'll only need grommets at the corners. I have a table banner that I have attached to a tablecloth with Velcro®. I drape the tablecloth over my Artist's Alley table and then attach the table banner using the Velcro. The tablecloth helps my table stand out and look professional, and having the pre-measured Velcro strips attached to the tablecloth makes set-up and tear-down simple and quick. If you split your time evenly between displaying in booths and Artist's Alley, consider making your horizontal banner less wide and letting it double as a table banner.

As important as horizontal banners are to booth displays, vertical banners are a key element of Artist Alley presentations. A standard vertical banner is like an upside-down window shade. The banner rolls up into a base. It can be pulled out at the top and locked to form a vertical sign. If you have a choice in size, don't be timid. I think a three-by-six-foot banner is pretty close to optimal. There are companies that specialize in printing displays for tradeshows. But before you place your order, type "Retractable banner stand" into eBay.com. You'll find a number of printers who do this for a very good price. In many instances, the actual printing of the banner is free, and you only pay for the banner itself.

You can also create a sturdy, lightweight backdrop display using PVC pipe and printed vinyl. PVC pipe can be found at almost any hardware store. It comes in varying lengths and has different fittings for corners, connections and intersections. You can build a very good frame and base with PVC pipe, and attach a vinyl banner to it with some wire and duct tape.

As you're designing your presentation visuals, keep in mind that most people are going to be glancing at your display as they're walking by. To stop them in your tracks, you need large, attractive visuals and short, punchy text. Visuals should focus on single characters — not groups. Text should be limited to title and short taglines — not story synopses. Less is more.

Guesting

Of course, the best price to pay for a booth at a convention is "free." Most conventions offer free booth space (on the floor or in Artist's Alley) to guests of the convention. Guests are people the convention invites that they can use in their advertising. In other words, if you can make the argument that your exhibiting

Taxes

Be sure to keep the receipts for everything you do during a convention: Hotel, travel, dinner, etc. They all may be tax-deductible. Be sure to save them until you meet with your C.P.A.

— Brad

at the convention will draw a number of attendees to a con, it might be in the best interest to the promoter to make you a guest so he or she can use your appearance as they promote their con.

Guests can be offered many perks depending on the degree to which a promoter believes that guest will drive ticket sales. These perks may include booth space, travel compensation, and hotel accommodation.

One of the things that keep many creators from taking advantage of guesting at a con is the word itself: Guest. Unless you're a very, very popular creator, they're not going to ask you to be a guest. You'll need to ask them! But how awkward is it to ask someone to invite you to an event? Relax. It is perfectly acceptable to contact a promoter and inquire about the possibility of attending their convention as a guest.

Still feeling awkward? Use this letter as a template:

> Dear sir or ma'am,
>
> My name is Brad Guigar and I create a daily comic strip called "Evil Inc" that can be found on the Web at http://www.evil-comic.com. I live in the Philadelphia area, and I would be interested in the possibility of attending Philly-Con in Philadelphia this November as a guest.
>
> My site traffics approximately 13,000 unique visitors a day and generates about 75,000 page views. As a guest, I would be promoting Philly-Con from my blog, which appears under the daily comic once a week for the four weeks leading to the convention. I could also offer a standing banner ad (linked to the Philly-Con.com) above the comic for two weeks prior to the event.
>
> Since Philly-Con is a local event, I don't need accommodation for travel or hotel, but I would appreciate a table in the dealer's room in exchange for my promotion.
>
> I am also available to moderate or participate in panel discussions on a variety of topics such as "The Business of Webcomics" and "Creating Believable Villains."
>
> I look forward to your response. Thank you for your time and consideration.
>
> Sincerely,
>
> Brad Guigar
>
> (Contact information)

I tend to end my letters with "P.S. I'm friends with Brad Guigar." I can't guarantee it'll work for you, but why not give it a try? Brad's name is like butter to convention organizers.

Of course, you're probably thinking that your comic isn't popular enough to justify being a guest at a con. However, you may find that a smaller con is happy to offer a limited compensation package (for example, just the booth space) in return for your attendance. You might even sweeten the deal by promising to promote the convention with a predetermined number of free ads on your Web site. It helps to see a convention from a promoter's point of view. If they throw a con and few people show up, they're ruined. They'll lose money this year and no one will pay exhibitor's

fees next year. They need as much free promotion as they can get. Offering you booth space costs them little. The promise of a grateful creator banging the drum for their convention for a solid month from his or her Web site could be awfully attractive.

Finally, don't expect to be invited to a party if nobody knows you want to go. Somewhere on your Web site — or in a blog post that gets repeated every few months — you should mention that you're available to attend comic conventions as a guest. Mention some of the same benefits of your attendance that you'd mention in a query letter like the one above. A guest invitation is very likely to come your way if you put the suggestion out there. Who knows? One of your readers might be a con promoter or volunteer.

Panel Discussions

In the above query letter, I mentioned panel discussions. Panel discussions are scheduled events at a con in which a group of people discuss a topic on which they have a degree of expertise. This could be a how-to session or it could be a critical analysis of a given work or genre. It could be promotion of an upcoming project or it could be a chance to participate in a group interview of specific comic creators.

Panel discussions are scheduled throughout the convention. They're usually held in rooms away from the convention floor. A panel usually has one designated moderator and a small number of panelists.

As an exhibitor, I would recommend keeping panel participation to a minimum. In fact, in many cases, I would advise against it entirely. When you exhibit at a convention, you are essentially setting up a small store for a finite number of hours. Every hour you spend away from your store is time that you're losing money — both in booth cost and in potential sales/promotion. If you're going to be drawn away from the store, there had better be a very good reason for it.

Participating in a panel in return for guest status at a con is a very good reason. In fact, as I showed in the example above, you might be able to design a discussion that fits your unique talents and experiences. If the panel enables you to attend the

Getting Ready

Here are some tips to help you survive the con floor with your sanity intact.

1) Bring bottled water with you, chilled in a cooler.

2) Stop. Get up. Walk outside. It's OK to take a break. Panels and lunch do NOT count.

3) Stand up for a bit. Sometimes, I get so tense sitting over books and sketching that I forget that I can stand up and stretch.

4) Take your time — even if you're lucky enough to draw a crowd. All those people are waiting. What if they get mad? Don't worry about it. Don't give in to the urge to rush.

5) Get to bed on time. If you're doing a mutli-day con, don't stay up all night and then show up late. A good night's sleep is the best prescription for a great con the next day.

— *Scott*

con for free — and to promote yourself as an "expert" in a particular topic — I'd say it's time well spent.

There are knock-on effects to appearing on con panels, like free press. Let's face it, journalists are lazy like the rest of us. They'll take at face value that the panelists are "the" authorities present, and report accordingly. I've had many an article (or follow up interview) stem directly from a panel appearance.

Another good reason to participate in a panel discussion is to promote your work. To do this well, the panel discussion in which you participate should be chosen such that it exposes you to potential readers who might not find you otherwise. In other words, a panel discussion in which you promote the projects of a collective you belong to is a somewhat inefficient use of your time. Only people familiar with the collective will attend — you're preaching to the choir. You might pick up a few outsiders, but in general, it's a wasted effort. Participate in panels that are more indirect in nature — particularly those that talk about wider topics. If you do a space-themed Sci-Fi comic, I would encourage you to offer yourself for "Themes of Good and Evil in Star Trek" or "The Use of Symbolism in Star Wars." Mind you, you have to have the ability to speak intelligently on those topics. But the further you get away from a panel discussion that's directly related to your comic, the more promotion potential you'll be able to tap into.

If you expose your comic to a few dozen new readers at a panel discussion, then you can consider it time well-spent. But be prepared. Bring flyers, books, and any other promo materials you have available to the discussion. Hang around for a short while after the discussion closes and make yourself available to anyone in the audience your comments may have touched. If people express interest, tell them how they can find you on the convention floor. Give them some promotional material. Show them your books. Schmooze. Done well, a panel discussion can be well worth the time away from your booth.

Photos

As Dave mentioned in Chapter 8, photos of fans are powerful, so bring your camera. When people buy from you, photograph them as they lovingly grasp your merchandise. Inform them that you're going to be posting their pictures on your Web site. This serves two purposes.

First, if they're not already readers, it will give them an added reason to visit your Web site. Once they're there, it's up to the comic to get them to come back tomorrow.

Secondly, readers — whether they attended that con or not — will relate to the people in the photos in different ways. Maybe somebody finds one of the attendees attractive. Maybe Hal Jordan fans will react to the attendee in the Green Lantern T-shirt.

In other words, they will be looking at your photos and saying to themselves: "I like that person," and "This person is just like me." And those are the basics of community building.

— *Brad*

The first time I was ever on a panel, I was up there with Scott Kurtz, Dave Kellett (both of whom I didn't know too well at the time), Mike Krahulik and Jerry Holkins of Penny Arcade, Michael Jantze of The Norm, and I think the Pope.

Talk about a trial by fire — I was so nervous I don't think I said five words up there.

Public speaking isn't a core trait of the cartoonist, but try to remember that you're on the panel because you know what you're talking about, and you're there to share what you know. Be yourself and crack a joke or two if they come to you, and you'll be fine.

On the opposite end of the spectrum from the nervous guy is the clown. Some cartoonists like to roll up their sleeves and really ham it up on panels. Everything they say is a joke, and they don't respond to a single topic seriously.

That approach can be a crowd-pleaser, but be prepared to walk through a gauntlet of eye-rolling from your fellow panelists when you're shaking hands goodbye afterwards. I like to have fun on panels, but I'm there to answer questions, too.

Front and back of the "Evil Inc" comic-convention flyer.

Giveaways

Few people are going to pass up the opportunity to get something for nothing. Giveaways serve two purposes at once. They help stop people who would otherwise walk past, and they put your information into people's hands when they leave your booth. Giveaways should be cheap to produce, fun and attractive. And they should carry the URL of your Web site prominently. The more likely they are to pull it out of their bag after the convention, the more likely they'll be to see your URL and give your Webcomic a try.

The most common giveaway is the simple flyer. A flyer should include your comic's title, a tagline, your URL and a sample (or several samples) of your work. You can get black-and-white flyers printed cheaply from any photocopy store. But I would encourage you to look into getting color flyers printed. If you add up the number of black-and-

white flyers you'll use over the course of the year and compare it to an order of a couple thousand color flyers (printed on the front and the back), you'll see that you're not really spending very much more. You're just spending it all at once rather than throughout the course of the year.

As you're designing your flyer, you'll want to choose your sample comics very carefully. These should be the very best examples of your work. They should be the funniest and the most well-drawn — and the shortest — comics in your archive. You want people to be able to read and react to the comics on your flyer while they're still standing at your table. You're aiming for a very small word-count with these sample strips.

Your comic's URL should appear several times on the flyer. After the sample comics,

© 2007 KRISTOFER STRAUB

WWW.STARSLIPCRISIS.COM

this is the second-most important thing on the flyer. Try to strategize the best locations for the URLs, and make sure they're clear and legible.

What you'll order is an 8.5x11" color brochure, printed front and back (sometimes this is denoted as "4/4" for four-color (CMYK) printing on the front and the back). Of course, you will not order any folds — rather the "brochures" will be shipped flat. Type "color brochure printing" into Google and you'll see dozens of companies vying for your business. Ask your Webcomics peers about their experiences and do a little cost comparing before you place your order.

I can save you a little time, there. I've been very happy with the quality of the flyers ("brochures") I had made at Overnightprints.com.

Other Giveaways

Aside from flyers, there are hundreds of promotional items that you can use as giveaways at a convention: Posters, temporary tattoos, cups, stickers, magnets, buttons, candy — the list goes on.

As long as they feature your URL and are branded to your comic — and as long as you can buy them cheaply enough to justify handing them out for free — giveaways are excellent ways to promote your comic. The more unusual

or useful the swag, the more likely the attendee is to take it out of their bag after the con and see your URL.

Let me offer one note of caution about stickers. At some conventions, if your stickers are found defacing the convention hall or hotel hosting the con, you will be charged with the clean-up — not the person who actually put the sticker up.

— *Brad*

GREAT
COMIC-CON
MOMENTS:
"MEETING THE
CREATORS BEHIND
YOUR FAVORITE
COMIC BOOKS"

If you have five open slots in your flyer design, print out ten of your very best comics and show them to a large number of people. Number them, and let people vote anonymously. Use the results of this informal poll to guide your decision-making process.

If you're doing a flyer that's printed on the front and the back, do some serious thinking about strategy. Perhaps one side of your flyer should play up the best general-topic comics in your archive while the other emphasizes comics that might appeal specifically to the more zealous attendees found at comic conventions. That way, you can pitch to a generic attendee or a hardcore fanboy by simply flipping the flyer to the correct side.

A lot of conventions have a giveaway table near the registration area where you could drop off some of your flyers or old stock that's taking up too much room in your basement. You would be surprised how many people stuff everything off the giveaway table into their bags and read it later when they get home. These are people who may never make it to your booth, so don't pass this opportunity to get your work in front of their eyeballs.

Also! Don't forget to pick up any leftovers at the end of the con. You paid good money for those flyers — so if there's 300 left, bring 'em home and use 'em at the next con!

The Pitch

The main purpose of a giveaway is to stop an attendee as she passes so you can deliver your convention pitch. Your pitch is a 10-20-second verbal explanation of your comic. You'll want to say the title, what it's about, and what makes it unique. It has to be clear, concise — and if at all possible — clever. You have a very short time to make an impression. Putting a little time into a pitch is going to increase your potential at a con exponentially.

Press Kits

You should have several small press kits available to hand out to anyone with a press badge at the convention. Often, I will write a press release to include in the kit that talks about a recent achievement or milestone. The rest of the kit should have pages devoted to Web traffic, the concept of the strip, your biographical information, and anything else that you think might interest a member of the media.

I also include a separate sheet with the URLs of several pieces of hi-res and lo-res images (my mugshot, sample strips, my comic's logo, etc.). Members of the media are encouraged to download these images and use them in any stories they may choose to run.

— *Brad*

Field Guide to the COMIC CONVENTION

Inside the comic panel:

...REMEMBER THE STORYLINE WHERE YOU AND NED WENT CAMPING? I BOUGHT THE TENT FROM THAT EPISODE ON E-BAY AND I--

...SOMETIMES I READ YOUR COMIC *AFTER* DILBERT--

...COULD YOU DO A SCENE FROM "GREYSTONE" FOR ME? LIKE THE ONE WHERE--

Booth Barnacles
barnaclous blahblahblahblus

The first step in pitching is getting the attendee to stop. The best way to do this is to hand a flyer to them. People will unconsciously reach for something that is handed to them. Once they're stopped with your flyer in their hands, you can give them your pitch.

"Would you like to check out my daily comic strip, 'Evil Inc?' It's about a corporation run for super-villains BY super-villains — because you can do more evil if you do it legal. You can read it free, every day, at that Web site [point to URL on flyer]."

A good pitch mentions the comic's title, the comic's core concept and a clever tagline. It goes on to point out the URL on the flyer and mention where the comic can be read and how often it updates. Anything that doesn't fit into these parameters should be saved for your post-pitch discussion.

DAVE

One thing worth noting in Brad's pitch, above, is his use of the word "my." I can't emphasize that word enough. So many times in life, we're bombarded by some corporate message, or a guy dressed up in a sandwich costume sellin' us on some new, 12-inch sub. We've tuned it out. And we've justified tuning it out because, hey, it's just another company. But when you use the word "my" in relation to the art you've created, something clicks in people's heads. You get a very different reaction, a postive reaction. I guarantee they'll be more likely to at least listen to what you have to say. So stress the "my."

Your pitch should be given from a standing position. Eye contact is key. And don't forget to smile. You should speak loudly enough to be heard above the ambient noise of the convention — but not so loud that you're offensive. Speak clearly — enunciate your words. Your tone should be informal and friendly. You're trying to establish a relationship here. So be inviting.

Don't turn into a carnival barker. Don't scream into the crowd at no one in particular. Don't adopt a confrontational or sarcastic tone. If people immediately shy away when you deliver your pitch, you're coming on too strong.

KRIS

Given the demeanor of most cartoonists, "coming on too strong" is probably the opposite of the problem. Remember to speak up!

Here's a great reason to do your con appearances with cartoonist friends you enjoy. If you're laughing and having a good time *while* you pitch, that directly influences how people will feel about your work as you hand them the flyer.

Once you've delivered your pitch, you must read your subject. Is he interested? Move to your post-pitch discussion. Is she reading your flyer? Wait patiently for her to finish and then move to post-pitch. Did he stuff the flyer into his bag and walk on? Success! They might be more comfortable reading the flyer on their own in a corner of the con. There's a very good chance that they'll check out your site on the Web when they get home.

I stood next to Dave Kellett at Comic Con International in San Diego, CA, when a fan walked up with the flyer Kellett was handing out at Comic Con the PREVIOUS year. "You handed this to me last year," said the fan, "And I've been looking for you ever since to buy your books." He walked away with three. Now that was a well-delivered pitch.

 Ha! It took me a year, but I got the sale! Oh, and that reminds me: If you're printing up con-specific flyers, make sure you put your booth number on the flyer itself. I can't tell you how many times I've had folks tell me that I handed them a flyer as they walked past, they read it and loved it, and then they couldn't find me again amid the con madness. As Brad said, the guy above found me again the next year. But that episode tells me I could've made the sale (and probably a few others) a year earlier if I had the booth number on there.

After you've delivered your pitch — and provided your subject is still standing in front of you, receptive to further discussion — it's time to go into your post-pitch discussion. In post-pitch, you're trying to promote your comic and sell merchandise. This takes a little practice. Watch your subject and listen to what she says. Respond calmly and in a positive manner. Don't be self-effacing. Meet any compliments with a simple "thank you," and direct the subject's attention to the merchandise you're offering for sale. And quote one or two prices of the items in which you think the subject might be most interested.

And then, simply respond.

If the subject offers a positive comment, accept it with thanks and add something else positive about your work that might be related. If the subject mentions a favorite topic, tell him in what ways your comic covers that topic.

Don't lunge and don't push. Be playful and relaxed. Steer the topic back to the merchandise if the conversation wanders after a while. Above all, have fun.

This person is attending a convention to have fun. They're paying to be entertained — not to be pressured into reaching for their wallet. It is your responsibility to see to it that they have fun. Treat them to a good time, and they will reward you.

That doesn't mean that you have to devote an unnecessary amount of time to a long-winded attendee. If the conversation is droning on (and if your repeated attempts to steer the discussion back to your merchandise fails), then you need to move on — even if your subject refuses to. Gradually decrease the frequency of your responses and the amount of eye contact. Start handing out flyers to other attendees. Be polite, but firm. If necessary, explain that you're really enjoying the conversation, but you're also there to promote your comic to the greatest number of people as possible.

Con Sketches

This is one of the great debates among Webcomic creators exhibiting at conventions: Whether or not to charge a fan for a convention sketch. I fall solidly within the pro-charge camp. Convention sketches are an excellent source of revenue for me, and most people have absolutely no problem paying a reasonable fee for a sketch.

I usually have a small sign on the table that lists how much sketches cost. This is delineated into the type of sketch (i.e.: Foreground illustrations for $20; Full illustrations for $40; and full-color illustrations for $60). When people ask for a sketch, I inform them politely that I'm offering them for the prices listed on the sign.

"But I just want a simple sketch," they sometimes reply.

Now, it's a judgment call. Unless I'm extremely busy with commissioned sketches, I usually acquiesce. I have a series of about four comic-related images that I can whip out in about thirty seconds. If the foot traffic in front of your table is at a peak (or if you're otherwise occupied), I think it's completely reasonable to politely decline.

The only "free" sketch I'm in favor of is in the case of personalizing a book that is being purchased. I'll often use it as an added incentive in my post-pitch discussion ("If you'd like to buy a copy, I'd be happy to personalize it with a free sketch"). Again, I think this should be a sketch that you're able to do in less than two minutes. The more time you spend with your head down at a table, the worse you're likely to do.

How much should you charge? You should charge as much as the market will bear. Start with a reasonable amount, and gauge the reaction. If you sold a favorable amount of sketches, you might consider bumping the price up a little for your next appearance. When you notice people shying away at the price, then you know it's time to reduce the price.

I often fall on the opposite side of the "free sketch" debate. I'm a very quick, accurate, free-hand sketcher, so it's easy for me to hand these puppies out like candy. I find they generate a great deal of goodwill that pays me back over time. And in slow-traffic moments, especially, I find that giving away sketches is a great way to sell books. While a passerby is waiting for their free sketch, I'll say, "Why not flip through my book while I finish your drawing?" Then, while they're reading, I gauge my sketching speed to their reactions. Are they not enjoying the book? Then I bust out that sketch in record time, and send them on their way in under 15 seconds. Are they laughing? I slooooooow down, and give them a chance to read and laugh more. Invariably, I'll make a sale out of it. And even better, I find that giving out sketches draws a crowd of curious onlookers. "Who is this artist? What's he givin' out?" is a common expression on their faces. And while these additional newcomers "wait" for their sketch, I make sure to hand them all books to peruse. This now-larger crowd of waiting, reading people in turn attracts a larger crowd. I'm not kidding: this works.

Whichever tactic you choose, do it with confidence. If you've settled on a $15 price, and someone asks how much for a sketch, don't screw up your face and hiss through your teeth "Ermm... fifteen? Dollars?" Say "It's fifteen dollars!" with a smile. It's $15 because it's your work, and it's worth something.

Con Ettiquette

There's a bit of unspoken etiquette among exhibitors that you should be familiar with. First, it's unkind to set up a display that covers more than your allotted space. This is particularly important in Artist's Alley. It is not impolite to get a ruler out to make sure you're getting all the space you paid for. If your neighbor is sprawling onto your area, it's up to you to politely say so.

Secondly, it's not nice to block your neighbor's table from the standard line of sight of people walking through the aisle. Erecting a display that makes it difficult for your neighbor to see attendees as they approach (and vice versa) is uncalled-for. When in doubt, ask.

Third: Never — ever — interrupt when your neighbor is talking to an attendee. In fact, you should not address an attendee until she is standing in front of your table. Luring a subject's eyes away from a neighbor's display is dirty pool. Don't do it.

Fourthly, Keep your materials in your own area. This is an especially important matter for the pipe-and-drape booth displays. It's easy to pile boxes and other materials so far into the corner of your booth that it begins to spill into someone else's designated area.

Fifthly, respect your neighbor's readers. If you do a mature-subject-matter comic and your neighbor does a family-friendly comic, try to move any suggestive images away from his side of your table. If your neighbor is addressing a family with small kids, be careful of your language.

Lastly, it is common practice to ask a neighbor to keep an eye on one's table in order to take a short break. If you're asked to do this, you should take the responsibility seriously. If you're the one on break, you should take care not to be gone too long. Also, if you're going to take a break — and especially if you've asked your neighbor to watch your table — it is good manners to offer to pick something up for that person as well.

You'll find that a little common consideration will make your con experience vastly more effective. For starters, you'll be more relaxed and have more fun. Secondly, you're more likely to make friends with your neighbors and widen your valuable network of professionals. Thirdly, you'll avoid a fat lip if you're ever exhibiting next to me.

I kid, of course.

KRIS

DAVE He kids *now*, but if you come back to the table and don't have a pretzel for Brad, save him the trouble and punch yourself in the mouth.

Here's the one bit of con etiquette that I rarely see followed: If you weigh over 225, please don't go squeezing into that lycra "Flash" costume. Leave something to the imagination: Go as a Klingon warrior.

Your comic-con appearance should be equal parts trade show, circus, family reuinion, and World Series. Clear out your schedule the week before a con to prepare. And to rest. And then enjoy it. The singular drawback to cartooning is that you never get to see people appreciate your work. The convention is your chance to make up for all that. Prepare all you can, then have the time of your life.

Next Steps

Creativity surges in leaps and bounds if cultivated properly. So does business. Once you've got the rhythm of being a Webcartoonist down, it's time to turn your attention (what little you can spare) to the future.

Thinking about where your Webcomic should go next, from both a creative and a business standpoint, is one of the hardest things for anyone to decide.

What happens when you really feel like you're out of ideas?

What's the next move to kick your business up to the next level?

To answer these questions, you really have to be able to see your Webcomic from all sides, objectively. It takes years to get there. It's not an easy road to travel, but the reward is doing what you love day in and day out for a living. For many cartoonists, there's no other option.

Creative Fatigue

Writer's block happens to everyone. Scott talked about it in Chapter 5. But writer's block can develop into a whole other beast when you've been drawing a strip for years. At times it can seem like you've literally wrung every possible storyline and punchline out of these same characters with this same premise. Here are some tips on handling the kind of existential writer's block that makes you ask, "Why am I still doing this strip?"

• **Introduce new characters, while keeping with the same spirit of the strip.** Your Webcomic needs young blood like any other long-running entertainment. The key is to not bulldoze the rest of your cast and let a new character completely alter the dynamic of the strip.

Scott mentioned the Mary Sue character, which is really little more than a fundamentally flawed attempt at a character. It's the reason why everyone knows a TV show is doomed when a dumb new cast member is added — the writers want you to accept the new guy, so if they write your favorite characters accepting him, the audience will too! This is flawed thinking. Those aren't characters we accept, they're characters we resent for showing up and breaking what we loved about the show before.

Though he's been with the strip since early on, "PvP" has an occasional antagonist in Max Powers, the rival magazine owner. Max is deployed as needed to shake up the PvP cast, rally them together or divide them — both for the sake of a story. Be faithful to your main cast. If they're well defined, you'll know how they'd react to new characters, be they friend or enemy. If you're honest about that, your audience will be able to accept a new character.

I added the little Jinxlets to "Starslip Crisis" after Dave said I needed a cute character. I actually fought him on this point! The Jinxlets storyline went live and they were accepted by my readers pretty quickly, and it's due to the fact that they didn't overshadow or usurp the existing characters. Now I bring them in from time to time to punch up a sight gag, or have Vanderbeam show some emotion that he usually tries to keep secret.

It's inevitable that your Webcomic is going to evolve, probably in ways you would have never seen when you started it. Don't fight that evolution if it's keeping your audience excited.

• **Introduce new storylines.** Like a new character, a new scenario can wake up a strip and give you some fresh ideas. But if you had new scenarios, you wouldn't be in this fix in the first place. I'm not recommending that your characters travel to Europe, or the moon, or some other scenery change. That option is always there, but even that can get stale. I'm referring more to shifting relationships between characters. Don't be afraid to get a little dramatic this late in the game — as I said before, if the characters'

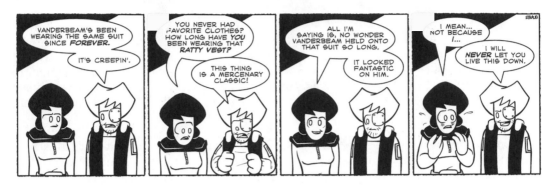

motives are true to themselves, even a radical change can work out over the course of a few months, while providing you fodder for new stories.

For example, in one "Starslip Crisis" storyline, Vanderbeam discovers his old suit has been torn, and he's forced to buy a new one. There was fun to be had there, but I also introduced the angle that a female crewman (and secondary cast member), Holiday, has spent so much time in space with the arrogant, pompous Vanderbeam that she's actually developed a secret crush on him.

Now, Holiday had been known as a thinker before, and too smart for this kind of thing. So for it to work, even she had to kick herself for letting a crush develop! Now I've got a subplot to play with for a while, until it ultimately bubbles up and creates a problem (giving me yet another storyline).

Don't be afraid to change the status quo of your Webcomic bit by bit. Your audience will follow if it's not a jarring, arbitrary change (i.e. suddenly two characters hate each other for no reason, just because it switches things up).

• **Introduce new inspirations into your own life, thereby bringing them into your Webcomic.** Pablo Picasso said, "Good artists copy. Great artists steal." (I'm sure he was mostly kidding.) But if your Webcomic is stagnating, maybe you're stagnating too. What drives you; interests you? Which other cartoonists' work do you look at in amazement? What are they doing that you admire?

I'm not saying take ideas and character dynamics wholesale from other people's work. The fact is, we all write what we know. To write more, you need to know more — find influences to take your work in new directions. Think about how someone you respect would handle it. Like I always say, "What would Dave Kellett do?" Besides have seconds, I mean.

 Ooo! Snap!

• **Try a second Webcomic.** I have more ideas than I could possibly fit into one Webcomic. I think that has to do with the idea that some jokes just don't fit into a sci-fi art museum setting. (A lot of jokes don't.) If you've got a Webcomic down pat, running like a well-oiled machine, try coming up with another one. Maybe update it once or twice a week instead of trying to do two dailies.

Start writing different material for different characters, and see how it affects how you think about your other Webcomic. You might be surprised at what you come up with.

I've got one:

> • **Redesign your Web site.** Let's face it, you look at it several times a day, and perhaps the repetition is getting you down. This is a good time to re-examine the functionality of your site, and it's an opportunity to see your work in a new light.

Ha, Brad's right. Maybe before you get to work on a second Webcomic, you could find out how to make your original Webcomic easier to approach, easier to navigate. Improvements can always be made. Even if you don't want to do another Webcomic, playing with new premises, characters and formats can give you ideas for new material for your existing strip.

Plan for Growth

You're nearing the start of your third year in Webcomics. You've done a book through print-on-demand, you've exhibited at two or three conventions, and you're going to order your first run of T-shirts with a clever design. Is this all there is, or are there places to expand your business?

Maybe it sounds obvious, but how about another book? It's never too early to start planning your next collection of strips, but there's an added benefit that Dave made me aware of. One book may sell reasonably well on its own, but when you have two books in your store, sales on your first book will increase. The same happens with any wider variety of merchandise — it's about giving the consumer more choices to browse and decide upon.

Even a reader that passed on your first book, when it was all you were selling, may come back and look at two books side-by-side and say, "I like the first book better." Or better still, "I want them both."

I'm hesitant to use the phrase "the illusion of choice," because it sounds like a trick on your audience. It's not. In reality, what happens when you up your selection from one item to multiple, is that you shift the consumer's primary question from "do I buy it or not," to "which one do I buy?" That's a much stronger position for you from which to make a sale.

Multiple book collections and other merchandise also reassure the reader about your strip's longevity. If you've got more than one book out, your Webcomic must have some staying power. It increases your work's perceived value, and reinforces the sense that you'll be around for a long time to come — so now is the time to get onboard with the first couple books, before there are too many to collect!

Speaking of which, the mentality of collecting is another great phenomenon to tap into. Having more than one item of the same category in your store already works with this, but the effect can be enhanced with simple nods, like book cover design. Dave's "Sheldon" collections all have unique covers with individual color choices and art, but they also have design elements that tie all the books together. The most striking one is the horizontal ribbon that wraps all the way around the cover — it's satisfying for the consumer to look on his bookshelf and see the individual ribbons on the book spines all line up. And when the next book arrives, you've got a hook into the reader's completist side: If a book from their favorite Webcomic comes out, they'll need to grab it.

Upselling

Along with these benefits, a variety of merchandise comes with the ability to upsell.

If the consumer is already making a purchase, it's easy to add extras like "for another $5, you can get an original sketch in the book," or "for $10, you'll also get the special collection of Sunday strips."

The best way to handle upselling is having different tiers, or price points, in your store. It's smart to fit your products into low, middle and high tiers.

• **Low-tier items** are inexpensive: Stickers, buttons, bookmarks, and other products you'd offer as swag at conventions — stuff that you don't charge more than $5 for apiece.

• **Middle-tier items** are the backbone of your store: Your book collections, T-shirts, and mid-priced prints. These can hover between $10 and $20 per item.

• **Top-tier items** should include original art, production sketches, special limited editions of other products (like "artist editions" of your book collections that feature an original sketch inside). A consumer might expect to spend $30 to $100 on one of these.

With your tier structure in place, you can now take a look at what your consumers are interested in buying (and what they won't buy), and then sweeten the deal by including one or two low-tier items in packs, or having limited offers of free stickers or buttons as promotions. The high-tier items will appeal to only a select few of your readers — the diehard fans — but you only need to sell a small handful to make it worth your while. The tier approach also works well at cons — if you can't sell a book to a particular person, maybe they'll walk away with a handful of buttons.

There's a lot of room for creativity in your merchandise, so keep an eye out for unique items to offer your readers. If you're doing a strip about a culinary school and you want to make stickers, don't just toss up a picture of your cast with a URL underneath. Put a recipe on there or make the bumper sticker look like a parking pass to your fictional school. In time you'll get to know your audience and what interests them most about your Webcomic — then you can give it to them in merchandise form.

Expanding Needs

In Chapter 9 Dave talks about how, at the beginning of your Webcomic career, you'll want to hang on to every dime your strip generates. But as your business grows, it may not be possible to handle everything you once could. Getting your work done in a timely manner and staying organized helps enormously, but no single person can understand how to take care of everything coming their way.

You're in the Webcomics business for the long haul, so pace yourself. Don't burn out, trying to do everything at once. Make an "actionable list" of things you can do over the course of time. Think of these as "baby steps." You'll find you can get a lot more accomplished is you take them one-at-a-time than is you try to get everything done at once.

Where Dave advised you to take on all the tasks yourself as a learning experience that saves you money, it's now time to elicit outside help with the more nuanced aspects of your business. If you think some parts of your business finances aren't making sense, or you need to make sure your taxes are done right, you'll need an accountant. One will run you between $150 to $500 per year, but the peace of mind is worth it.

Don't let that cost scare you. It's money well spent. And besides, ironically enough, it's tax-deductible.

It may not be a problem you have for a while — and what a great problem to have

— but there may come a day when you've got too many orders to manage and sell by yourself. In terms of effort, shipping represents a serious commitment. Once you've alienated all your friends, relatives, and spouses with long weekends of boxing items and affixing postage, you may want to sign on with a fulfillment provider or distributor.

Companies that handle fulfillment for you will need a means of receiving up-to-date order information from you to start with. You'll also be shipping the bulk of your merchandise to them for storage and handling, since they'll be the ones mailing goods to your customers. Expect them to charge you for both, as well as a fee per order. One company I recently dealt with wanted $3 per order shipped (along with some monthly storage fees I will call "healthy").

It's something to be aware of, and I leave it up to you to compare providers, and see if they'll work for you.

Intellectual Property and Ownership

The sanctity of intellectual property (or IP) ownership is deep in the heart of every Webcartoonist. Webcomics as a whole have taken the power out of the hands of syndicates and controlling interests and placed it firmly in the hands of the creator, where the power belongs. You have an opportunity to keep all your profit — it's an arrangement without peer in the publishing world.

This isn't the old days. Almost all of the opportunities you'll have are ones you create for yourself, not ones that get handed down from on high. Cartoonists have gone a long, long time without the rights and privileges that you, working on the Internet, enjoy right now. So let's examine ways to defend your rights, and some common scenarios to watch for in the ownership battleground.

Copyright: Fiction and Fact

You've seen copyright notices on comics before, but what exactly does it mean, and how do comics attain the right to that protection? The good news is your Webcomic has the right of copyright protection just by virtue of it being created. Is that really all you need, though? Here are some common misconceptions about copyrights.

• **Copyrights protect ideas.** False. Copyrights are powerful, but they don't cover ideas or concepts. Rather, copyrights protect "the form of material expression." I can't apply a copyright to my character Memnon Vanderbeam and his personality, but I can copyright all existing drawings of him, and all the "Starslip Crisis" strips he's appeared in — as well as all of the "Starslip" books. In other words, my Webcomic is copyrighted, protecting me from people who would try to pass it off as their original work.

• **Copyrighted material must carry a notice to be protected.** This used to be true, but the vast majority of countries observe the Berne Copyright Convention. In the United States, for example, all work created after 1989 is automatically copyrighted by the creator, whether the copyright symbol appears next to the work or not.

• **Copyrights must be registered to be valid.** Not exactly true, but it's a good idea to register with the US government. The copyright applied by the simple act of creation is called secured copyright — you're the creator, it's your work, and thereby you own the right to it. But if you were taken to court by, say, someone who claimed to have created the work first, the onus of delivering proof of creation/ownership is on you, not the government. Getting a registered copyright involves filling out a form and paying a small fee to the United States Copyright Office, along with a complete sample of the work you want covered by the copyright.

It's easier than you think to register the copyright to your comic.

Put into one envelope or package the following:

• A completed application Form VA (http://www.copyright.gov/forms/formvai.pdf) and Form CON (http://www.copyright.gov/forms/formcon.pdf), if needed.

• A $45 payment to "Register of Copyrights." Check or money order. No cash.

• Nonreturnable copy(ies) of the material to be registered. Read details on deposit requirements.

Send the package to:
Library of Congress
Copyright Office
101 Independence Avenue, S.E.
Washington, D.C. 20559-6000

Your registration becomes effective on the day that the Copyright Office receives your application, payment, and copy(ies) in acceptable form. If your submission is in order, you will receive a certificate of registration in approximately 4 months.

For more information, visit http://www.copyright.gov/circs/circ44.html.

• **If you're not actively using your copyright, it's up for grabs.** Of course this is false. If you're on vacation and away from home, does that mean it's not your house? Just because you're not working on the comic strip you came up with in high school doesn't mean someone else can make it theirs. No one can take your copyright — and copyrights last from the moment of creation until seventy years after the creator's death.

• **Copyright only applies to work being used for profit.** Nope — copyright applies to all work, whether or not it has made, will ever make, or was ever intended to make money. If it's created, it's copyrighted by the creator.

Although copyright secures ownership of a work, there are other rights to be aware of. Ownership is great to have, and a right that comes with it is controlling the work's

Copyright, Trademark and Patent

These three terms sometimes get thrown around like they all mean the same thing. While they all involve protecting intellectual property, they're not interchangeable.

Patents apply to inventions and physical processes, and last twenty years. Since you're not an inventor, patents don't apply to Webcomics.

Copyrights protect the authors of "original works of authorship." This includes works of fiction, essays, drawings, paintings, music and spoken word recordings. Copyright protects form of expression, not the subject. So while someone couldn't use Sheldon strips without Dave's permission, they could write a text-only review of the plot development in Sheldon.

That original review would be copyrighted by that author, too, even though it's about an existing work! However, that author could not legally write "Sheldon: Arthur's Adventures on Saturn," because the characters belong to Dave.

A trademark is "a word, name, symbol or device used in trade with goods to indicate the source of the goods." Trademarks protect companies from others using confusingly similar product names. In other words, I couldn't start a tissue company called "Kleenox" because of trademark law.

— *Kris*

distribution. As the creator of your Webcomic strips, you have say over whether or not another Web site, print publication, or other digital medium can display them. It is possible to sign a contract with a company that lets you retain your ownership rights, while giving up your distribution rights. We'll talk about distribution and contracts in a little bit.

Copyright is something to be keenly aware of when you're signing a contract or giving the OK to a terms-of-service agreement. Your copyright is not yours indefinitely. If you don't read the fine print carefully, you may end up signing away your own copyright.

For example, if you sign a "work for hire" contract, you usually give away any and all claims to copyright for the work done under that contract. In other words, the holder of the contract is seen as the artist or writer of the work in the eyes of the law.

In some cases you'll actually want to sign over your rights — kind of. For example, if a magazine wants to run a reprint of one of your strips, you will specify "one-time reproduction" rights in the contract. That means the magazine is allowed to publish it once — and only once — for the specified fee.

For an excellent guide to contracts and contract language, head to the Graphic Artist's Guild Web site (www.gag.org) or buy their book: "The Graphic Artist's Guild Handbook of Pricing and Ethical Guidelines."

Incorporating

Incorporating your business is the act of legally creating an entity to act as the face of your business. When you start a business, it's considered a sole proprietorship by the government. You are the proprietor, and you are wholly responsible for the actions and liabilities of your business.

That liability is the reason why people incorporate. Let's say you commission a plush toy and begin selling them. If a child gets injured by it, you may be held personally responsible for the damages, and there would be nothing in place protecting your personal assets from an ensuing lawsuit. Your house and your car could be seized to pay a settlement.

(A less morbid scenario is one in which your business goes into debt: In a sole proprietorship, it's your responsibility to pay, and your house is as viable as the money in your bank account.)

A corporation protects you from losing your personal assets in these cases. You become a shareholder in your corporation, and your liability is restricted to the amount you've invested. There are tax benefits and other positives, but incorporating can be expensive and time-consuming.

There are also several different types of corporation, each of which have their own merits. Common ones include LLCs (limited-liability corporations), S-corps (named for Subchapter S of the Internal Revenue Code, Chapter 1) and C-corps (guess which Subchapter?). When and how to incorporate is a little beyond the scope of this book, as you'll need to talk with an accountant and/or an attorney to determine which is appropriate to your business.

But if and when the time comes, don't be afraid of the word "corporation." It sounds huge because we're used to thinking about the multi-billion-dollar kind, but many, many

small businesses — even ones run by only one person, like you! — get incorporated every day.

Contracts and Lawyers

In time, your Webcomic may become attractive to companies brokering various agreements between creators and other media. An example of this would be a company that sells downloadable content to different cell-phone companies. The company is seeking control of your right to distribute your content on a given medium — which isn't necessarily a bad thing, depending on what they offer you in return.

But oftentimes it's hard to know exactly what's being offered. Legal-speak is unfriendly to the layperson. Contracts are (ideally) very specific legal documents that set in stone what all parties involved need to expect from one another to fulfill the agreement. Contracts also lay out contingencies, or what happens when one party doesn't live up to their promises.

Contracts are almost always written to protect the party writing the contract — that's just the way it is. So what is this company really offering you? Payment up front? A shared profit deal? In the case of our cell-phone content broker, the company may be offering you a percentage of every wallpaper and ringtone of yours they sell. Or, they may be telling you that, while there is no monetary compensation, this is an excellent move for you to raise your Webcomic's visibility.

Before you agree to anything, get a copy of their contract, and hire an intellectual properties lawyer to go through it with you and decipher all the legal language.

I've got some very simple advice for you. When a person or company approaches you and says, "I won't be paying you money, but this move will expose your comic to an entirely new audience," HEAD FOR THE HILLS.

You've got the World Wide Web, my friend, and your ability to reach an audience is limitless. Anybody that tells you differently is trying to swindle you.

That bears repeating, and it's something we've seen (and experienced) too many times to count. I was offered a standing writing position from a Web site that at least seemed notable. They were very, very interested in having me produce content for them, and I felt like it'd be a fun, possibly lucrative opportunity. But on digging deeper, I found out that they weren't willing to pay me for my time, and their traffic was actually much less than mine, despite their big name. In effect, I would have been providing them free content indefinitely, and driving my traffic to their site in the form of links and association. I had to pass on it.

So it's crucial that you fully understand exactly what you'll be signing. Contracts can transfer property rights and distribution rights of your Webcomic to someone else, and the terms of the contract don't necessarily have to have a tangible benefit to you.

Asking Questions

Let's be honest: We're artists, not businessmen. The business world is big and scary and confusing to us.

You may find yourself saying yes to a face-to-face business meeting with the cell-phone content distributor. When you get there, they'll be wearing ties and you'll be in your sweatpants, and they'll be saying things that stand a good chance of going right over your head.

And you will feel the overwhelming urge to nod quietly and politely, and hide your dumbness behind a thoughtful, chin-stroking "go on, I'm listening and completely understanding" look.

Do yourself a tremendous favor, in addition to hiring a lawyer — don't tell yourself you'll figure it out later. Ask questions then and there. Any questions, all questions, right now. Ask a question after every sentence they finish if you need to! It's their meeting with you, not your meeting with them.

And pay attention to the answers — not only the words but the attitude. How are they treating you? Are they placating you — filling you with lofty promises? Follow your gut. You've got a B.S. Detector. Use it.

As intimidating as this all sounds, most businessmen aren't out to "get" you and steal your work. There are a lot of great businesses out there, with kind and open and professional people who want to work with you, not exploit you.

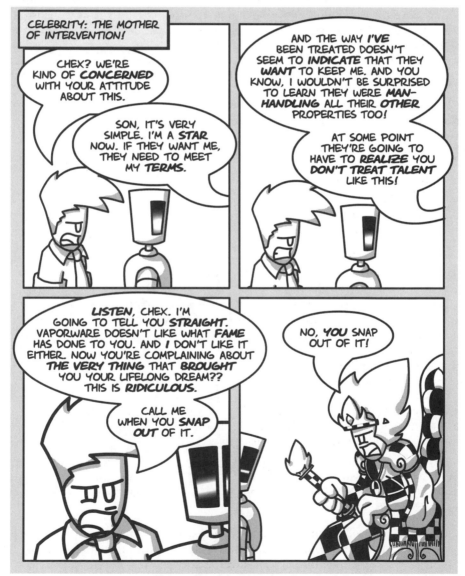

I'm emphasizing caution, but don't let it go to your head!

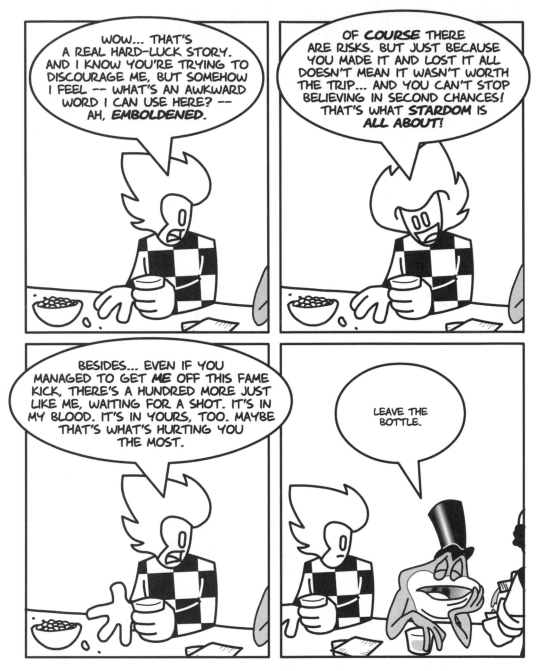

So give them a chance to show you which kind they are, and ask more questions.

The fact is, whether or not they're interested in your personal success, they are primarily interested in their own. That's not harsh or selfish, that's business and they know they need to look out for Number One. If you give them reason to believe you know exactly what's going on, they probably won't press you to make sure you understand all the finer details of the contract.

It's your job to look out for yourself. You may even inspire more respect from them for asking questions and thinking aloud — maybe something you work through with them will even help them provide a better service to other creators in the future. Do a little research ahead of time. See what other properties the company has done business

with in the past. Ask other creators how they feel about them. Then, take your own time to weigh it all, and decide for yourself.

Saying No

Bottom line: if you don't like what's being presented to you, walk away. You hold all the cards. The interested party may lean on you, or present it like it's a no-brainer, or that it's going to be the Next Big Thing. But ask yourself at every turn: What do they get out of me? What do I get out of them? Is their way really the only way for me to achieve what I want or are there other options?

There is a misconception at large that even I'm still subject to. People don't get "discovered" in the traditional Hollywood way, where the creator is minding his own business when a corporation comes knocking with a huge check and the clout to catapult them into the big time. "Making it," for sufficient definitions of "it," is a series of many, many small steps and little decisions, not any single, sweeping deus ex machina. If you're prepared to make those decisions, you'll be as set as any successful cartoonist.

Saying Yes

Once you've decided the offer is attractive to you, and you're fully aware of everything the contract entails, and you still want to do it... do it. I know I come off as negative towards signing a contract with someone, but it's for a good reason: It's not so much negativity as cautiousness. A contract can have repercussions that can make you kick yourself later, and the right time to learn if that's the case is before you sign it.

Once you have signed, though, and are comfortable with what that entails, now's the time to be optimistic, and make the most of the opportunity.

Valuing Your Work

There are all kinds of Webcartoonists from all walks of life, each of them making decisions that they believe will be the best for them and their work. While in the last couple paragraphs I've come off as strongly anti-contract and anti-businessperson, I want to dispel that notion with a few words.

You can sign a contract for the wrong reasons, and you can turn down a contract for the wrong reasons, but both stem from the same source: misunderstanding the value of your work. The people who jump to sign a contract without reading it think there's nothing else good down the road coming their way; that this opportunity is their last option, and if it passes them by, that'll be the end of everything. That's an awful way to feel about something you've put so much effort into. This kind of person doesn't value their work, or has lost sight of the value of their work.

The people who turn down every contract without even considering it think there's no way this could turn out positively; that their Webcomic can only suffer from association with other groups or companies. Maybe they don't see their work for what it really is, and what it actually needs to give it a boost, so they say no to even the fair, equal arrangements that make good sense. They don't know the value of their work either!

It's your blood, sweat and tears that got you here. Your work is valuable and important. Treat it that way. Guard it from cheats and questionable arrangements, and cultivate it with beneficial partnerships when possible. You're here for a reason. Let go of those feelings of inadequacy, of fear that we're all tortured by. Keep your wits and your heart about you. If your work keeps bringing you satisfaction, you're on the right track.

A Final Thought...

There are many paths to the same mountain, and many paths to making your Webcomic work.

And if your goal is to create, share, and make a living from your webcomic, then your path will most definitely be unique to you. We've tried to give you an encompassing guide to the setbacks and successes you can expect (hoping to write, in essence, the book we wish had existed when we were starting out), but no single book could be the perfect guide to all cartoonists' careers.

So allow me some final, general thoughts to help you as you filter through our advice, and you begin carving out your own little corner of the Web.

First, don't get ahead of yourself when you're starting out. Just as Rome wasn't built in a day, so your Webcomic won't be an overnight sensation. It's a years-long journey involving many, many steps, and a lot of late nights. In your initial months — perhaps even your initial years? — focus on your Webcomic before everything else, and build your skills as a cartoonist and storyteller. Then, and only then, start to build outward. In the successive months and years, begin adding to your Website and design skills, your branding and public interaction, and finally your business acumen.

Secondly, don't let your research stop with this book. Turning a hobby into a part-time job, and a part-time job into a career, will take continuous experimentation and research — especially on the Web, where the landscape seems to change every six months. Watch and learn from Webcartoonists you admire, and note the steps they take to keep their audiences happy, and their businesses growing. Study, too, the broader trends among artists and businesses plying their wares online. What are successful bloggers doing? Musicians? Media companies? The skill sets needed to make a Webcomic work are drawn from many specialties, so keep your eyes open to learn from many sources in many fields.

Third, manage your risk. As an artist with a creative temperament, business is going to seem scary and fraught with financial risks. And it is. Mitigate that by tackling new ventures one at a time, and raising your financial risks only as you raise your business savvy. Avoid huge, make-or-break moves in your early years: Grow slowly, and learn from (manageably-sized) failures. Similarly, be wary of pie-in-the-sky contract offers that may come your way, promising riches or overnight audiences. The kingmaker who can deliver you an instant career is an increasingly rare thing in comics. Don't sign with a company simply because "Surely they must know how to handle this stuff better than I do." Educate yourself, and be crystal clear on what it is you're signing, what creative rights you're giving up, and what you're getting in return. And know this: No one will ever care for your comic as much as you do, whether or not there's a contract involved. Ultimately, you are the greatest determinant of whether your career in Webcomics will be a success.

Finally, never lose sight of the joy behind creating a Webcomic. Whether your audience is 5 people or 500,000, there's something awesome about creating these little worlds and sharing them with others. It's a gift, really — an opportunity. So take that opportunity and run with it. And make sure you enjoy the process along the way.

We've shown you how to make Webcomics…now it's your job to show the world what you've learned. Good luck!

Get To It

Only put off until tomorrow what you are willing to die having left undone.

— *Pablo Picasso*

A tour of Scott's studio*

My studio is the front room of my house in the North Dallas Area. You walk in the front door and to your left in the entryway is a set of double french doors. This leads into the studio.

Entrance

Above the door hangs my "QUIET, CARTOONIST AT WORK" sign. This sign was made by a wood-carver in Keystone, South Dakota during a family vacation. I told the carver I would one day be a cartoonist and I would keep this until then. Once I was grown up and a cartoonist I would hang this over the door of my studio so my family would know to stay quiet while I was working.

The back is signed by the artist and reads "Good Luck! 8-15-1984. Keystone S.D."

Trophy wall

1. Superman clock that my wife found for me at a flea market or something. It doesn't really keep time anymore, but that's never been its main purpose anyway.

2. This is a cool dry-erase calendar (also my wife's doing). All the cons for the year are on there. So are my important deadlines so I know exactly when I miss them.

3. This is a cat-scratcher that my cat never uses.

* Reprinted from an Interview at www.comicbookresources.com. This was Scott's studio before he moved to his current office outside his home.

4. Frank Cho's wonderful drawing of Jade on a bear-skin rug. I desperately want to get this colored and made into a poster.

5. Original art to "PvP" #7 by Mike Wieringo. Mike was kind enough to give this to me.

6. Framed page from PvP's first appearance in "PC Gamer." The strip ran in that magazine for over a year.

7. "Rose is Rose" art from cartoonist Pat Brady. I sent him fan-mail years ago and he sent me this.

8. This is a program from the 2002 Lonestar Comicon. It was an incredible con for me because "PvP" had just been written up in Wizard and this was the first time people in the comic book industry I have respected for years wanted to talk to me and told me there were fans. I met Kurt Busiek, Mike Wieringo, Todd Dezago, Mark Waid, Devin Grayson, Jim Mahfood, Scott Morse, Andy Kuhn and so many others. Everyone signed my program. I remember turning to my wife who attended with me and saying "This is a huge turning point for me."

9. Henry Martinez fan art. Henry used to work for Marvel, but I met him playing Ultima Online.

10. "PvP" appeared in "Dork Tower" and John Kovalic gave me the original art. This is from my Dork Storm days.

Workstation

Turn to the left and the long wall has a built in desk and shelving system. We had this put in custom a year and a half ago. Best money I ever spent. Closetsbydesign.com, I think. Great guys. I hated working at home until we put this in. I live here. I spend most of my days, weeks and months right here.

1. This is a thing I found online. It's stuffed plushes of a drop of pee and a piece of poop. It's dutch I think. I'm sure it seems morbid to Americans, but Europeans don't flip out about this stuff so much. I bought it because we're planning babies in the next year or so and hopefully someday soon, I'll be using these to help my kid understand how the potty works.

2. I got a ton of toys and shit up on these shelves. Muppet figures, Asterix statues and a ton of Peanuts stuff. Whenever a statue or toy grabs my attention, I pick it up and it ends up here.

3. Two prized possessions: A picture of myself and my late mother right before my wedding, and my Eisner. Mom died in 1996, two years before I started "PvP." She never got to see me get to do this for a living. She doesn't know I became a cartoonist. I think that's why I keep the Eisner near the photo. I never got to share this stuff with her.

4. 30" Apple Cinema display. This is truly a luxury item. It's like looking into the face of God.

5. Mac Pro. I just got this thing after a year of saving. I am not a Mac nut who feels the need to push the platform on others. It's all the same now. This thing runs windows on a 2nd drive if I ever need it for anything (mostly games). I use it as a Mac 99% of the time and as a Windows machine if I ever need it

Hardware on the Mac Pro:

Two 3.0GHz Dual-Core Intel Xeon processors

2GB (4 x512 MB) RAM

ATI Radeon X1900 XT 512MB

6. This used to be my Mother's. We grew up knowing it as the "Brum Bear." if you press its stomach, it makes a little bear growl or "Brum" in German. It was something we were never allowed to play with when we were kids. After mom died, everyone had something of hers she wanted and I never took anything. I went to my dad a year ago and said, "I have a nice place for him now where I know he'll always be safe. I want Brum Bear." And he gave it to me. So Mom's here.

7. Amidst my trades and comics, I have the copy of Previews where "PvP" #1 was solicited. Jim Valentino gave "PvP" the cover of this issue. I kept several copies as well as PvP's 2 page "secret stash" article in "Wizard."

8. A bunch of comics.

9. What says "old man" more than slippers?

Window

Turn left again and you see the window looking out front.

1. This is a great Christmas gift my brother gave me one year. He found an old photobooth strip from when we were on the boardwalk in Sana Cruz as kids. I must have been... shit...14 or something? He had them blown up and framed. We've always been very close. We moved a couple times due to my dad's company transferring him around when we were kids. Brian was my closest friend growing up.

2. Scratch's bed. He watches birds out the window all day.

3. Tivoli Audio Sirius Satellite radio. It's small, but the

sound quality is great and Sirius is an awesome service. I always have exactly the music I want for whatever mood I'm in.

4. Computer router, modem and stuff. Internet is my life's blood.

Full circle

Turn left again and we're back at the french doors that lead into my studio. I don't spend much time here since I learned how to use my Wacom tablet.

1. Posters of my comic books. "Justin" and "PvP." You can buy these at my Think Geek store. See how great they look framed?

2. Track lighting. I am not gay.

3. This is pretty cool. When Charles Schulz retired, the Fort Worth Star Telegram sold these limited edition reproduction prints of some "Peanuts" Sunday strips. There was a charity raffle one Christmas and the Telegram took four of them that they saved, framed them and put that up as a raffle prize. My Dad and Step mom bought a ton of raffle tickets to win that for me so they could give it to me for Christmas. My dad went back up for one more set of tickets at the last minute and those were the ones that hit.

4. Cat treats.

5. This is my old PC. I put it back here on my drafting table in case I had trouble switching over to the Mac and needed it as a safety net to get work done. I set it up and never went back to using it.

6. This is a 30-plus year old Oak Mayline drafting table. It used to belong to my dad. Dad studied Architecture when he was my age (shit, younger probably), and he got a job doing it for a while. The guy who hired him had a whole room full of these. Dad didn't keep the job but the guy let him take a table. It comes apart and can be re-assembled with these nuts and bolts so it's easy to store and move around. It's in really great condition. It's an insult having a computer hogging it up right now.

Additional Resources

We've done our best to give you a headstart in making your Webcomic soar. But the truth is, any single chapter in "How To Make Webcomics" could itself be a full book. To help you dig deeper and find the knowledge you'll need to tackle each step with your Webcomic, we've put together a short list of key resources. Do yourself a favor and don't stop your research with this book: Keep learning!

Cartooning

Caldwell, Ben. Action Cartooning. Sterling, 2004.

Glasbergen, Randy. Toons!: How to Draw Wild & Lively Characters for All Kinds of Cartoons. North Light Books, 1997.

Guigar, Brad. The Everything Cartooning Book: Create Unique And Inspired Cartoons For Fun And Profit. Adams Media Corporation, 2004.

Eisner, Will. Comics and Sequential Art. Kitchen Sink Press, 1992.

Lee, Stan and Buscema, John. How to Draw Comics the Marvel Way. Titan Books Ltd., 1996.

McCloud, Scott. Making Comics: Storytelling Secrets of Comics, Manga and Graphic Novels. Harper Paperbacks, 2006.

McCloud, Scott. Reinventing Comics. Paradox Press, 2000.

McCloud, Scott. Understanding Comics. DC Comics, 1999.

Nordling, Lee. Your Career in the Comics. Kansas City: Andrews McMeel Publishing, 1995.

Artistic Inspiration

Cameron, Julia. The Artist's Way. Tarcher, 2002.

Covey, Stephen R. The 7 Habits of Highly Effective People. Free Press, 2004.

Edwards, Betty. Drawing on the Right Side of the Brain. HarperCollins Publishers Ltd, 2001.

Helitzer, Melvin. Comedy Writing Secrets. Writer's Digest Books, 1987.

Hogarth, Burne. Drawing the Human Head by Burne Hogarth. Watson-Guptill, 1989.

Hogarth, Burne. Dynamic Anatomy by Burne Hogarth. Watson-Guptill, 1990.

Horn, Maurice. 100 Years of Newspaper Comics. Gramercy Books, 1996.

King, Stephen. On Writing. Pocket, 2002.

Web Design & Maintenance

Beaird, Jason. The Principles of Beautiful Web Design. SitePoint, 2007.

Robbins, Jennifer Niederst. Learning Web Design: A Beginner's Guide to (X)HTML, StyleSheets, and Web Graphics. O'Reilly, 2007.

Schafer, Steven M. Web Standards Programmer's Reference: HTML, CSS, JavaScript, Perl, Python, and PHP. Wrox, 2005.

Small Business

Anderson, Chris. The Long Tail: Why the Future of Business is Selling Less of More. Hyperion, 2006.

Bhldt, Amar; William Sahlman; James Stancil; and Arthur Rock. Harvard Business Review on Entrepreneurship. Harvard Business School Press, 1999.

Burd, Rachel. Graphic Artists Guild Handbook: Pricing and Ethical Guidelines. Graphic Artists Guild, 2003.

Burlingham, Bo. Small Giants: Companies That Choose to Be Great Instead of Big. Portfolio Trade, 2007.

Caputo, Tony C. How to Self-Publish Your Own Comic Book. Watson-Guptill, NY 1999.

Cox, Mary. Artists & Graphic Designer's Market. Writer's Digest Books, OH 2003.

Finell, Dorothy. The Specialty Shop: How to Create Your Own Unique and Profitable Retail Business. AMACOM/American Management Association, 2007.

Gladwell, Malcolm. The Tipping Point: How Little Things Can Make a Big Difference. Back Bay Books, 2002.

Levinson, Jay Conrad. Guerrilla Marketing: Easy and Inexpensive Strategies for Making Big Profits from Your Small Business. Houghton Mifflin, 2007.

Luecke, Richard. Entrepreneur's Toolkit: Tools and Techniques to Launch and Grow Your New Business. Harvard Business School Press, 2004.

Ross, Tom & Marilyn. Complete Guide to Self Publishing: Everything You Need to Know to Write, Publish, Promote, and Sell Your Own Book. Writer's Digest Books, 2002.